A Guide to Art
at the University of Illinois

A Guide to Art
at the University of Illinois

Urbana-Champaign, Robert Allerton Park, and Chicago

Muriel Scheinman

University of Illinois Press
Urbana and Chicago

© 1995 by the Board of Trustees of the University of Illinois
Manufactured in the United States of America
P 5 4 3 2

This book is printed on acid-free paper.

Library of Congress Cataloging-in-Publication Data
Scheinman, Muriel
A guide to art at the University of Illinois : Urbana-Champaign,
Robert Allerton Park, and Chicago / Muriel Scheinman.
p. cm.
Includes bibliographical references and index.
ISBN 0-252-06442-9 (pbk. : acid-free paper)
1. Art—Illinois—Catalogs. 2. University of Illinois (System)—Art
Collections—Catalogs. I. Title
N6530.I4S34 1995
708.173—dc20 94-5257
 CIP

Photographs of Master of the St. Ursula Legend, *Virgin and Child with Four Saints,* and Tom Otterness, *Untitled,* courtesy of Krannert Art Museum and Kinkead Pavilion. Photograph of the *Chester Krater* courtesy of the World Heritage Museum, University of Illinois at Urbana-Champaign.

Contents

Maps for parts 1, 2, and 3 follow pages 1, 95, and 141, respectively.

Preface

This book serves as an introduction to art at the University of Illinois's Urbana-Champaign and Chicago campuses and at Robert Allerton Park, its educational conference center near Monticello. Catalog entries are selective, as the enormous number of art objects acquired over the course of the university's long history—1867 to the present—places limits on inclusion. Choices rest on quality and interest, and illustrate the broad range of works acquired. As much social history as art history, the book deals with issues of patronage and describes holdings in the museums, the Arts Study Collection, and Jane Addams' Hull-House. But the focus is on paintings and sculptures animating the everyday environment—in classrooms, rotundas, hallways, libraries, student centers, lobbies, and theaters, and outdoors along walkways, near buildings, on facades, over entrances, in the landscape. It is art that teaches, delights, stimulates, inspires, symbolizes, beautifies, commemorates, or puzzles—or does nothing more than enrich the lives of those who see it.

The catalog entries are arranged as far as possible in geographical order, following routes a visitor might take on foot. Dimensions of objects are stated with height preceding width and depth. Dates are given if known. A separate listing of portrait paintings and sculptures is organized alphabetically by name of sitter. Maps for Urbana-Champaign and Chicago give building addresses; the map for Robert Allerton Park shows buildings and gardens near which sculptures are located.

I am indebted to many individuals and institutions who aided in the preparation of this guide. Thanks are in order, first of all, to Allen S. Weller, professor emeritus of art history and former director of the Krannert Art Museum, for his wisdom and constructive suggestions; Robert Adelsperger, archivist at the Library of the Health Sciences, for interest and help that transcended mere duty; Ruth Weinard, associate director for communications at the University of Illinois Alumni Association, for her unfailing generosity in sharing information; Maarten van de Guchte, director of the Krannert Art Museum, for providing encouragement as well as facts; and Carol Bolton Betts, manuscript editor at the University of Illinois Press, for sharp eyes and knowledgeable comments.

My gratitude goes also to Maynard Brichford, University Archives; Barbara Bohen, World Heritage Museum; Marcel Franciscono and Jerrold Ziff, Department of Art History; James Kaler, Department of Astronomy; Robert Johannsen, Department of History; and Donald Charlton and Richard Alexander, Division of Operations and Maintenance, all of the Urbana-Champaign campus. I gratefully acknowledge the grants given in support of this project by the University of Illinois Foundation and by Robert Allerton Park.

For material relating to Robert Allerton Park, I appreciate the contributions of Jennifer Eickman and the late John Gregg Allerton. For information about the university's Chicago campus, I am indebted to Ruth Best, Health Sciences Center Auxiliary; Dr. Lloyd Nyhus, professor and head emeritus of the Department of Surgery; Robert Mrtek, professor of pharmacy administration; Mary Ann Johnson, director of Jane Addams' Hull-House; and Ross Edman, professor of art history and curator of the Arts Study Collection. The latter three graciously responded to my requests for written statements by providing information that formed the basis for my descriptions of, respectively, Jefferson League's pharmacy murals, Hull-House, and the Arts Study Collection.

I extend thanks also to Esther Sparks, Art Institute of Chicago; George J. Mavigliano, Southern Illinois University, Carbondale; Laurel Bowen, Illinois State Historical Library; Patricia Bartkowski, Wayne State University; Martha Holland, University of Alabama; Hal Marshall, University of Arizona; Virginia Xanthos, Columbia University; Daniel Reich, University of Chicago; Richard J. Wolfe, Harvard Medical Library; Karen L. Wilson, Oriental Institute Museum; Victor A. Sorell, Chicago State University; Robert Kvasnicka, National Archives; Judith Throm, Archives of American Art; Pat Lynagh, National Museum of American Art; Francis V. O'Connor, Fellow, National Humanities Center, Research Triangle Park, North Carolina; and Barbara Bernstein, writer and film maker.

Photographic credits go mainly to Bill Wiegand, Tom Klute, and Andrew Scheinman. Special gratitude goes to a unique cheering squad: James Gobberdiel, Judith Ikenberry, Jerrold Soesbe, Virginia Gilmore, Adriaan de Witte, Shirley Weber, and Edmund DeWan.

As for my family—always supportive, nearly always patient—my love knows no bounds.

1

*The University of Illinois
at Urbana-Champaign*

URBANA-CHAMPAIGN CAMPUS

36 Agricultural Engineering, 1304 W. Pennsylvania, U.

11 Altgeld Hall, 1409 W. Green, U.

28 Architecture, 608 E. Lorado Taft, C.

22 Armory, 505 E. Armory, C.

1 Beckman Institute, 405 N. Mathews, U.

25 Bevier Hall, 905 S. Goodwin, U.

33 Education, 1310 S. Sixth, C.

7 Engineering Hall, 1308 W. Green, U.

6 Everitt Laboratory, 1406 W. Green, U.

20 Foellinger Auditorium, 709 S. Mathews, U.

4 Grainger Engineering Library, 1301 W. Springfield, U.

19 Gregory Hall, 810 S. Wright, U.

23 Harding Band, 1103 S. Sixth, C.

14 Henry Administration, 506 S. Wright, U.

26 Huff Hall, 1206 S. Fourth, C.

12 Illini Union, 1401 W. Green, U.

32 Krannert Art Museum, 500 E. Peabody, C.

17 Krannert Center for the Performing Arts, 500 S. Goodwin, U.

34 Law, 501 E. Peabody, C.

24 Library, 1408 W. Gregory, U.

18 Lincoln Hall, 702 S. Wright, U.

31 McKinley Health Center, 1109 S. Lincoln, U.

9 Mechanical Engineering, 1206 W. Green, U.

37 Memorial Stadium, 200 E. Florida, C.

8 Metallurgy and Mining, 1304 W. Green, U.

29 Mumford Hall, 1301 W. Gregory, U.

13 Natural History, 1301 W. Green, U.

35 Natural Resources, 607 E. Peabody, C.

2 Newmark Civil Engineering, 205 N. Mathews, U.

15 Noyes Laboratory, 505 S. Mathews, U.

27 Rehabilitation Education Center, 1207 S. Oak, C.

16 Roger Adams Laboratory, 1209 W. California, U.

40 Small Animal Clinic, 1008 W. Hazelwood, U.

21 Smith Memorial Hall, 805 S. Mathews, U.

10 Swanlund Administration, 601 E. John Street, C.

5 Talbot Laboratory, 104 S. Wright, U.

30 Turner Hall, 1102 S. Goodwin, U.

3 University High School, 1212 W. Springfield, U.

39 Veterinary Medicine Basic Sciences, 2001 S. Lincoln, U.

38 Willard Airport, Airport Road, Savoy

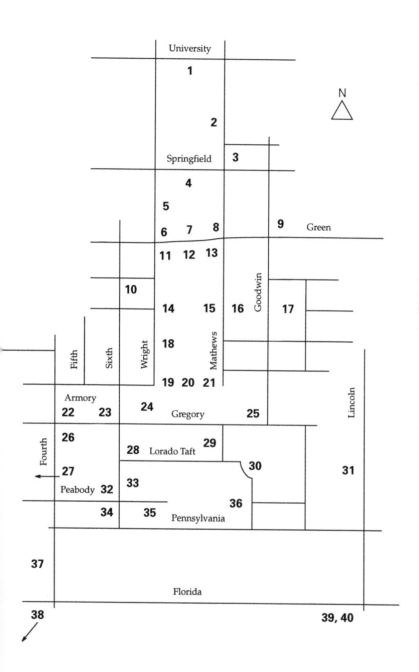

Urbana is east, Champaign is west of Wright Street.

A merican colleges and universities seem not to have had the acquisitive instincts associated with great church, governmental, corporate, and private collectors of art. Portraits of distinguished teachers and patrons served a traditional commemorative function and early hung in their halls, but recognition of art for its own sake developed unhurriedly and without special plan.

At Urbana, the art department at the Illinois Industrial University (renamed the University of Illinois in 1885) was established in 1877 to teach basic freehand drawing and clay-modeling courses to architecture and engineering students and remained a service facility, precluding the purchase of original works of art at an institutional level until well into the twentieth century.

How was it then that an ambitious Fine Arts Gallery opened to the public less than a decade after the university's start in 1868? What happened to it? What sort of art patron has the university been?

Gregory's Fine Arts Gallery

Any school characterizing George Washington as "the great farmer of the Revolutionary period," as the newly instituted Illinois Industrial University did in describing the portrait displayed on its dedication-ceremony platform, must have put a good deal of stock in agriculture as well as industry. That is not surprising, since roughly two-thirds of the twenty-eight members of the original board of trustees made their livelihoods from agricultural, horticultural, or stock-breeding enterprises, and the Federal Land-Grant Education Act under which the university was founded had as its stated objective the "liberal and practical education of the industrial classes," specifically as related to agriculture, engineering, and home economics. The curriculum included courses in

Gregory's Fine Arts Gallery, University Hall, c. 1878

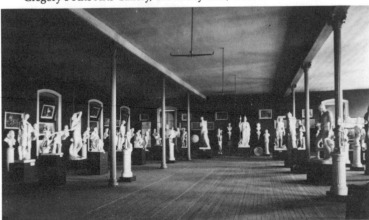

the sciences, engineering, commerce, mathematics, languages, literature, history, and architecture—but nowhere is art mentioned until a movement to assemble an art collection commenced in 1874 and an instructor was hired in the fall of 1876 to teach industrial art and design.

At the university's inception, its first regent, John Milton Gregory, wisely did not raise the possibility of asking for state appropriations to acquire art or, for that matter, to include painting and sculpture classes in the curriculum. Proposals of that sort surely would have generated controversy among pragmatic legislators and trustees geared to the harsh realities of prairie life. The frontier had only recently been pushed back and their chief interest lay in training Illinois youth in the most modern, efficacious methods of farming and what were known as the mechanic arts. Gregory had a profound commitment to the ideals embodied in the democratic, innovative programs of the land-grant college movement, yet his vision of teaching young Americans who never before had had opportunities to attend upper-level schools reached far beyond the prosaic.

To a large degree the university they organized had no precedent, and Gregory proceeded from two fundamental assumptions. He regarded the mechanic arts and agriculture as the equals of any other disciplines in importance, dignity, and scope, and he thought that complete mastery of these arts demanded an education different in kind yet as systematic and comprehensive as that required for the learned professions. Working people, he said in his inaugural speech, were just beginning to covet the rich heritage of knowledge for their children, and more and more "the light of high and classical learning will be found as beautiful and becoming when it shines in an educated farmer's home as when it gilds the residence of a graduated lawyer or physician."

Gregory assured the board of trustees that the arts had played too important a role in civilization's history to necessitate "any new defense of their utility and power," and that the university would derive from the presence of an art collection "advantages and renown of no small extent." Attentive local audiences heard him tell of the incredible spread of art in New York and Boston and of how, if successful in raising money for an Illinois museum, "it would give Champaign and Urbana a character abroad for art, genius and refinement, and in that respect [they] would stand ahead of the cities of the west." The student newspaper, the *Illini*, put it more bluntly: "the age no doubt is rapidly approaching when foreigners will no longer cry out against the disgusting taste of Americans."

Gregory managed to establish a Fine Arts Gallery in 1874 after soliciting from Urbana-Champaign citizens contribu-

tions that ultimately amounted to $3,000 and by traveling to Europe at his own expense to obtain works of art. There he purchased 260 plaster casts, 286 photographs of famous paintings and Italian and Swiss scenes, 388 lithographed historical portraits, and an assortment of other art items.

The gallery opened to the public on the third floor of the main building's west wing, on New Year's Day, 1875. So packed with statuary was the room that only 250 people could be accommodated at one time. There before them in the gas-lit expanse of bare wooden floors, low horizontal partitions, and dark maroon walls, visitors saw a panorama of "celebrated" chalky white busts and variously posed figures as well as several hundred "inalterable" pictures of famous paintings and portraits.

In a special dispatch, the *Chicago Tribune* reported that "the grand collection is now the largest west of New York," containing replicas of the best pieces in existence. The *Illini*, editorializing about the value in stimulating productive work and in giving meaning to life itself, asserted that the gallery "will undoubtedly, in its ultimate and beneficial results, be found to be one of the most valuable" of all university facilities.

What happened to these treasures? In spite of press attention as late as 1894—the year the *Chicago Herald* discovered the university's small-scale but choice art collection, "with a head janitor who could explain things as well as a master of the arts"—the *Illini* had even ten years earlier commented about the gallery's disconcertingly low attendance rate: "If our gallery as at present made use of has any influence," it prophesied, "it must soak its way through brick walls and find its way into student life as best it may."

The fact is that indifference and insufficient facilities for display and storage led to the eventual loss of almost all the collection. Moved first in 1897 to the new library's west basement, the casts and statues were "very seldom looked at" and did "little good," according to one report. The gradually diminishing, deteriorating remainder migrated over the years to various campus locations. Surviving in the World Heritage Museum are a small number of busts, some photographs, photoengravings, lithographs, and miscellaneous items, and about ten casts, among them the *Laocoön*, *Apollo Belvedere*, *Venus de Milo*, and *Thorn Extractor*. There are busts also in the Lincoln Hall basement, the Library attic, the Armory, and the foreign languages and classics libraries.

In an inconspicuous spot between the Administration Building and Altgeld Hall is John Milton Gregory's grave, the small marker inscribed with the epitaph "If you seek his monument, look about you." It may be obvious to say so, but nowhere will his Fine Arts Gallery be found.

The Krannert Art Museum

Very slowly at first and then only occasionally, the university obtained objects classified as art—rugs, vases, stained-glass windows, and casts from the 1893 World's Columbian Exposition in Chicago; Japanese, German, and English prints from the 1904 St. Louis World's Fair; and unsolicited gifts such as two pictures of "interest and beauty" presented in 1913 by "twelve ladies" of Shelbyville, Illinois. Beginning in 1908 the art department organized small loan exhibitions fairly regularly in the lobby of the newly built Auditorium, and in 1924, in what surely augured increasing academic status and professionalism, it mounted its first annual faculty art show.

A phenomenal nationwide awakening of interest in art came with 1920s prosperity. Galleries and museums grew in scope and number, American artists and regional themes gained greater recognition, and the search for an authentic American style intensified. On campus, the impetus to collect came from a realignment of the university's aesthetic interests that culminated in a unified College of Fine and Applied Arts, the erection of a special building for "architecture and kindred subjects," and liberal appropriations (until the Depression hit) to obtain the nucleus of a permanent art collection for its own "small but high-class art gallery." With the art market developing and art collecting becoming more serious, attention everywhere turned not only to the original but to the rare, the novel, the unique, the irreplaceable.

The committee on art objects accepted nearly everything that came its way, even if a home for the works could not

Flemish Master of the St. Ursula Legend, *Virgin and Child with Four Saints*, fifteenth century

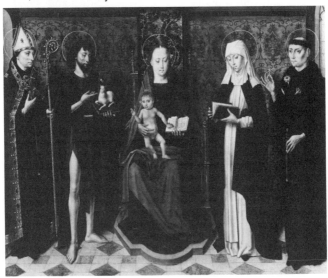

immediately be provided. Early important acquisitions included thirty-nine Old Master and modern paintings that had been purchased during the Depression by alumni Emily N. and Merle J. Trees with a future gift to the university expressly in mind; photographs, paintings, graphics, and miscellaneous objects originally underwritten by the New Deal's Works Progress Administration Federal Art Project (WPA/FAP); and the contents of Lorado Taft's Chicago studio purchased by the university after the sculptor's death in 1936.

After World War II when funds again became available for university collecting, the art department in 1948 launched a series of pioneering competitive exhibitions of contemporary American art, with prized purchase awards. Shortly after the first, these expanded to month-long biennial festivals of music, dance, theater, architecture, city planning, and film, as well as of painting and sculpture. By 1952, the *Chicago Herald American* said the Urbana show surpassed those of all other universities and rated above exhibitions of any museum in the country; by 1974, however, it all came to an end because of prohibitive insurance costs and the realization that avant-garde shows had by then become routine.

What was accomplished by these exhibits? Ambitious illustrated catalogues reached a national audience. Ninety-eight notable paintings and sculptures swelled the university's holdings. Controversial art, given public exposure by a prestigious educational institution, focused serious attention on new art forms. Encouragement through large purchase awards lent credibility to the worth of American artistic production. The idea of universities as legitimate, active patrons of art gained momentum.

Across the United States during the late fifties and the sixties, colleges and universities increasingly gave status to the studio and performing arts, which began to receive relatively lavish administrative and monetary support. The remodeling, enlargement, and construction of museum facilities to adequately house growing art collections became the order of the day.

At Illinois the movement came full circle with the opening in 1961 of the Krannert Art Museum, a gift of an Indianapolis industrialist and University of Illinois alumnus, Herman J. Krannert, and his wife, Ellnora. The east wing, the Kinkead Pavilion, built chiefly through a bequest of William S. Kinkead, also an alumnus, was completed in 1988. In the size and quality of its holdings and the number of its projects, the museum is a resource second in Illinois only to the Art Institute of Chicago; but as it has had little or no purchase funds from the state at its disposal and only modest operat-

ing budgets from which to carry on normal curatorial, educational, and exhibition programs, it must rely on donations of art or unrestricted gifts of money channeled through the University of Illinois Foundation to extend its usefulness to students, scholars, and the community. Endowments from outside sources have permitted the mounting of temporary shows, the purchasing of otherwise unaffordable works, and the organizing of special events.

The Krannert Art Museum's collections comprise more than eight thousand objects of sculpture, paintings, graphics, textiles, and the graphic arts, the majority in storage, the remainder displayed on a rotating basis. They date from prehistoric times to our own day and represent art as varied in cultural and geographical origins as they are in style, subject matter, and meaning.

Lorado Taft's theatrical yet controlled and individuated group sculpture, *The Blind,* is just inside the entrance to the Kinkead Pavilion. Inspired by Maurice Maeterlinck's symbolic one-act play of the same name (1891), Taft modeled the monumental work in hollow plaster in 1906–7, but because of a lack of funds it was, incredibly, not cast permanently in bronze for some eighty years. Figures of a totally different spirit are two sinuous, winged Art Nouveau nudes by another American, Adolph Weinman, reduced-scale bronze versions of temporary statues he made for the San Francisco Exposition of 1915. The fair's guidebook admiringly described the male *Rising Day* as suggesting "hope, faith, courage, inspiration, renewed vigor," while the female *Descending Night* denoted "a soft and comforting twilight [who] sinks gently to her radiant rest."

As their fiftieth anniversary memorial gift, members of the class of 1908 gave monetary support for a gallery of Oriental art that would bear their name, and gradually other donors and the museum added more objects of importance. The collection consists primarily of Chinese porcelains but includes ancient terra-cotta figures, ivories, and hanging scrolls; Tibetan, Thai, and Indian pieces; and Japanese sculptures and woodblock prints. Among the Chinese works are a large neolithic ceramic jar with swirling designs across its surface; splendidly painted and variously glazed and ornamented porcelain vases from several different periods of Chinese history; four painted T'ang earthenware tomb figurines of horses and a camel; a number of delicate vertical and horizontal narrative handscrolls of ink and color on silk or paper; and fine examples of bronze, jade, and lacquerware. From India come pieces such as a fourth-century sandstone carving of a regal Bodhisattva, a being who is on the way to becoming a Buddha; a fourteenth-century bronze Matrika figure, a mother goddess from Mysore seated in the lotus position, her four

arms implying power to ward off evil spirits; and an acclaimed collection of exquisitely detailed miniature paintings. The Japanese works include a pair of gloriously and subtly colored six-panel folding screens illustrating events from the *Tale of Genji*, the famous court novel of the eleventh century, and a group of delightful, tiny ivory carvings, *netsuke* (belt toggles), and *okimono* (alcove ornaments).

The oldest pieces in the Gallery of Near Eastern and Medieval Art are from late Roman sources in Asia Minor, Syria, Egypt, and North Africa. Later pieces reveal that by the sixth century, Christian images were well established and a major artistic subject. From the years between these two eras comes a marble funerary stele of 240 AD, with stiff frontal figures, typifying the provincial style of Phrygia, now central Turkey. The breadth of the medieval period is represented by a twin-shaft French Romanesque weathered marble wall capital carved with birds pecking at grapes; two rondels in a resplendently colored stained-glass window made for a thirteenth-century French church, depicting scenes from the story of the Prodigal Son; and the elegant tempera on wood *St. Catherine of Alexandria* (c. 1335), a work by the Sienese painter Ugolino di Nerio that reveals Byzantine influence.

European and American art given by Emily N. and Merle J. Trees includes paintings by François Clouet, David Teniers the Younger, George Romney, and John Singleton Copley. Other gifts of the Trees family are Frans Hals's sparkling, vivid portrait of a mayor of Haarlem; Jacob van Ruisdael's dark-toned panoramic landscape, a realistic yet emotional response to nature; Eugene Delacroix's spatially dramatic interior composition of an historic event; Camille Pissarro's Impressionist urban view of the Pont Neuf on a winter morning; and George Inness's country scene, a shimmering, magical moment of light and atmosphere before an impending storm. Among gifts from other donors are the fifteenth-century *Virgin and Child with Four Saints* by the Flemish Master of the St. Ursula Legend; Murillo's *Christ after the Flagellation;* a very fine Gainsborough; an excellent French painting from around 1770, possibly by Jacques-Louis David; and a portrait of George Washington by Jane Stuart, the daughter of Gilbert S. Stuart.

The collection of twentieth-century art reflects the constantly changing styles, methods, and tastes of our often chaotic, technology-driven era. Works may be sensuous, disturbing, political, contemplative, or inexplicable—or simply say nothing beyond the fact that they exist, as suits an art world valuing innovation for its own sake. Famous artists adding luster to the holdings include Tamayo, Rothko, Hofmann, Hanson, Shahn, Matta, Tanguy, Munter, Burchfield, Epstein, LeWitt, Arneson, and Beckmann.

Items in the Theresa E. and Harlan E. Moore Gallery of Decorative Arts transcend the idea of mere ornament or function: they qualify as works of art in their own right. Handsome examples abound—English Spode and Staffordshire pottery, an exceptionally beautiful Wedgwood vase, Austrian and French porcelain and Italian majolica, Irish lead crystal, German Meissen ware, Japanese and Chinese export ware, English and American silver and china, and pressed and blown glass. William Morris's closely woven peacock-and-dragon textile design (1878) reveals the artist's interest in rich, intricate patterns of medieval origin; Louis Sullivan's copper-plated bronze elevator grille for the Chicago Stock Exchange (1893) humanized its commercial environment; a deep, elliptical faience salver (sixteenth century), attributed to the French master Bernard Palissy, has sumptuous plants, reptiles, and shells cast from nature; a precious Sèvres punch bowl (late eighteenth century), made for Count Nicholas Cheremetev at the court of Catherine the Great, is embellished in regal turquoises and golds. Stoneware pieces by Wallace and Cornwall Kirkpatrick of Anna, Illinois, include their fanciful and inventive whiskey *Snake Jug* (c. 1885), which very likely was intended as a temperance lesson; and among abstract glassware produced in the 1980s are Dale Chiluly's extravagantly curved, organic *Seaform Group* and William Carlson's small, sharply angled and edged, cast and laminated *Glass Sculpture.*

A number of artifacts in the Gallery of Old World Antiquities illustrate the gradual resolution of problems in rendering anatomy realistically. An ancient limestone Egyptian tomb relief fragment (c. 2352–2160 BC), for instance, is a tribute scene bearing frontal and profile renderings of the human body and a hieroglyphic inscription; a carved black granite Theban figure of Yupa, the temple scribe under Rameses II, from a thousand years later, holds a ram's head as a votive offering. The museum's stunning collection of black and red figured Greek ceramics, celebrated for its exceptionally high quality, ranges from a large lidded bowl decorated with a geometric frieze of birds, horses, and riders (eighth century BC), to variously shaped jars and vases picturing mythological events, warriors, athletes, wild animals, and pipers and revelers.

Artists of two major cultural groups of sub-Saharan Africa, the Senufo and Yoruba peoples of the Ivory Coast and Nigeria, made most of the works in the Gallery of African Art. These include a monumental Senufo headdress customarily worn during a men's secret society (Poro) ceremonial dance celebrating the rite of spiritual rebirth; two Senufo anti-witchcraft masks that belonged to members of blacksmiths' and farmers' ethnic groups; and a small square Yoruba window decorated with a stylized head, part of a shrine dedicated to the popular god of thunder and justice, Shango.

Other interesting items are a glass-beaded Bamileke elephant mask (Cameroon), a pair of Ashanti combs (Ghana), and an especially fine example of a Bamana antelope headdress made of wood for the agrarian Chi Wara society (Mali).

By any criteria of scope, quality, and condition, the museum's assemblage of over six hundred specimens of pre-Columbian art is outstanding. Colorful and intricately woven textiles are on display, as are molded and painted ceramics for both daily and ceremonial use, sculpture and featherwork, and metalwork in gold and silver. Peruvian examples comprise the greatest portion, but a small number of Meso-American pieces such as an ancient Olmec mask complement them. The most spectacular object is a precious work of Peruvian silver-smithing (c. 1200–1450), the only artifact of its kind outside Peru; it shows an incredibly detailed symbolic funerary procession of two men carrying an oval burial casket followed by four men bearing an empty throne. Of particular importance too are the textiles, especially one masterful Nazca burial shroud having a sober monochrome center bordered by colorfully knitted wool hummingbirds (c. 100 BC).

In addition to all these riches the museum possesses a broad collection of works on paper—drawings, watercolors, wood-cuts, etchings, engravings, lithographs, serigraphs, and photographs. Because of the fragile nature of the material and problems associated with long exposure to artificial light, these must be displayed selectively for limited periods. Artists extend from Cranach, Rembrandt, and Hogarth to Piranesi, Callot, and Daumier; from Hokusai, Kuniyoshi, Toulouse-Lautrec, Morisot, Prout, Manet, Renoir, and Matisse to Rouault, Whistler, and Kollwitz; from Picasso, Dali, Klee, Chagall, Grosz, Orozco, Rattner, Benton, and Wood to Motherwell, Albers, Pollock, Nevelson, Warhol, and Lichtenstein. Included among the important photographers are Steiglitz, Abbott, Evans, Cunningham, Weston, Callahan, Bullock, and Conner.

The World Heritage Museum

When Lincoln Hall was built in 1911, the trustees approved not an art museum, as the head of the art department wanted, but two museums to supplement courses in the humanities and social sciences: a classical museum and a museum of European cultures, both located on the fourth floor of the new building. An Oriental museum was added in 1917. Because of the trustees' conviction that the collections were "bound to become increasingly important factors at the University for teaching the history of culture and promoting aesthetic appreciation," each museum received generous appropriations of from $2,000 to $4,000 annually for acquisitions. Except for a brief period during World War I, these remained at $2,000 a year until the Depression necessitated

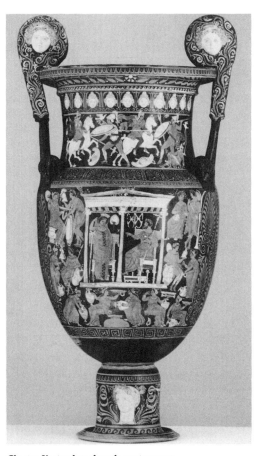

Chester Krater, late fourth century BC

drastic cuts to about $400. In 1971 the disparate holdings were fused into one newly organized entity named the World Heritage Museum. Doing its best to attract attention and support with initially meager resources, it has since the early 1980s received greater administrative support and funding as well as alumni and community gifts. Extensive programs of education, acquisitions, and exhibitions have been developed to serve the university and a wide public. In the near future a two-level facility to house the collections will be built to the east of the Krannert Center for the Performing Arts, at Lincoln and Illinois streets in Urbana. To honor its donors, it will be called the William R. and Clarice Spurlock Museum of World Cultures.

Originals and reproductions of prehistoric, Sumerian, Babylonian, Egyptian, Greek, Roman, Etruscan, European, Asian, African, American, Arctic, and Oceanic artifacts make up much of the World Heritage Museum's holdings. There are remarkable examples of authentic ancient coins, bronzes, terracotta figurines, and vases bought before World War I, when such objects could be obtained relatively cheaply. Thirty fragments of papyrus include the earliest known passage from the

Epistle of James (third century AD). Acquired in the early days too are over 1,800 Near Eastern clay tablets spanning a 2,000-year period. Inscribed in cuneiform, some of these have only recently been translated. From Northern Europe come Stone Age, Bronze Age, and Iron Age pottery, weapons, and tools. From later eras there are manuscripts, engravings, maps and rare books, sculpture, textiles, glassware, enamels, ceramics, jewelry and ivories, household utensils, ship models, weapons, suits of armor, costumes, stained glass, medals, masks, and musical instruments. There are also a number of plaster replicas of ancient, medieval, Renaissance, and modern statuary, objects surviving from John Milton Gregory's Fine Arts Gallery and from a collection amassed by Lorado Taft for his "Dream Museum," a project never realized. More contemporary artifacts include parts from Illiac I, the first modern computer built at the university.

The museum owns forty splendid plaster casts that replicate 167 feet of the Parthenon frieze, depicting a religious procession honoring the Greek gods. They show details, even entire panels, of the fifth century BC Athenian masterpiece that have subsequently been lost or defaced. Purchased in 1911, the casts were made from molds commissioned by the French consul to Greece sometime before 1795, the year vandals caused considerable damage to the original frieze. The sculptured slabs therefore document the frieze as it was before it was damaged, before Lord Elgin dismantled much of it in 1801 and transported it to the British Museum, and before air pollution and acid rain eroded the remainder.

Other notable objects include the *Chester Krater*, a monumental late fourth-century BC Grecian wine vessel from southern Italy vividly painted with funeral scenes and visions of Hades and the Elysian Fields; a page of a Gutenberg Bible; three Gothic tracery windows and a pair of sixteen-foot-tall ornamental portals given by the Art Institute of Chicago; a delicate and detailed fifteenth-century French oak carving of St. Michael the Archangel doing battle with the devil; and memorabilia of the Olympic Games donated by university alumnus Avery Brundage, president of the International Olympic Committee from 1952 to 1972. Further enriching the collection through recent alumni gifts are items as diverse as a fine-grained second-century white marble head of the Greek god Hermes; a Roman mosaic panel depicting three birds around a "fountain of life," a motif common in provincial Roman houses; a rare marble head of Fausta, the wife of Constantine, the first Christian Roman emperor; a wooden Juggernaut carving representing the Hindu god Vishnu; an ancient Egyptian human-shaped sarcophagus made of gilt polychrome wood; and numerous opulently embroidered silks from the last Manchu dynasty in China.

Alma Mater Group, 1929

Bronze group, granite base, figures approximately 13'6" high

Gift 1929, Classes of 1923–29, the sculptor, and the Alumni Fund

In front of Altgeld Hall, Green and Wright Streets

Although a bronze plaque on Taft's *Alma Mater* says he conceived the sculpture in 1922, his own letters reveal that he had wanted to do one like it, based on the university motto, Learning and Labor, as early as 1883. Actively seeking support for such a work in 1916, the year after Daniel Chester French made his grand *Alma Mater* for Columbia University, Taft warned that his statue must not be a "dwarf," that "it must stand at least twelve feet high." He told of his dream

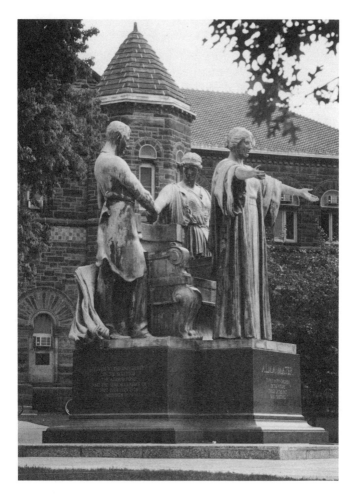

"to show 'Our Mother' as a benign and majestic woman in scholastic robes, who rises from her throne and advances a step with outstretched arms, a gesture of generously greeting her children. Our motto is fortunate," he added, "permitting me to introduce two more figures which while of the same scale will be subordinated in a sense. 'Learning' will be a modification of the so-called 'Lemnia Athena' which is distinctly archaic and admirably suited to the heraldic treatment. She will stand back at one side of the throne and will clasp hands with the sturdy figure of 'Labor' who will stand at the other side. Thus their hands will meet over the back of the chair."

Taft's group, executed as envisioned, owes the leather-aproned, husky personification of Labor to the nineteenth-century Belgian populist sculptor Constantin Meunier's dockhands, ironworkers, and miners; the classically draped Learning to Phidias's colossal bronze Athena Lemnia on the Acropolis; and the central figure to French, whose *Alma Mater* is seated in a similar version of an ancient Greek klismos chair. At the base is the inscription: "Alma Mater / To thy happy children of the future those of the past send greetings / her children arise up and call her blessed."

Taft's signature appears on the statue itself, but he said he had difficulty making his intentions understood. "My name will be on the bronze and I do not wish it repeated anywhere else. I am not doing this thing for personal glory, and refuse to be mentioned in the inscription. If it is done, I shall not come to the dedication. That is final." He did attend, and in a letter to a friend wrote that throughout his life he had "retained a romantic love for my Alma Mater. . . . I once told Daniel Chester French that his noble Alma Mater, on the steps of Columbia's Library, was happily expressive of the reserve and reticence of the east; that a midwest mother must be more cordial. So I made my lady with wide-spread arms and smiling face. . . . I understand that [the young people in Urbana] have dubbed our group the Ideal Chaperone. I hope they may keep the bronze throne polished by their visits!"

For thirty-three years the sculpture stood "temporarily" on the south campus just behind the Auditorium, but in 1962 it was moved to its present site amid student protests over its "shocking" new location. The *Daily Illini* found the placement to be in the "worst possible taste; it makes the Alma Mater a debased, commercial 'advertisement' for the University." No matter. The monumental, dark-green weathered bronze group is wonderfully effective in beckoning visitors and students to campus, set as it is among Canadian hemlocks and flowering crab apple trees, nicely harmonizing in scale and spirit with the important building forming its backdrop: Altgeld Hall, the original university library of 1897.

Taft himself had been a student at Illinois. After graduating with a master's degree in 1880, and having been deeply inspired by Gregory's Fine Arts Gallery, he studied for three years at the prestigious Ecole des Beaux-Arts in Paris before settling permanently in Chicago in 1886. He taught at the Art Institute of Chicago, lectured and wrote extensively on the history of art, took a leading role in the Central Art Association, a group dedicated to the encouragement, exhibition, and sale of American art—conservative American art—and for some forty years produced large-scale sculpture with a loyal coterie of pupils and assistants in his Midway studio on the University of Chicago campus.

Early public recognition came with two decorative groups he made for the Horticulture Building at the 1893 World's Columbian Exposition in Chicago. Following that, he earned accolades for his many sensitive works, among them the *Solitude of the Soul* in the Art Institute; the experimental fifty-foot cast-concrete form of *Black Hawk* in Oregon, Illinois; the many-figured *Fountain of Time* on the Chicago Midway; and the *Young Lincoln* opposite Urbana High School.

Taft retained close ties with the University of Illinois. Named nonresident professor of art in 1919, he came to campus each spring to give a series of illustrated talks. At the unveiling of his *Alma Mater* in 1929, the university granted him an honorary Doctor of Laws degree and, a year later, with a large endowment subscribed to by friends and alumni, established the ongoing Lorado Taft Lectureship on Art.

The Four Colleges: Literature and Arts, Agriculture, Science, Engineering, 1898–99

Four murals, oil on canvas, 11' x 37' and 11' x 23'

Mathematics Library rotunda, 216 Altgeld Hall

To its planners, the first university library building, now Altgeld Hall, was an especially significant structure, tangible evidence that the industrial college of 1868 had been transformed into a respected institution of higher education. Of all elements of its design, none furnish more insight into the project than the four great allegorical paintings in the rotunda. More than artistic embellishment, they suggest by their very existence, as well as by their lofty themes, the university's commitment to scholarship and culture. The artist, Newton Alonzo Wells—educated at Syracuse University and in Paris at the Académie Julian under Bougureau, Laurens, and Benjamin-Constant—underscored the symbolic idea at the unveiling ceremonies in March 1900, saying that he meant his decorations to create an atmosphere of historical associations "so that those entering these halls should feel the spirit of the mighty past brooding here and inspiring to the emulation of its noblest achievement."

The murals are an integral part of the gracefully blended Classical, Romanesque, Gothic, and Byzantine architectural motifs used throughout the building. Simple figures and shallow space establish a psychologically restful environment, while placid colors and smooth surfaces unify the separate areas of the room. Wells's labors took three forms: stenciled decorations in stylized organic shapes on virtually every capital, arch, frieze, and wall, and in imitation mosaics in the vestibule; medallion portraits—reminiscent of ancient Roman coins—of "America's greatest soldiers, statesman and scholars" around the first floor; and murals on the upper level of the rotunda.

All four paintings in the lunettes of the arches express the artist's conviction that control of one's emotions is a virtue, that calm, restrained individuals in a work of art convey not only an untroubled mood, but self-assurance as well. That attitude ultimately finds its source in state and school officials' profound confidence in the university's rapid growth and rising status. Since Wells wrote at length on the technique, subject matter, and meaning of his creations, as well as on his artistic inspirations, it is both instructive and interesting to know what he had to say.

The Forge of Vulcan, original state, c. 1900

He noted, for example, that he spent time making careful studies from models, experimenting with color schemes, preparing plaster walls, stretching and nailing canvas onto walls, and finally transferring the outline drawings to the canvas before applying paint. He found that a mixture of oils and dissolved white wax dried slowly and did not discolor. Another advantage of wax over turpentine was that it produced a "perfectly flat and lusterless surface, with a delicate and aerial bloom like that of real fresco; and not the least of its good qualities is its preserving influence upon the color, protecting it from the contact of coal-gas, the bête noire of decorators in our climate."

Thoughtful preparation also went into Wells's selection of subjects. Representing the College of Literature and Arts is *The Sacred Wood of the Muses,* meant to conjure up a glade of classical antiquity "where choice spirits might love to retire to listen to Homeric tales." Pythagoras, Plato, Phidias, or Pericles are suggested, Wells said, but did it matter if these "personages were actually separated by centuries of time?" Determined to produce "reposeful" compositions, he apparently responded to the pervasively serene work of the French artist Puvis de Chavannes, in particular his 1884 painting *The Sacred Wood, Dear to the Arts and Muses* (now in the Art Institute of Chicago). Undoubtedly this work suggested title, arrangement, and colors, but in the course of various revisions Wells eliminated classical architecture, pressed figures closer to the picture plane, and transformed

naturalistic landscape into stage sets with backdrop. Wells's "choice spirits" are of nineteenth-century vintage, their stilted, self-conscious poses reminiscent of living statues in collegiate Homeric tableaux.

Arcadia, for Agriculture, is a bucolic festival. Youths and maidens bear garlands and the sacred hearth of the hearthstone, "typical of the joys of love and courtship which lead to Hymen's altar, the foundation stone of the home." Behind them troop the family with its "loved burdens and happy cares guided by stalwart men and youths whose lustyhood speaks of a life of freedom and frugality." Wells's familiarity with Gari Melchers's murals of battle processions (for the 1893 Columbian Exposition and for the Library of Congress [1897]) is evident in figural and compositional elements that found their way into his painting. For the stallion led by a youth, it is likely he looked closely at details of the Parthenon frieze.

For the College of Science, Wells shows "seven virginal figures" at work in *The Laboratory of Minerva.* Minerva instructs from the Book of Knowledge. Around her are personifications of Geology, Chemistry, Mathematics, Astronomy, Biology, and Physics. The artist accommodated himself to American moral standards, avoiding the shifting drapery and unrestrained nudity relished by the French. Chitons might carelessly slip from shoulders, and limbs might be indicated under voluminous garb, but the women in the mural are fully dressed, their substantial forms covered in quasi-Greek garments very like those affected by sorority women pictured in university yearbooks of the day.

A decidedly unclassical scene distinguishes the last lunette, *The Forge of Vulcan* for the College of Engineering, from the rest. The mood "induced by historical association is suddenly dissipated," the artist wrote, "and in its stead we are brought face to face with the activities of the twentieth century." Making no attempt to idealize his steel-foundry workers— stocky, ordinary men absorbed in their task of forging great steamer shafts—Wells shows an actual engineering accomplishment. In an age of quickening technology and scientific demands, cultural tastemakers and their public continued to yearn for some remote, ideal past, yet *The Forge of Vulcan,* despite its anachronistic title, indicates an American iconography emerging. To judge by enthusiastic critical response in local and Chicago newspapers, this one of all four murals was found most compelling and relevant to everyday lives.

Altgeld Hall, built in 1897, has fared rather well on its exterior. Its four additions are restrained and in the spirit of the original structure. Not so with the interior rotunda, where unsightly partitioning destroyed its spatial integrity and

eliminated the east reading room; where nondescript tan plaster replaced beautiful opalescent glass in the domed ceiling; and where dismal lighting and poor maintenance have compromised the murals' visual impact. The building is listed in the National Register of Historic Places—but sorely needs, and merits, restoration.

Newton Alonzo Wells stayed on at Illinois as a professor of art until his retirement in 1919. Besides exhibiting at several Paris salons, he painted murals for the Sangamon County Courthouse in Springfield, Illinois, and the Colonial Theatre in Boston. Eleven of his portraits, two of them in a special mosaic technique he devised, are at the University of Illinois.

Diana Fountain, 1930

Bronze and marble, 15' high

Gift 1971, Class of 1921 and Time Incorporated

Courtyard west of the Illini Union

In 1928 the architectural firm of Holabird and Root commissioned this delightful fountain for the owners of Chicago's Michigan Square Building (Time-Life Building after 1945). It was Milles's first work created solely for an American site, a version of the *Diana Fountain* he had fashioned a year earlier for the Swedish Match Company in Stockholm. The Chicago piece stood for nearly four decades in the center of a spacious modern interior court surrounded by smart shops and tiers of angular stairways, but with the building's sale and impending demolition, the work faced an uncertain fate until Samuel Lichtmann, a Chicago architect once in Holabird and Root's employ, arranged to have it donated to the university. Lichtmann's fellow alumni of the class of 1921 raised $50,000 to dismantle, transport, and reset it, and in June 1971 it was rededicated on the occasion of their fiftieth reunion. Frances B. Watkins, class secretary, expressed her "exhilaration" at obtaining the valuable artwork for the Urbana campus and told of her special pleasure that Time Incorporated had donated it because of the "eminence of the College of Fine and Applied Arts."

When the fountain is turned on during the long summer months, it imparts a sensation of coolness to the Illini Union's patio. The goddess of the hunt—a pale green figure of patinated bronze—holds a bow and balances precariously on schematized, Art Deco–style fern fronds, her slender body turning sharply as if to catch sight of some fleet-footed animal running past. Below the vegetation, two concentric bronze urns form the base. The top urn is plain but the lower one has figures in such high relief that they appear almost in the round. The figures include four nymphs, one being attacked by a leering satyr; a centaur chasing eight wild boars; and a unicorn, a mythical beast whose presence here alludes to Diana's chastity. The round water basin at ground level is of lightly veined, buff-colored marble. Within it, one pair of nymphs lolls in languorous indolence and another cavorts playfully, while a third figural group is of a particularly repulsive satyr couple relishing the spectacle being played out before it.

In Sweden, Milles's work had been of a decorative or com-

memorative nature—fountains and monuments containing bold, often exuberant animals, spirits, seagods, mermen, sunbathers, archers, and dancing maidens, and more serious sculptures involving Nordic religious and historical themes. The university's fountain differs from the Stockholm prototype in subtle yet discernible ways, perhaps reflecting Milles's preconception of American taste. In the European original, only the goddess, several birds perched in delicate tendrils, and a peacefully sleeping boar, deer, and satyr appear. In the Illinois version, however, the arrangement is more complex, the participants more vigorous, and the wide-awake satyrs and voluptuous nymphs put into a context both violent and sexual.

In 1921 Lorado Taft recognized Milles as a gifted artist whose sculpture was "exceedingly up to date" and whose apprenticeship with Emmanuel Frémiet equipped him to cope with all subjects, "from heads of poets to prehistoric monsters."

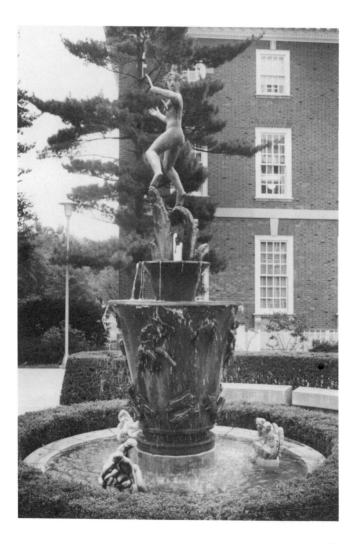

Robert Allerton, the university benefactor and art connoisseur, found Milles's work so compelling after seeing his work at the Tate Gallery in London in 1927 that he initiated a successful movement in Chicago to purchase a replica of the Triton Fountain in Lidingö for the Art Institute; and two years later he ordered an original casting of the magnificent *Sun Singer* for his own estate (now Robert Allerton Park) near Monticello, Illinois.

With Milles's popularity growing in the States, the sculptor made his first trip here in 1929, and in 1931 he settled in Michigan as a professor of sculpture and head of the department at the Cranbrook Academy of Art in Bloomfield Hills. He lived there until 1951. Besides the Allerton Park and Chicago Art Institute sculptures, major American examples of his work are the *Meeting of the Waters Fountain* outside Union Station, St. Louis; the *Peace Monument* in the City Hall at St. Paul, Minnesota; and the *Aganippe Fountain,* a piece that once graced New York's Metropolitan Museum of Art and is now at Brookgreen Gardens, near Charleston, South Carolina.

Science and the Arts, 1917–18

Limestone cartouche, figures approx. 6'6" high

Over west entrance to University High School

University High School, designed in "Collegiate Gothic" style by the notable Chicago firm of Holabird and Roche, was built in 1916–18. It opened as a practice high school for the College of Education on September 21, 1921, with about one hundred pupils enrolled. Eighty youngsters were from Urbana-Champaign and the remainder were university stu-

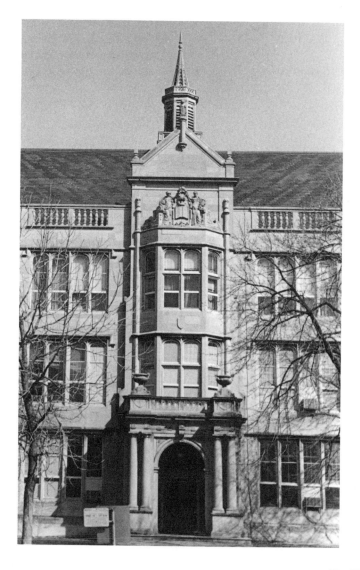

dents registered to take the same classwork and observe teaching methods. In its years as a secondary school, it has played a role in innovative and progressive pedagogical experimentation of national importance.

Terminating the bays high over the main entrance to the structure is the carved limestone allegorical group *Science and the Arts* by Charles A. Beil and Leon Hermant, Chicago sculptors. The woman to the left holding a sphere represents Science, while the other, with a lyre, represents the Arts. Both are modeled in classic French Beaux-Arts style, with ample forms, voluminous, heavy drapery, and an elegant, easy grace. Between them is the open Book of Knowledge illuminated by the Lamp of Learning. High up on the north and south ends of the building and also at the peak of its west entrance stand beasts holding shields before them. Their creators are unknown.

Hermant came to the States to work at the French pavilion at the 1904 St. Louis exposition. After fighting for his native France in World War I, he returned to settle permanently in Chicago. Taft said of him that he was "exceptionally prepared for important work." Hermant's commissioned pieces include the *Louis Pasteur Memorial,* now in a park in front of Cook County Hospital, for which he received the French Cross of the Legion of Honor, and the 72-foot-long *Olympian Games Frieze* for the Illinois Athletic Club, Chicago; the *Logan Memorial,* Murphysboro, Illinois; and the *Calvert Street Bridge Reliefs* in Washington, D.C. Beil and Hermant created large reliefs for the Medinah Athletic Club (505 South Michigan Avenue) and panels symbolizing Labor for the Cook County Building (North Clark Street), both in Chicago. The two artists were awarded medals at the 1900 Paris and 1904 St. Louis expositions.

Eric Bransby (1918–)

Educational, Research, and Public Service Functions of the Mechanical Engineering Department, c. 1952–53

Two murals, fresco and plaster relief, 12' x 18'6"

Gift 1953, Faculty and Alumni honoring Prof. Oscar A. Leutwiler

South entrance to Mechanical Engineering

Bargain rates and a chance to alleviate "the cold impersonal attitude that people associate with engineering" were the reasons behind the commissioning of murals for the stark entrance lobby of the new Mechanical Engineering Building. For Eric Bransby, a young art instructor scheduled to be at the university just one year longer and willing to do the work on his own time in addition to his regular duties, the mural fulfilled graduate thesis requirements for his Master of Fine Arts degree from Yale University. Norman Parker, then head of the Department of Mechanical Engineering at Illinois, noted that only half the job could be accomplished unless his colleagues acted rapidly: "If you remember the rather barren, operating room atmosphere of the main entrance, I feel sure that you will agree that we should not miss the opportunity of providing this real improvement at this really bargain cost."

Parker cooperated with Bransby during the planning of the murals, offering categories of mechanical-engineering research that might suggest visual images. The artist said that he wanted to touch on all of the suggested main subjects yet not clutter the design with an excess of details, adding that he intended "to set down in a confined area within the mural a portrayal or interpretation of Man—the investigator and creative thinker."

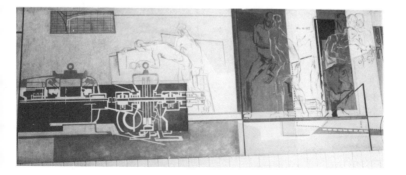

The compositions consist of geometric shapes and lines interspersed with easily recognizable, vaguely symbolic, semiabstract objects and notations such as formulae, blueprints, diagrams, machinery, coils, anatomical charts, graphs, gauges, computers, and nine sketchily drawn, busy engineers. Unlike murals previously installed on campus, these were not painted in oils on canvas in the studio but were made on the site, in a modified fresco technique that involved spreading wet plaster on the wall itself, then painting directly on these freshly plastered surfaces with a water-based tempera medium. The works appear rough and densely textured, with a deliberate overlaying of dry brushstrokes to emphasize their tactility. Bransby's technique of building up layers of plaster in some places and cutting back to the mortar in others creates an intriguing ornamental relief pattern that repeats the murals' irregular finish.

For all the surface interest and intense experimentation, the artist's draftsmanship lacks authority. Nonetheless, subtle combinations of greens and blues, tonalities of yellow, and textural and compositional contrasts distract attention from this weakness. The department did not obtain great art, but the two murals do contribute favorably to alter the ambiance of a vestibule covered otherwise only with boring institutional-tan tiles.

Bransby, who produced a number of murals for the Works Progress Administration Federal Art Project, was a student of Thomas Hart Benton and Fletcher Martin at the Kansas City Art Institute and of Josef Albers at Yale. He later taught at the University of Missouri, Kansas City. Living now in Colorado Springs, he is still actively engaged as a muralist.

Alexander Liberman (1912–)

Mananaan, 1986

Welded steel, 26' x 24'6" x 16'6"

Acquired 1994 through unrestricted gifts to the university, including the John Needles Chester Fund

Quadrangle south of Grainger Engineering Library

Liberman's aesthetic tastes derive from early twentieth-century Russian Constructivism: a predilection for the nonfigurative, architectural, and geometric; for machine-age materials and techniques; for constructed, not modeled or carved, forms; for space as an absolute sculptural element apart from any closed volume; and for a restrictive use of color. His most prominent outdoor sculptures reach great heights (some more than fifty feet) and stand, like architecture, directly in the ground, free of platforms or bases. Raw materials come from a junkfield strewn with old boiler heads, tank drums, steel beams, and giant pipes. Slicing creates diagonal, vertical, and horizontal modules. Diagonal cuts obtain ellipses. Welding unifies the elements, and colors tend toward vivid reds or the uncamouflaged original tones.

He fashioned this strong, architectonic work from five scraps of discarded rusty steel. The elliptical top element serves as a giant oculus, poised amid a tall leaning cylinder, two curv-

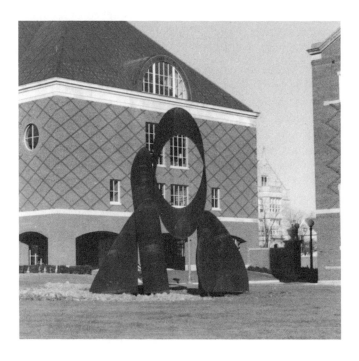

ing triangles, and a smaller disc that completes the asymmetrical composition. The raw surface, which the artist at one stage considered painting white, has weathered to an extraordinarily rich, deep chocolate brown.

According to Liberman, the sculpture's title comes from James Joyce's *Ulysses*. Mananaan, the god of the sea in ancient Irish mythology, occurs in the thoughts of Stephen Dedalus as representative of the sea, as a symbol of change. Joyce calls the "whitemaned sea-horses, champing, brightwindbridled, the steeds of Mananaan."

But that ought not be taken literally. Asked once about giving so many of his works evocative or heroic names—*Icarus, Prometheus, Totem, Eros, Adonai, Ariel,* and *Covenant,* for instance—the artist confessed that the titles actually meant nothing to him, that everyone today wanted them, that he hated them. "It's like attaching a wooden handle to something that hopefully cannot be pinned down, which is depressing in a way."

It is the *idea* of the primitive or exalted that interests him, and scale—epic, colossal scale—is crucial. It can inspire terror, domination, or humility, as in a religious experience, and takes into account as well the enormity of American architecture. "Awe is a very important ingredient in art," Liberman has said. "Part of religious experience is terror, a God that punishes. There's terror in scale." Still, he told an interviewer, with some candor, there are practical considerations. "If you're doing so-called public sculpture next to a skyscraper, and you want your work to have at least some meaning, it has to compete with a certain scale. I don't consider many of my sculptures to be anything other than perhaps decorative ornaments to buildings."

Born in Russia and educated in London and Paris, Liberman moved to New York City in 1941. After joining the staff at *Vogue* magazine, he was by 1962 editorial director of all Condé Nast publications, one of the most powerful positions in American journalism. He stepped down from that job in April 1994. A painter and sculptor as well as photographer, essayist, and collector, Liberman exhibits widely and has works in many institutions, among them the Seattle Art Museum, Guggenheim Museum, Smithsonian Institution, Museum of Modern Art, Metropolitan Museum of Art, Whitney Museum of American Art, Los Angeles County Art Museum, Art Institute of Chicago, Tate Gallery, and the universities of Hawaii, Minnesota, Pennsylvania, California (Berkeley), and Connecticut.

Stephen Luecking (1948–)

Upwells, 1990

Granite and bronze, 40' high spire

Acquired through John Needles Chester Fund and Illinois "Percent for Art"

Central plaza, south of Beckman Institute

By its very scale, its prominence, and its contrasts of shapes, materials and textures, *Upwells* attracts attention. It is participatory; people can move through the middle and children can play in the water. And it is educational, illustrating basic principles of astronomy that deal with the motion of the earth through the solar system.

The gigantic work consists of five components aligned in a north-south direction: three low domes overflowing with

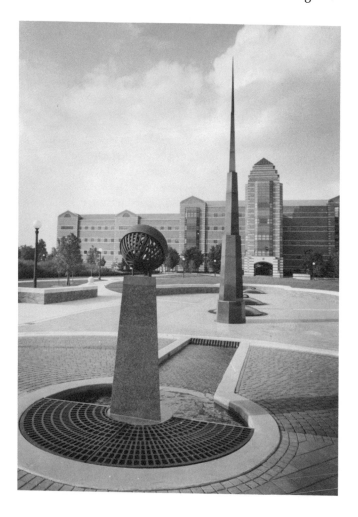

water, a stepped and faceted spire, and a tilted globe atop a pedestal in a keyhole-shaped pool. They stretch across a sloped, variegated brick pavement at the center of the north campus, near the Beckman Institute.

Piercing the 25-inch globe is a telescopelike tube that parallels the earth's axis. It points to the celestial north pole in a direct line with the tip of the tall spire. This pole (which marks the daily rotation point of the earth) is imaginary, but with the "telescope" it can be located even in the daylight. Polaris, the North Star, which is visible only at night, almost marks the location of the celestial pole; they are about a half degree apart.

The expansive domes, each nine feet in diameter, are spaced to define the changing seasons. Although the shadow of the spire sweeps across the area throughout the year, its length depends on the altitude of the sun, which ranges about 47 degrees. At the summer solstice, when the sun is at its highest position, about June 22, the tip of the shadow strikes the center of the dome closest to the spire. At the equinoxes, about March 21 and September 22, when night and day all over the earth are of equal length, it strikes the middle dome. At the winter solstice, about December 22, when the sun is at its lowest altitude, the shadow is longest and falls across the last dome. The shadows are difficult to discern, because the spire is so thin at the top and the shadows diffuse over the open grills at the centers of the domes.

No one could really use the sculpture for a calendar to mark the solstices even if the shadows were sharp, as the sun's position changes so slowly at these times of the year, astronomy professor James Kaler explained: "The sculpture is symbolic. Anyone looking at it, and understanding it, can immediately see how the sun moves to the north and south, casting shadows of different lengths as the months progress and the seasons change. You can locate accurate directions; it shows a great deal about the orientation of the earth, the orbit of the earth, the tilt of the earth's axis, and the origin of the seasons. I think it's a nifty piece of work, and it's fun to see a nice astronomical sculpture that is not a sun dial. I am going to recommend that my Astronomy 100 students examine and study it."

North campus wags have dubbed *Upwells* "Beckhenge," and recent summer solstices have drawn festive crowds and bagpipers. It may be that a new university tradition is in the making.

Luecking is active as a reviewer and essayist for art and architecture journals. He has exhibited in one-person and group shows and served as art juror and curator. His works include a collaborative environmental installation near Albuquerque,

New Mexico, sponsored by Earthwatch, and a lodge expansion in Giant City State Park, Makanda, Illinois. He is a professor of sculpture at DePaul University, Chicago.

Funds for *Upwells* (and a number of other works at the university) came from two important sources. The John Needles Chester bequest is designated for the purchase of objects such as rare books, works of art, and museum items. Chester, a prominent alumnus of the class of 1891, was the first donor to the University of Illinois Foundation and later served as a member of the board of directors of the foundation and of the Alumni Association. He died in 1955. The Illinois "Percent for Art" program is part of a national art-in-architecture movement that emerged in the 1970s and 1980s. With the goal of promoting and preserving the arts by "securing works of art for the adornment of public buildings," the law mandates that one-half of 1 percent of state funds appropriated for construction or reconstruction projects be set aside to acquire art by Illinois artists.

Peter Fagan (1939–)

Arnold O. Beckman, 1988

Bronze, 6' high

Gift of the University

Rotunda, Beckman Institute for Advanced Science and Technology

Arnold O. Beckman, born a blacksmith's son in Cullom, Illinois, in 1900, earned his B.S. degree in chemical engineering at the University of Illinois in 1922 and completed his master's degree in physical chemistry the following year. He received his Ph.D. in photochemistry from the California Institute of Technology in 1928.

While teaching at Caltech, he formulated and produced an ink to end the problem of clogged postal meters, and in 1935 he invented the pH meter, a portable measuring device that launched his career as an important inventor and manufacturer of scientific instruments. These include the quartz spectrophotometer, which automatically analyzes chemicals; the ultracentrifuge, used to measure the density of chemical substances; and the protein sequencer, which has helped unravel the mysteries of DNA. In 1982, his multi-billion-dollar international company, the giant Beckman Instruments, Inc., merged to form SmithKline Beckman Corporation.

Devoted to philanthropic causes, Dr. Beckman and his wife, Mabel Beckman, gave the university $40 million in 1985 to build the Beckman Institute for Advanced Science and Technology. With supplementary funds supplied by the state, the structure opened in 1989. Grants for research at the center are awarded by corporations, foundations, and the federal government. The university and the state of Illinois cover operation and maintenance costs.

The institute is the largest and most ambitious university-based multidisciplinary research facility in the United States, focusing on broad problems in the life sciences and the physical sciences. Its programs extend from biochemical, molecular, and cellular studies to cognitive science. Programs in the physical sciences and engineering range from efforts to synthesize new materials with potential application in information-processing devices, to studies of artificial intelligence, robotics, and computer vision.

Peter Fagan made this life-sized bronze statue of Dr. Beckman from the more than 160 photographs he took of him in 1987. He remembers him as "a very nice, modest man; he was sort of embarrassed by the idea of the sculpture." Im-

34 ∎

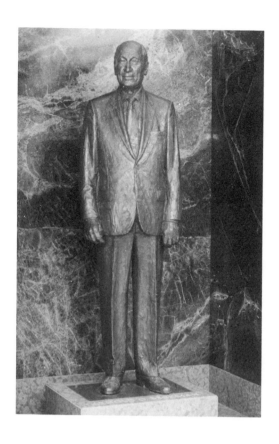

pressed by Beckman's presence in the room, Fagan believes he successfully "captured his character, his aura. He commanded space, just as a sculpture commands space."

A member of the university art faculty since 1967, Fagan has designed and executed a number of major commissions, among them the bronze and concrete *Raptor 5* for the North Point Marina, Mt. Zion, Illinois; three monumental bronze figures comprising the *Illinois Workers Memorial,* on the state capitol grounds; an over seven-foot-high polished bronze crucifix for Holy Cross Church, Champaign, Illinois; and the full-size bronze statue of Chicago mayor Richard J. Daley, in the Illinois state capitol rotunda.

Christiane T. Martens (1943–)

Tsunami Ascending, 1990

Painted steel, 10′6″ high

Beckman Institute Art Enhancement Fund

Patio, Beckman Institute for Advanced Science and Technology

Christiane Martens had her sculpture *Tsunami Ascending* placed at the far end of the patio so that it would not be dwarfed by the building's monumental size. It stands out because of its bright red color against the surrounding evergreens.

A tsunami is a tremendous, often destructive sea wave caused by underwater earthquakes, but the artist acknowledged that this phenomenon had nothing to do with inspir-

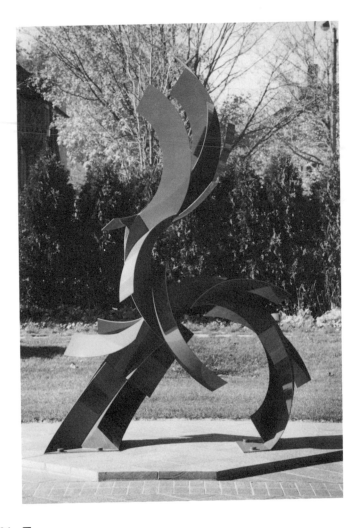

ing her. She gave the abstract work its title only after completing it, after reflecting on its emotional impact. The name is not descriptive, she said, but is meant to evoke an image, in this case that of a tidal wave.

Curved elements suggest the power and movement of tremendous currents, she noted, while the "red color underscores the unleashed force and commanding presence of this natural phenomenon. The light blue edges highlight and activate the linear gestural and expressive quality of the sculpture."

The focus of Martens's art has been welded steel or stainless steel sculpture, which evolved from gallery-size geometric pieces to large-scale, site-specific corporate or public works. Under the nationwide "Percent for Art" program, she has won nine commissions, including sculptures for the University of Alaska, Fairbanks; the Columbia Correctional Institution, Portage, Wisconsin; and the State Revenue Building, Springfield, Illinois. In 1993, she was a top prizewinner in the prestigious Fujisankei Biennale International Competition for contemporary sculpture, at the Hakone Open Air Museum, Japan. Active as an exhibitor and lecturer, she has been a professor of art at the university since 1981.

Billy Morrow Jackson (1926–)

We the People: The Land-Grant College Heritage, 1987

Oil on panel, 4' x 6'

Acquired through the John Needles Chester Fund

Reception to President's Office, 364 Henry Administration

The Federal Land-Grant College Act, known also as the Morrill Act, passed by Congress in 1862, gave the states public lands to establish colleges offering studies in engineering, agriculture, and home economics, as well as traditional academic courses. Emphasizing practicality and the liberal education of the "industrial classes," the Act created 130 major colleges and universities, in every American state and most of its territories. This painting celebrates the system's democratic, innovative programs, and its rich heritage of cultural and pragmatic learning.

Three historic individuals dominate the scene. Illinois native Jonathan Baldwin Turner, to the left, spoke up for the idea that working people had to increase their knowledge if they wanted to rise above their "present terrible conditions." His belief that agricultural reform could come through public education provided the basis for the Land-Grant Act. Abraham Lincoln, in the center, holds the bill he signed into law. Justin Smith Morrill, the congressman from Vermont who sponsored the legislation, stands to the right. He worked out details, obligating new institutions to provide instruction in the mechanic arts, in agriculture, and—reflecting the Civil War still being fought—in military training, "without excluding other scientific and classical studies."

Crowding the lower portion of the panel, many figures illustrate enduring aspects of university life. They busily climb stacks of books to reach their goals, reach out to help others along the way, and engage in pursuits as diverse as painting, astronomy, music, surveying, computer science, farming, and mathematics. Lorado Taft's *Alma Mater* welcomes incoming generations of students, gathering casually in the space behind her, while from the other side, an orderly procession of graduates emerges. Other images include grain elevators, cattle, planes, sea divers, astronauts, Altgeld Hall, the Krannert Center for the Performing Arts, and the Beckman Institute.

Naturalistic and sharply defined, as is typical for Jackson's work, the composition nonetheless conveys an almost surrealist disequilibrium. Yet its disconnected activities and its

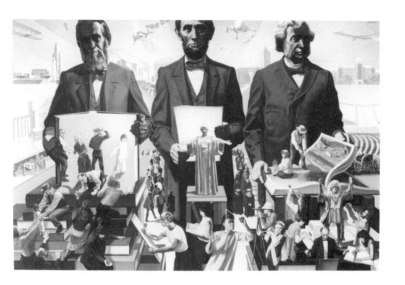

figures of various sizes tell a lively story, help create spatial recession, and paradoxically work well with the three main characters, whose cropped-off heads make clear that Turner, Lincoln, and Morrill are larger than life, not to be confined within an ordinary picture frame.

A prolific graphic artist and painter, Jackson has depicted a broad range of subject matter throughout his career. Numerous institutions own his work, among them the National Gallery of Art, the Library of Congress, and the National Museum of American Art in Washington, D.C.; the Metropolitan Museum of Art in New York; the Union League Club of Chicago; the First of America Bank and the Busey Bank in Urbana-Champaign; and the Krannert Art Museum on the university campus. He is an emeritus professor of art at the university.

The Life of Lincoln, 1911

Ten terra-cotta panels, approx. 3' x 9'6"

East facade, Lincoln Hall

To memorialize "the first citizen of this state to be elected President of the United States, the signer of the bill which made the state university possible, and the consistent and persevering friend of higher education and the nation," the Illinois state legislature in 1909, the hundredth anniversary of Abraham Lincoln's birth, appropriated $250,000 to erect Lincoln Hall. Among the building's exterior decorations, above the second-floor windows, are quotations from Lincoln's speeches and writings and medallion portraits of men closely associated with him in his work.

But placed in the most important position, at either side of the main entrance at the same height, is still another architectural feature—a series of ten white terra-cotta panels depicting scenes from Lincoln's life, from his early years as a rail splitter to the close of the Civil War, each set off with a date to clarify the subject matter. From left to right, they are entitled *Lincoln as a Rail Splitter, 1830; Lincoln as a River Boatman, 1831; Lincoln as the Circuit Rider, 1849; Lincoln-Douglas Debate, 1858; Lincoln's First Inaugural Address, 1861; "We are Coming, Father Abraham, One Hundred Thousand Strong," 1861; Abraham Lincoln, the Savior of the Slave, 1863; Battlefield of Gettysburg, 1863; Surrender at Appomattox Courthouse, 1865;* and *The Soldier's Return, 1865.*

Karl Schneider, chief of the artistic staff of the American Terra Cotta and Ceramic Company, Chicago, designed the pieces, spending nearly a year on the project. He complained about his laborious research, noting that biographers did not sufficiently cover dramatic events or inspire him, that he had to visit historical sites and communicate with Lincoln's descendants and others to learn anecdotes and gather pictures himself.

Despite careful craftsmanship, not uninteresting compositions, and a skillful enough naturalistic style, the sculptures lack impact because of their distance from the viewers below. They suffer a lack of clarity due to their whiteness, their extremely shallow modeling, and their proximity to the building's white window frames.

Even in April 1911, questions about their artistic value were raised when an informal committee of architectural and art faculty inspected the first of the reliefs set into position. While not finding fault with the work itself, they did unan-

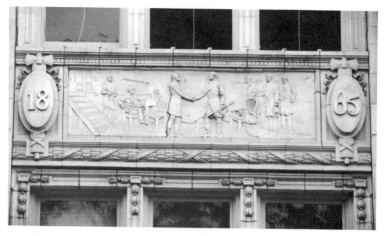

Surrender at Appomattox Courthouse, 1865

imously report that the "type of panel proposed was entirely out of place in such a position on the building; and on the question as to whether the present panel is at all worthwhile as now set, six voted 'No,' and one was in doubt."

Informed of their unfavorable response and the fact that work would be held up temporarily until further decisions on the matter could be made, William D. Gates, president and general manager of the terra-cotta company, caustically wrote to President Edmund Janes James, "You have a mighty fine faculty socially and educationally but they are too much for me as critics. Your Mr. White ordered work stopped some little time since. Now Mr. Green suggests submission to State Art Commission and criticizes the second panel as to whether Lincoln saw any slave sale. Now my hands are up. . . . Unfortunately Michael Angelo [*sic*], who might have been able to do this work[,] is not now accessible and indeed it occurs that it's possible that if he had been compelled to submit to the Art Commission before placing his work, Italy might not today have some of her art treasures. . . . This is the work your Architect wanted, but your Professors will have to live with it."

Abraham Lincoln, 1915

Bronze bust, 2'6" high

University purchase, 1928

Niche, east entrance to Lincoln Hall

In 1923 the university's supervising architect asked Lorado Taft's advice about putting a marble or bronze bust in the Lincoln Hall niche, observing it had been suggested that "Borglum's head of Lincoln, the original of which is in the Rotunda of the Capitol at Washington, would be the best thing we could copy and would probably be better than the original of one which we could have made." Taft did not equivocate: "I regret to say that Borglum's so-called 'Lincoln' is my pet aversion; I would prefer not to help in this matter." Five years later MacNeil's bust was bought with $450 from the Reserve and Contingent Fund.

Lincoln's expression is contemplative in this gentle, very appealing sculpture. An air of intimacy as well as tension is created by the tightly folded arms, which rest on a simple rectangular plinth, while the hand clutching a document suggests something of a troubled inner conflict.

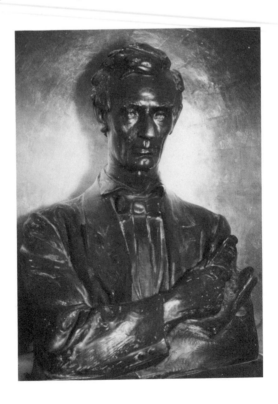

MacNeil, who studied at the Académie Julian, the Ecole des Beaux-Arts, and at the American Academy in Rome, taught at Cornell University, Pratt Institute, and the Art Institute of Chicago. He established his reputation with Native American subjects such as the romantic *Sun Vow* group of 1898, which by 1900 was considered "America's most popular sculpture." But the major part of his work consisted of large-scale memorials, portraits, and murals, among them the Washington Square Arch reliefs in New York; the Père Marquette memorial in Chicago; and the pediment sculpture on the nation's Supreme Court Building in Washington, D.C. He was a follower and friend of Taft's in the Central Art Association, a group dedicated to the promotion of American art. Taft observed that running through MacNeil's work "is a dependable sanity most gratifying to meet amid the eccentricities and vagaries of current endeavor."

To the Fair Memory of Anna Margarethe Lange, Wife of Edmund Janes James, 1917

Bronze plaque, 6'9" x 4'10"

Gift 1917, Edmund Janes James

Foyer of Foellinger Auditorium

In 1917 President Edmund Janes James commissioned and presented this nearly seven-foot-high bronze plaque to the university as a memorial to his wife, Anna Margarethe Lange, who had died three years earlier. The gifted sculptor Kathleen Robinson Ingels, a member of Lorado Taft's Chicago Midway studio group, created it.

Taft told James that he considered it "one of the best things that have gone out from these studios. The beautiful idea was yours[,] and Mrs. Ingels has given it worthy embodiment. Her composition is lovely and most sympathetic and the execution leaves nothing to be desired. I congratulate all concerned, including the University, for these are the things which enrich the background of college life." Aware that the artist might not be accorded sufficient recognition in public announcements, he went on to emphasize, "It is her work and not mine."

While made to commemorate Mrs. James's warm, enlightened, devoted service to family, faculty, and students, the sculpture was also in recognition, the president explained, "that women who have no official connection with the University, except through the fact that their husbands are members of the staff, may form a very real source of strength and power in the accomplishment of those ends for which the University exists." Others described her as "a grandmother to all faculty babies" and "an earnest advocate of women's suffrage."

James saw certain parallels between the biblical Ruth and his German-born wife, and the tablet depicts, in flattened-out, very shallow relief, hazy, almost incorporeal, idealized figures of Ruth and other women gleaning in the barley fields. Ruth gazes back toward her homeland. The touching inscription says, in part, that "her life was a new version of an ancient story. She, too, like Ruth of old, left home and kindred and journeyed into a far country. She made this people her people and this country her country, and though, standing amid the alien corn, she sometimes paused to gaze with tear-filled eyes and longing heart to her old home beyond the seas, it was only to gather new strength for the tasks

before her. . . . A gracious spirit, she moved through life a joyous, strong, and helpful presence; a source of power and inspiration to all who knew her, giving joy to the joyful, strength to the weak, and comfort to the sorrowing; a loving and devoted daughter of her adopted country, the land in which her children and her children's children will rise up and call her blessed."

Ingels exhibited at the Art Institute of Chicago between 1909 and 1917 and received awards from the Art Institute and the Los Angeles Museum. Her sculpture *Inspiration*, a marble group designed as a memorial to the artist Florence Adams, was a gift of her pupils to the Art Institute and has been in its collection since 1915.

Editors' Hall of Fame, c. 1922–30

Nine bronze busts, ranging from 27" to 30" high

Gift 1930–31, Illinois Press Association

First- and second-floor corridors, Gregory Hall

In an era when bronze statues immortalized heroes, a modest pantheon came into being: an Editors' Hall of Fame, established in 1927 by the Illinois Press Association to "preserve the spirit and achievement of notable members of the press." A university location was chosen for the busts envisioned, so that journalism students would see and be influenced by them. While a good deal of correspondence remains about the selection of Hall of Fame members, no information has come to light about the criteria used to award the few sculpture commissions.

At the dedication ceremony in 1930, eight busts stood on the Auditorium (now Foellinger Auditorium) stage, and a year later the ninth and final one arrived. All were displayed in the lobby until more permanent housing could be found. The director of the school of journalism, Laurence Murphy, wrote a colleague about the continuing need to give recognition to reporters and editors working for a free press and to assemble a numerically ambitious collection. "It is important," he confided, "that the busts keep on coming as we will get a journalism building of the right size if the Hall seems to be filling up rapidly and it looks as though there would be a large gallery instead of a small one. The University is not sold on the idea that we need a place for 100 or more busts because it sees only eight or nine on the grounds."

Gregory Hall, housing the journalism school, was built in 1940, and the busts were installed in first- and second-floor corridors. But the outbreak of war effectively ended thoughts of expanding the collection, so that by 1943, the last year elections to the Hall of Fame were held, just eighty-nine men and one woman had been honored, among them, Joseph Addison, Benjamin Franklin, Thomas Paine, John Peter Zenger, Myra Bradwell, and Noah Webster. Only the nine bronze busts, however, constituted its visible, artistic manifestation. That is still the case.

Especially worth study are Jo Davidson's unidealized, intensely expressive portrait of the publisher Edward Willis Scripps and Frances Savage Curtis's fine characterization of Melville Elijah Stone, founder of the Associated Press. Lorado Taft, Albin Polasek, Viola Norman, and Oskar J. W.

Dedication of the *Editors' Hall of Fame*, 1930

Hansen did the others, portraits of Elijah Parish Lovejoy, David Wright Barkley, William Osborne Davis, Victor Fremont Lawson, Joseph Meharry Medill, Henry Wilson Clendenin, and Henry Means Pindell.

Artistic comparisons aside, the spectator might muse on the ephemeral nature of fame and immortality. Opposite a large lecture room in the center of Gregory Hall is a lettered metal plate informing the public that the *Editors' Hall of Fame* was meant to "perpetuate the spirit and achievements of great editors." Despite recently improved lighting conditions, it is difficult to ignore the fact that the busts are neglected, their inelegant wooden supports peeling, their history and sentiment certainly forgotten.

Lorado Taft (1860–1936)

Sons and Daughters of Deucalion and Pyrrha, 1933

Four limestone figures, ranging from 5' to 7' high

Purchase 1937, Lorado Taft Collection

South side, Foellinger Auditorium, and east side, Library

From 1910 throughout the rest of his life, Taft hoped to beautify the old Columbian Exposition Midway Plaisance in Chicago by creating a mile-long expanse of trees, lawns, fountains, and "statues of the world's greatest idealists." A fountain of Time would be at the Washington Park end, one of Creation at the Jackson Park end, and, between them, lagoons and bridges with sculpture symbolizing Science, Art, and Religion. Due to a lack of support for the project, only the *Fountain of Time,* which many consider Taft's masterpiece, came fully into being.

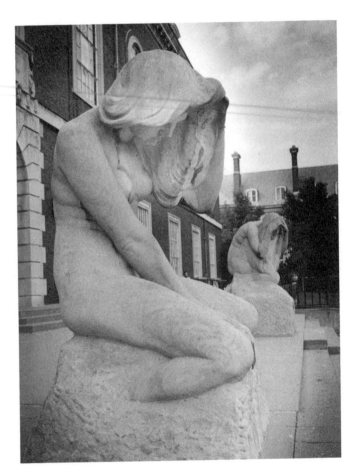

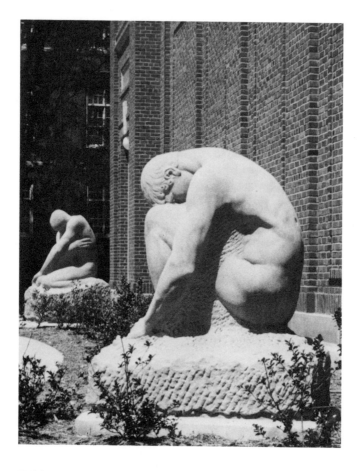

Taft began the artistic process for a fountain of Creation with a tiny plaster maquette first exhibited in his studio in 1910. About forty figures, each approximately 2½ to 5½ inches high, were arranged in fourteen single- or multifigure parts; their final size was to have been about 10 feet high, with the fountain measuring about 70 by 40 feet. Water would rise up around the groups, form mist, and flow to suggest great floodwaters, imagery derived from the Noah-like Greek myth in which Deucalion and Pyrrha, the only two people left on earth after a deluge, consult "a convenient oracle as to the best way of restoring the human race." They are told, in Taft's words, "to cover their heads and throw the bones of their mother behind them." In his maquette, the sculptor shows us the moment when these "bones," which Pyrrha perceived as the stones of Mother Earth, are changing into men and women, who materialize from the cold and flood into life and light.

Most notable of Taft's several versions of the figures are the four full-size statues at the university. Under Taft's direction, Walter Zimmerman, a Chicago sculptor, carved the two males and two females from Indiana limestone for the Century of Progress exposition in Chicago in 1933. Massive,

dynamic, seemingly incomplete, they metamorphose out of rough-hewn boulders—in the fashion of Michelangelo or Rodin—into human form.

In 1945, classics professor William Oldfather discovered misspellings on the sculptures' explanatory plaques. He informed the director of the physical plant about "'Pyrrah' (for Pyrrha) and 'Ducalion' (for Deucalion)," assuring him that "I am thoroughly familiar with what I am talking about in this letter, because Deucalion and Pyrrha have been for many years one of the chief concerns of my research. The spellings given above in quotation marks are unquaiifiedly incorrect for English," he chided, "the language in which the texts on the plaques are composed; and equally incorrect for Greek, in which language these names were first used; for Latin; for German; for French; and for Italian, these being the six languages with which most educated men are familiar; and I have no doubt that the spellings are incorrect also for other literary languages. I hope something will be done about the matter. It would be far better, in my judgment, for a University to have no explanatory plaques at all, than plaques which tend to make it ridiculous."

Two things are certain: Foreign-language requirements are not what they used to be, and the plaques remain misspelled.

Barry Faulkner (1881–1966)

The Four Hemispheres: Polar, Celestial, Eastern, Western, 1926–27

Four murals, oil on canvas, each 10' x 13'

Over the two grand staircases, Library

Four impressive Art Deco murals over the Library's main interior staircases represent, in allegorical, historical, and exotic figures, the Polar, Celestial, Eastern, and Western Hemispheres. That was not the way it was meant to be.

For the faculty committee advising on decorations for the new Library in 1926, enough could be seen on campus of murals with traditional nineteenth-century themes. Newton Alonzo Wells's murals expressed the uplifting spirit of the first library building (Altgeld Hall), and Frank Millet's grandiose *Return of Ulysses,* made for the 1893 Columbian Exposition, filled the space above the Auditorium stage. (Nicknamed "Everybody Works but Father," it disintegrated after being stored during a 1939 refurbishment.) A shift to recognizable imagery and real events was wanted. When it came to deciding on specifics, however, the academics and the artist had differing outlooks. The professors' thinking reveals a developing pride in regional culture and history. Barry Faulkner, the successful New York painter given the commission, was bound to the idea that architectural art ought to be primarily decorative.

The Celestial Hemisphere

The committee suggested Faulkner depict Indian villages with "trails passing hither and thither," fur traders and settlers battling precarious currents in flatboats; wilderness forts, primitive towns, and even Cave-in-Rock bandits; and for more contemporary times, little trains, prairie schooners, Great Lakes steamers, modern railroads, automobiles, and airplanes.

Faulkner offered instead sketches having an iconographic scheme of four hemispheres, "more appropriate for a library of a great university." Further efforts to influence him failed and the would-be mural planners finally accepted his ideas, conceding it would be "unwise to dictate to the artist." The library director got right to the point, confessing he had hoped the designs would be a little less conventional and related "a little more intimately to the part of the world which we, in this country, call the Middle West."

The murals employ striking compositional schemes of circular map areas within larger rectangles. Curved latitudinal and longitudinal lines simulate the globe's three-dimensional form. Dark blues and greens, muted brick-reds, and grays predominate. Sallow, almost greenish flesh tones and a generally cold palette intensify icy north and night sky scenes. Lighter complexions and hues of greater saturation reinforce tropical motifs. All four are period pieces in the Art Deco style, first known as Art Moderne (from the Exposition Internationale des Arts Decoratifs et Industriels Modernes, Paris, 1925), which emphasized the spirit of modernity, streamlining, and speed, and abundantly showed, in simplified forms and sleek lines, animals such as greyhounds, gazelles, jaguars, panthers, and porpoises, and long-legged and graceful athletes and dancers.

Of the *Polar Hemisphere*, Faulkner said only that the North Wind blew back ships attempting to cross arctic regions and that the "explorers' constant companions," Death and Fame, hovered over the arctic adventurers, Richard E. Byrd and Robert E. Peary. Classical allusions aside, Fame is very much of the twentieth century, her coiffure remarkably incorporating both bobbed-flapper and idealized-goddess styles.

In the *Celestial Hemisphere,* animal and human forms in identifiable constellations and other hazy, ghostly configurations rotate and move mysteriously in and out, animating the painting. Two female figures represent Day and Night. Ptolemy, the celebrated Greco-Egyptian astronomer of antiquity, squints through a small telescope. Copernicus charts the universe amid a clutter of astronomical appurtenances. The sun is shown as a petaled flower-baby staring popeyed at Ptolemy, while an openmouthed, waning moon floats between Night and Copernicus.

Well might the sun stare. Within two weeks of the mural's installation, alert academicians dispatched an urgent message advising that "It is clear that the figure labeled Ptolemy, who is represented as using a spy glass, or telescope, appears likely to bring the institution into a certain kind of ridicule. As one member of the faculty says, 'They might almost as well have Caesar crossing the Alps in an aeroplane.' We should all regret, of course, to have some prominent writer or other person give undesirable publicity to this painting." Perhaps, they suggested, the name "Galileo" could block out Ptolemy's.

Apprised of "the commotion among the astronomers," an undaunted Faulkner told the architect that he thought it "pretty certain that if those clever Alexandrines didn't have lenses they at least looked through tubes so as to isolate the portions of the heavens they wished to observe. I wonder if it's certainly known that they didn't have kinds of primitive lenses. So many things were known to the Greeks and then lost. I didn't investigate carefully when I painted Ptolemy . . . but I think the tube idea passes it off tolerably well. Anyhow, what is an anachronism between friends?"

Evidently nothing. The offending telescope is exactly as Faulkner created it in 1926, and no one in recent memory has paid it any notice.

In the *Eastern Hemisphere*, shadowy, silhouetted sea creatures swim in vast watery spaces. A nude woman identified as the South Wind spans the Indian Ocean. Female personifications of India and Egypt, bedecked in opulent jewelry, bellybands, and insubstantial peach-colored drapery falling in archaic zigzag folds, stand at either side. After Tutankhamen's tomb was discovered in 1922, the vogue for Egyptian design motifs strongly affected Art Deco production, and pseudo-Egyptian hairstyles, furniture, costumes, and other objects designed in this fashion remained popular until the early thirties.

A whip-brandishing Venus in a half-shell chariot skims across the Pacific Ocean in the *Western Hemisphere*. The Mississippi and Amazon rivers are two scantily clad indigenous figures in a tropical setting. Exotic places found expression in all decorative arts of the period. Much work in the Art Deco style reflects not only Peruvian and Brazilian sources but motifs taken also from Aztec, American Indian, Egyptian, Far Eastern, and Russian artifacts.

Illustrations of Faulkner's highly regarded art appeared regularly in architectural and interior design journals. A 1927 issue of *Architecture* characterized his residential decorations and screens as "charming," his Cunard Building sea charts as "quite the finest of their kind," and his work in general

as having "the quiet reserve of the painters of the early Renaissance, and a very beautiful modern sense of color." Examples of his mosaics and painted murals are in the older John Hancock Building, Boston; the National Archives, Washington; and the American cemeteries at Thiaucourt and Suresnes, France.

Printers' Marks, 1926–27

Twenty-seven tinted glass panels, 48" x 30"

Windows in Reference Room and over grand staircases, Library

Beautifully tinted glass designs, colored primarily in soft grays, browns, and ambers and representing the marks of printers in France, Italy, Scotland, England, Switzerland, and the Netherlands, embellish twenty-seven of the library's second-floor windows. In the corners of the central panels, small patterns reproduce watermarks in the paper from manufacturers in the respective countries, even if the paper was not always used by the printer with whose mark they appear.

Printers' marks are trademarks, publishers' distinctive emblems appearing on a book's title page or, less frequently, in the colophon in the back. They came into use with the spread of literacy in the fifteenth and sixteenth centuries, the founding of universities, and the beginnings of humanist thought in the Renaissance. As books took on greater significance and printing presses grew to meet commercial and academic requirements, it became necessary for printers to protect against reputation-damaging forgeries by inventing or adapting individual and trade signs as identifying marks. The first known mark, from Fust and Schöffer's Mainz Psalter (1457), shows a broken twig supporting two shields and compositor's setting rules. Later devices include geometric designs, tools of trade, heraldic signs, ecclesiastical symbols, visual puns, house and street markers, mythological and real animals, and birds and people.

Collaborating on the choice of printers' marks for the windows of the newly erected university library building were J. Scott Williams, the artist; Charles A. Platt, the architect; and Phineas Windsor, the library director. Windsor submitted a list of possibilities, acknowledging that some of his selections might "not be artistic, but among scholars and well read people generally, I fear we would always have to be explaining why some of these names are omitted." Most of his suggestions made the final list, but five others that the architect liked, despite their relative unimportance, also were used. Original books produced by all but two of the twenty-seven printers represented (Dal Gesu and Thomas Davidson) are in the library's Rare Book Room, where a file that identifies them may be consulted.

Windsor advised special care in spelling and name forms. So crucial was this point, he emphasized, that "I am inclined to

Badius Ascensius, Paris

suggest that the designs or a photograph of them be sent for final checking before the windows are made. They will be scrutinized so critically that I think the utmost caution is worthwhile." He need not have worried. Few library patrons today are even aware that the printers' marks appear on the panes, as readers disturbed by sunlight cause librarians to draw Venetian blinds over the windows most of the time.

The library windows differ in several ways from medieval stained-glass windows. To produce the windows with a minimum use of leading, the artist combined painting, staining, firing, and etching techniques. The leading uniformly orga-

nizes the compositions rather than separating portions into fragmented compartments, as is typical in medieval windows where small glass mosaic pieces were used. The colors too are different. Here they are soft and watery, not resplendent and jewel-like. Williams wrote that he and the glass loft's craftsman determined what colors to employ by picking from the type, character, and color of glass available. They selected from imported German and English glass as well as French flash glass, which they etched with hydrofluoric acid to obtain the color desired. Flash glass is made by hand-blowing together different layers into the same sheet so that one colored layer of glass remains when the other layer is etched away by acid. The resulting line between the two colors is sharp and clean, and the two colors show in one piece of glass that is quite vivid when light shines through.

Two of the windows are especially interesting. Directly opposite the Reference Room entrance is the only design Windsor thought might prove a source of embarrassment: the unauthentic combination of profiles of Gutenberg, Fust, and Schöffer with the twin-shield trademark of the latter two. Gutenberg, inventor of movable type and maker of the renowned Gutenberg Bible, did not use a device. Fust and Schöffer, his successors, issued a Latin Psalter in 1457 that has the distinction of being the earliest book with a trademark and date, place, and typographer's name on it, and the third to be printed from movable type. "The three profiles," wrote the library director in 1926, "unless carefully handled, may possibly become the butts of frivolous student jokers. Aside from this consideration I have no personal objection to the design."

Another mark is that of *Badius Ascensius, Paris,* located above one of the library's grand staircases. The earliest known illustration of a printing press, the mark appeared in 1507 and shows the press in action, at the instant the printer puts great effort into pulling the lever. This causes the screw to force the platen down upon the press, producing an impression upon the paper. In the logo at the bottom of the mark are the initials "I B," which stand for Josse Bade, the printer's original, un-Latinized name.

J. Scott Williams taught at the University of Wyoming (1946–49) and exhibited fourteen times at the Art Institute of Chicago (1918–59). Examples of his murals, stained glass, and other works of art are in the Memphis Museum, the Indiana State Library, the Johns Hopkins University, and Yale University.

Dr. Gallaudet and His First Deaf-Mute Pupil, 1888

Original plaster sculpture, bronzed, approx. 6' high

Purchased 1937, Lorado Taft Collection

North entrance, Library

Dr. Thomas Gallaudet founded the first free school for the deaf in the United States, the American School for the Deaf, in Hartford, Connecticut, in 1817. He is shown in this naturalistic sculptural portrait with Alice Cogswell, the child who sparked his interest in educating the deaf. She concentrates intensely, gesturing imitatively to form the sign for the letter "A" with her right hand. Dr. Gallaudet developed his sign language by utilizing elements of an English system of oral speech and a French method based on communication employed by a Spanish order of monks vowed to silence. Funds for the memorial were raised by Gallaudet's son, Edward, and came from the deaf in every territory and state in the country.

From a small plaster model that Daniel Chester French finished in November 1887, studio artisans made this full-scale plaster the following year. With some minor changes, French had it ready for the foundry by late November. The first bronze casting (1889) is on the grounds of the nation's only liberal arts school for the hearing impaired, Gallaudet University in Washington, D.C. (formerly Columbia Institute for Deaf-Mutes). Another casting (1924) is at the Connecticut school.

The plaster is more than just a means to produce a bronze statue; it is an artwork in its own right. Not only is it one of French's significant early works, it is valuable too as it reveals the sculptor's original conception of the piece before it was cast in bronze, especially in the variety of surface details the plaster allows. The sculpture is also innovative, as it presents a narrative portrait of an actual event without the customary allegorical implications.

When the expatriate American author Henry James saw a photograph of the large plaster in 1889, he wrote French, "I am delighted that work of such high distinction & refinement should come from the country which you appear, deludedly, to suspect me of not being in a hurry to return to. I feel in a tremendous hurry, when I think of the beautiful things you are doing—and when I do go back, the desire to see them will not leave me without a part in the adventure."

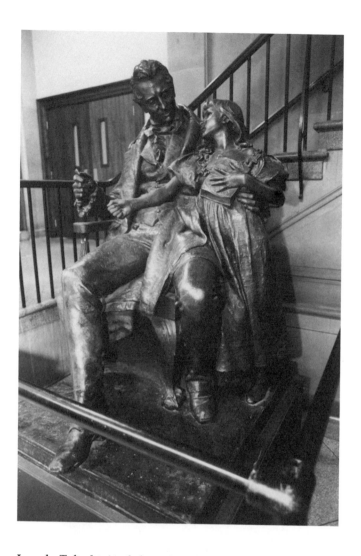

Lorado Taft obtained the original plaster from the artist in 1926, with the intention of putting it in his "Dream Museum" of great sculpture from all periods of history. "I wonder if you are ready now to receive contributions to your American Gallery?" French had asked him the previous September. "The Gallaudet group has been successfully cast in bronze and the plaster model is now at the foundry, and of course they are anxious to get rid of it. . . . I don't want to embarrass you by unloading my stuff on you."

French, born to a prominent New England family, studied in Europe and in the United States with William Rimmer, William Morris Hunt, and, briefly, John Quincy Adams Ward. Among his most famous monuments are *The Minute Man* at the bridge in Concord, Massachusetts; the *Alma Mater* on the steps of Columbia University, New York; and the great marble seated figure of Lincoln in the Lincoln Memorial, Washington, D.C.

The Pioneers, 1928

Original plaster group, bronzed, 10' high

Purchased 1937, Lorado Taft Collection

South entrance, Library

The grimly earnest, realistic figural group cast in bronze from this original plaster stands in a park in Taft's birthplace, Elmwood, Illinois. At the base is the inscription, "To the Pioneers / Who bridged the streams / Subdued the soil and / Founded a State." Gertrude Lathrop, a New York artist, modeled the dog.

After completing the sketch model for the group, Taft described his intentions: "The young Pioneer has been at work, possibly in the field, where his young wife has run in alarm,

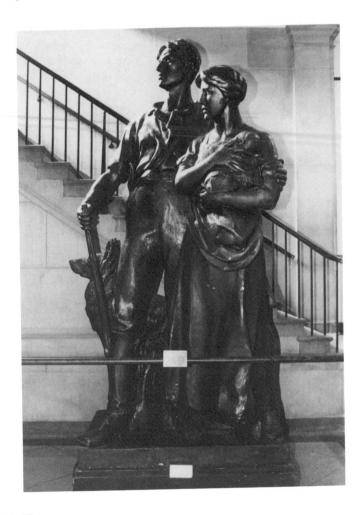

her baby in her arms, to tell him of some possible danger. They stand together looking in the direction of their peril, the young husband alert, with gun in hand and his faithful dog by his side, while the young mother, a hardy, brave type of American womanhood, holds the infant with a protective gesture. The faces of the small group are unfinished but give a hint of the beauty of expression which is Mr. Taft's hope to show in the full-size work."

Katharine Lucinda Sharp Memorial, 1921

Bronze plaque, 4' × 3'

Gift 1921, Library School Alumni Association

Hallway, 306 Library

At the invitation of President Andrew Draper, Katharine Lucinda Sharp (1865–1907) came to the university in the fall of 1893 to establish a professional library program and to build a major library. For four years prior to that, she had occupied a similar position at the library school she started at Armour Institute in Chicago, a technical school, and when she moved to Urbana, she brought her students with her. Serving ably until 1907, she pushed the school from a one-year sequence of classes to a four-year course of studies leading to a bachelor's degree and tried, without success, to introduce a graduate program. (That was accomplished in

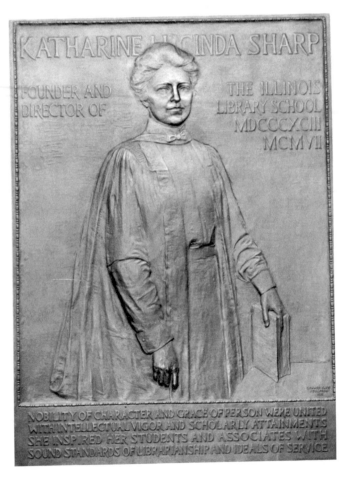

1911.) Today the UI Graduate School of Library and Information Science, which began as the earliest library school in the nation to be part of a university, has consistently been ranked first.

Taft made his low-relief, half-size portrait of Sharp from photographs, representing her as a dignified young woman in academic robes. During the working period, a minor dispute arose over the use of the appellation "Founder" in the inscription, but Taft balked at the possibility of having to redesign the lettering at that late date. "The more I experiment, the worse the tangle," he complained. "The spacing is all changed, the balance is lost and I see no satisfactory solution without remodeling the entire inscription." Fortunately, the cavilling ceased and he proceeded with his original plan.

Inscribed across the lower portion of the plaque are the words, "Nobility of character and grace of person were united with intellectual vigor and scholarly attainments. She inspired her students and associates with sound standards of librarianship and ideals of service."

The sculpture, said the journal *Public Libraries* at the time of the plaque's dedication in 1922, typifies "young womanhood prepared and able to meet the duties of her new environment. Mr. Taft, as was to be expected, has caught and expressed the ideals of the young professional woman at the beginning of the twentieth century which Miss Sharp truly exemplified in her attitude toward library service. . . . [The sculpture] is worthy of study by the oncoming ranks of librarians."

Architectural Fragments, 1888–89 and 1898–99

Cast iron or granite, various sizes

Acquired 1952–56 with the aid of architecture alumni

North side and entrance hall of Architecture Building

Taken from their original context, these architectural fragments ought to be regarded as art, seen independently but with regard to their original function as part of a building's design.

The heavy granite impost block just north of the Architecture Building is animated by exuberant, feathery plant forms and graceful corner scrolls that create lush, vivid linear surface patterns. Installed much as a bench and without identification or apparent reason, it imparts a vaguely romantic presence to the parklike setting. It originally supported the springing of two massive ground-floor arches of the Walker Warehouse, 200 South Market Street, Chicago, designed by Adler and Sullivan in 1888 and first known as the Ryerson Building. It was a structure that clearly reflected Henry Hobson Richardson's Marshall Field Wholesale Building of 1885–87. When the Walker Warehouse was demolished in 1954 for the Wacker Drive extension, most of the building was used to construct a breakwater in Lake Michigan.

Also characteristic of Sullivan's ornamental style are decorative panels displayed in the Architecture Building's entrance hall. They demonstrate his designs' kinship with contemporary Art Nouveau vocabulary—dynamic, undulating, delicate organic forms, freeflowing linear interplays of open and closed spaces, here tightly organized, symmetrical, and profusely intricate. As with Sullivan's other commissions, his chief draftsman, George G. Elmslie, worked out details of the design under the architect's supervision. The panels decorated the face of the Gage Building, 18 South Michigan Avenue, the northernmost of three buildings by Holabird and Roche that were erected diagonally across the street from the Art Institute of Chicago. Gage Brothers and Company was willing to pay an additional cost to have its building's facade designed by Sullivan.

When in the 1950s the building was modernized and Sullivan's panels removed, university alumni arranged to have them given to the architecture department. Members restored the colors in accordance with William Gray Purcell's statement of Sullivan's specifications for the Carson, Pirie,

Granite impost block from Walker Warehouse, 1888

Scott Building ironwork, a deliberate imitation of oxidized bronze achieved by allowing the red undercoat to show through in places: "Original finish was an honest paint job . . . sharpened up with English vermillion. Finish coat with a certain juicy not too sharp green. . . . I'd say halfway between olive and sap. . . . Put this on in a medium coat, letting it settle well into the deep places. . . . cover general surfaces—now swipe and pat the new paint with waste or handfuls of old newspapers so red will just barely show through here and there in high spots."

Tree of Life Fantasy, 1990–92

Painted steel and wood, 20' high

Gift of the artist, 1992

Lorado Taft Drive, near the Education Building

Aycock's *Tree of Life Fantasy* appears on the landscape as an intriguing machine or play apparatus that gives no hint of function. The painted white sculpture is at once a mix of opaque, transparent, and linear parts: kinetic roller-coaster loops, washboard and trellis forms, and jagged edges. Although created in three dimensions, only its front, sited straight toward the viewer coming from the west, seems significant.

The work's full title is *Tree of Life Fantasy: Synopsis of the Book of Questions Concerning the World Order and/or the Order of Worlds.* Meaning is elusive, yet in the context of themes explored in the artist's prodigious body of work, her fantasies, paradoxically, make sense. Involved are arcane musings on nature, philosophy, chance, magic, myth, technology, science, literature, history, psychology, dreams, and memory—imagined or real.

As Aycock put it, her art represents "investigations into the process of visualizing and constructing pseudo-philosophical theories to explain the inexplicable phenomena of the universe." As if to reinforce that notion, her earthworks, constructions, and drawings typically bear enigmatic titles, ranging from *How to Catch and Manufacture Ghosts* and *The Large Scale Dis/Integration of Microelectronic Memories* to *A Salutation to the Wonderful Pig of Knowledge, The Machine that Makes the World,* and *Angels Continue Turning the Wheels of the Universe Despite Their Ugly Souls.* "I just attempt to deal with what is around me," she once asserted. "I've always been interested in history. It's also necessary to play with science."

The question of what we need to know to understand a work of art comes into play here. How important are titles? How much must we know of Aycock's style, iconography, thought processes? Does it help to learn that her imagery derives from pictographs, hieroglyphs, magical emblems, board games, alchemical signs, tantric art, stage sets, dance diagrams, archaeological remnants, and even the structure of DNA? Must we know that she said that this particular work had associations with industry, with architecture, with cosmology, with nature, and with speculations of early mystics about universal spiritual and physical truths? That she de-

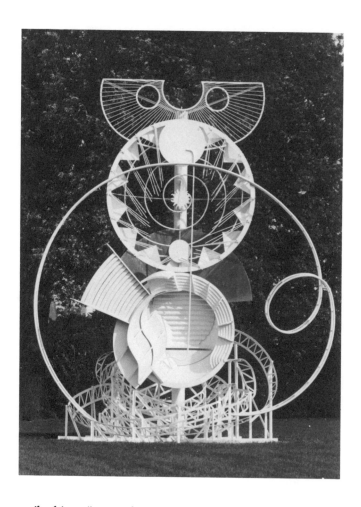

scribed it as "a nostalgic piece, a wish that the world could be ordered just like this"? Aside from matters such as aesthetics or artistic sources, can we not comprehend the sculpture solely as an interesting, if baffling, assemblage of disparate elements?

Aycock is an artist of solid reputation whose work has received much critical attention. She has taught at Yale University, the Rhode Island School of Design, Princeton University, and Hunter College of the City University in New York, and her work is included in the permanent collections of the Museum of Modern Art, the Guggenheim Museum, and the Whitney Museum, New York; the Hirshhorn Museum, Washington, D.C.; and the University of South Florida, Tampa.

Lincoln-Douglas Debate, 1936

Original plaster relief, bronzed, 7'10" x 12' x 12"

Purchased 1937, Lorado Taft Collection

Peer and Sarah Pedersen Pavilion, College of Law

This large-scale plaster relief commemorates the Lincoln-Douglas debate of October 13, 1858, the sixth in a series of seven oratorical contests waged throughout Illinois between the two men running for election to the U.S. Senate. The bronze casting made from it is in Washington Park, Quincy, Illinois, the site of the event. Local civic groups commissioned the work and Lorado Taft produced it, but people "of the Democratic faith in politics" indirectly but surely affected its appearance and content.

The main issue battled by the pair at length—each speech lasted two to three hours—involved the extension of slavery to the territories. Lincoln, a Republican relatively unknown outside the Midwest, gained national attention (and the presidency two years later) for his fervent conviction that slavery was repugnant, a moral wrong inconsistent with the spirit of democracy. He knew he could not interfere with the practice in the states where it existed; it was constitutionally protected. But it must not spread, he argued. It was a matter of the "common right of humanity," and only the power of strong federal government action would lead to its gradual extinction.

For Democratic incumbent Stephen A. Douglas, who won election by a very small margin, the raising of the moral aspect of slavery brought with it the danger of disunion and civil war. While not proslavery, he insisted that it was a matter of choice—that power resided at the community level, that people should decide the slavery question for themselves. It was the "great principle of self-government," he said, "the right of the people to rule."

Taft's first sketch for the monument was dramatically yet simply conceived, containing just three foreground characters: a man with a cane to the left, partially obscured by a lectern; Lincoln at center, a commanding, heroic figure turned away from his opponent; and Douglas to the right, seated, a small, compact mass. (At 5'4", the "Little Giant" was a full foot shorter than "Long Abe.") A mound of faces in back artfully suggested the dais audience.

But Quincy sponsors unanimously rejected the proposal. "While you have reproduced both Lincoln and Douglas

faithfully you have given Lincoln too much prominence, and have shown Douglas in too small a position," Loren Cox, chairman of the citizens' committee, told Taft. "Personally this would be no objection, but we have a host of people here of the Democratic faith in politics and they would criticize the committee severely if it appeared that this was principally a Lincoln memorial. . . . At least place the figures in a little different position and show them on a more even scale."

Without hesitation, Taft responded by saying that he could not see how a good composition could be made without a dominant figure. "I have treated the two with equal respect but obviously both cannot be shown speaking. If you prefer it we can have Douglas speaking and Lincoln sitting; that could be done," he wrote, adding diplomatically, "I am reading a very full life of Douglas and find him even more interesting than I had imagined."

Cox ignored him. "Could you work up a sketch placing Douglas on the other side of the stage, something along the lines of the rough sketch enclosed, having on stage some ladies as well as men. History states that both men and women were on the stage or platform from which the addresses were delivered."

At that, the artist gave up. "I shall do my best to follow your suggestion. Douglas is getting bigger and bigger as I read his story. I shall probably end by having a profound admiration for him."

How did it turn out? As can be seen, gradations of relief indicate depth and create an interplay of light and shadow in the crowded, rather woodenly modeled finished work. Dou-

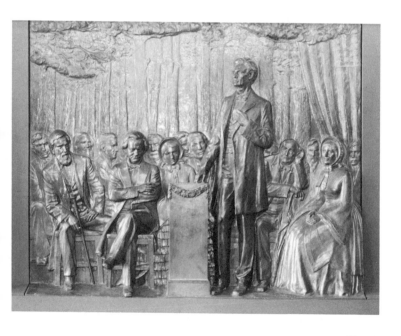

glas shares center stage with Lincoln and seems to have gained physical stature. Seated next to him, partly hidden by the lectern, is his vivacious young wife, Adele Cutts Douglas. Somewhere in the story is a lesson about respecting an artist's judgment.

The city of Quincy dedicated the plaque on October 13, 1936, the seventy-eighth anniversary of the debate. Taft attended the ceremony, caught a cold, and died seventeen days later in Chicago at the age of seventy-six. The *Lincoln-Douglas Debate* stands as his last creation.

Tom Otterness (1952–)

Untitled, 1991–94

Bronze sculptural group of four units, various sizes

Acquired with grants from the National Endowment for the Arts, the John Needles Chester Fund, the College of Fine and Applied Arts, and other sources

Gelvin Garden, Krannert Art Museum

This intriguing bronze group harmonizes perfectly with the other outdoor pieces placed along the same street: Basaldella's *Initiation* and Youngman's *Centennial.* All evoke a sense of archaeological discovery, of mysterious meaning, of civilizations unknown.

Here the sculpture is an ensemble of four units. A pair of enormous upside-down stylized feet functions as benches. Two tiny, cartoonlike police officers shovel and sweep big pennies into a pile. An equally small couple in formal evening attire, holding a lumberman's saw between them, begins to cut down a real lamp post. And sitting on a real bench, a diminutive woman embraces an oversized, bowler-hatted surreal cat with a strange human face. The bronze, burnished to a glossy sheen, possesses an unusually mellow blackish brown patina. Only the cat shows texture, with incised crosshatching covering its body.

While the piece at first suggests whimsy and great fun, it imparts as well a sense of the sinister. Tom Otterness, the sculptor, intended it as a commentary on the human condition, what he referred to in his other projects as symbols or

Detail

metaphors for society. Fascinated with partially submerged monuments and the idea that our knowledge of the past rests on fragmentary remains, he had trouble giving this work a suitable title—although he thought that something along the lines of *Submerged Society* might do. It will have to stay untitled for the present; it's like an artifact from another culture and viewers will have to figure it out for themselves.

Otterness, born in Kansas, lives and works in New York City. His sculpture is in many public collections, among them the Brooklyn Museum, the Guggenheim Museum, and the Museum of Modern Art, New York; the San Francisco Museum of Modern Art; the Dallas Museum of Art; the Israel Museum, Jerusalem; and Museo Tamayo, Mexico City.

Initiation, 1961

Cast, welded, and chased bronze sculpture, 10' high

Gift 1961, Ellnora D. and Herman C. Krannert

South entrance, Krannert Art Museum

Initiation, a powerful ten-foot-tall bronze constructed of planar and ribbon shapes, varied hollow spaces and rhythmic curved edges, while nonrepresentational, still suggests in proportion and stance a totemic human figure at once guarding and beckoning. A timeless quality also pervades the sculpture, marked and scratched as it is with a multitude of magical hieroglyphs of no known culture, although stylistically it bears close affinities to Chinese Bronze Age artifacts. Positioned in front of the blocklike, horizontal white marble original section of the Krannert Art Museum, it contrasts pleasingly in color, scale, and spirit.

The artist wrote that the piece "related to the character of the museum, a university museum where the young may be

initiated into an understanding of the different aspects of human activity. But I have not made a realistic interpretation of Initiation," he explained, "but rather an allusion to a personage who is both teacher and repository of all human knowledge, and solemn as are initiation rites. . . . The recurring motif of fullness and emptiness suggests the passing of knowledge from the initiated to the initiate and may be likened to ocean waves which are perpetually alternating and becoming. . . . The textural decoration on all surfaces of the work suggests a mysterious and ancient scripture to be revealed to the initiate."

Mirko—he used only his first name professionally—studied in Venice, Florence, Rome, and Monza, won many prizes, and participated in special exhibitions of his sculpture. His public monuments include the bronze *Fosse Ardeatina Memorial Gates* in Rome, which commemorate the reprisal murder of 320 Italians by the Germans in 1944; the *Italian War Memorial* at Mauthausen Concentration Camp, located not far from Vienna; and the *Piazza Benedetto Brin Mosaic Fountain* at La Spezia.

Robert Youngman (1927–)

Centennial, 1976

Cast concrete sculpture, 5' x 8' x 8'

Gift 1976, the sculptor, the National Endowment for the Arts, and the University of Illinois Foundation

Northeast corner of Peabody Drive and Fourth Street

Centennial commemorates the one hundredth anniversary of the art department's start of classes in the fall of 1876, a full semester before trustees officially approved the department's establishment the following March.

Placed on a grassy corner outside the west end of the Art and Design Building, the sculpture is a hollow, 5½-ton precast concrete cubical form with walls eight inches thick. It lies like a puzzling, partially revealed archaeological find slightly below ground level in a square concrete basin. The piece is richly patterned with rough and smooth, cylindrical and sharp-edged, and projecting and receding shapes on which sunlight and shadows cast constantly shifting designs.

Robert Youngman, a professor in the School of Art and Design and the director of its art-for-architecture program, believes that the concrete technicians with whom he works deserve credit too. "The most enjoyment to me is the physical part, but you're really not working by yourself. This requires the talents of dozens of people. It's such a long road from the point when you're sketching to where you're actually touching the piece." Always interested in experimenting

with various casting techniques, and especially attracted to creating sculpture of enormous size, Youngman counts among his works a city-block-long, two-story high, precast concrete sculpture (the largest bas-relief in the world, according to the artist) in the Manufacturers' National Bank, downtown Detroit; twenty-four sculptured elements for the international terminal of the Detroit International Airport; and a complex, computer-activated, precast concrete water sculpture for Purdue University, Lafayette, Indiana. His most recent work, *Trilon,* is to stand in front of the terminal building of Willard Airport, Savoy.

Artist unknown

Stadium Reliefs, 1923

Eighty-four limestone medallions and panels, various sizes

Gift 1923, Alumni and Friends

On four towers of Memorial Stadium

The first football game in a still far-from-completed Memorial Stadium took place November 3, 1923, when the stands overflowed with more than sixty thousand Illini enthusiasts who cheered their team on to a 7-0 triumph over the University of Chicago.

Holabird and Roche designed the structure, built in 1922–24 on eight acres of land on the south campus with monies contributed "to provide a fitting memorial to the sons of the University who gave their lives in the recent war." Inscribed on 183 of its 200 columns are the names of Illinois heroes who died in World War I. One honors a woman. While initial plans called for extravagant landscaping, a fountain, and a campanile, those ideas had to be dropped for lack of funds. But decorating the four towers are eighty-four dignified low-relief sculptures, repetitions of nine basic designs. Themes are ancient Greek; significance is contemporary.

Just above the entrance doors are groups of three panels, each about four by nine feet. *The Presentation of the Victory Wreath* depicts six heavily draped old men handing the symbolic wreath to six virile, nude athletes, a pastiche of figures nearly identical in drapery, pose, and gesture to the eponymous heroes on the east frieze of the Parthenon. The placing of their feet outside the rectangular frame (which gives a greater sense of space) is closer to a Roman compositional device

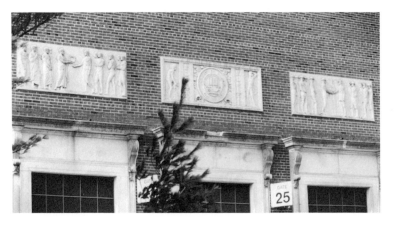

than that of a Greek relief, where it was never employed. In *Athletes and the University Seal,* the figure to the left shown fastening his sandal is an absolute copy of the hoplite warrior on the west Parthenon frieze. The other athlete is nearly identical to a figure on the north frieze. In the third panel, *The Welcome of the American Soldiers in France,* the artist equates ancient and twentieth-century heroes and preserves the symmetry of decorations through pendant compositions. The angel in the center is carved in extremely faint, low relief and seems ethereal, more distant in space.

Centered high over large windows at the north and south ends of the stadium are other panels, measuring three by four feet. These symbolize, in free interpretations of classical Greek sources, *War,* a typical Victory motif of a charioteer overcoming an opponent on foot; *Education,* an orator flanked by listeners; and *Athletes,* a traditional arrangement of athletes flanked by coaches and a judge.

At the same upper level are three alternating medallions, each about four feet in diameter. *War* is represented here by the helmeted head of Athena, with the words "World War 1917–1918." The *Discus Thrower* has the inscription "Athletes" spelled out in Greek letters. The *Owl of Athena,* signifying wisdom, is shown with the university motto, Learning and Labor.

Richard Hunt (1935–)

Growing in Illinois, 1982

Welded Cor-ten steel, approx. 23' long

Acquired through Illinois "Percent for Art" program

East side, Veterinary Medicine Basic Sciences Building

Richard Hunt's massive steel sculpture stands before the Veterinary Medicine Building as a big dark abstract form that seems strangely and vaguely recognizable. A combination of natural, flamelike outcrops and sharp-edged chunky planes, the work reaches a height of fifteen feet. "The whole construction is like a large animal growing, developing from the earth," the artist explained. "The imagery is generalized from a variety of sources. Conceptually it draws its spirit from a dynamic of growth and movement. It is evocative of animal forms, not a particular animal." Workers in the building evidently do not see it in quite this way. Recently a photographer took aim and a lab technician passing by yelled excitedly, "No! No! Shoot it from here! Then you can see it's a dog!"

Cor-ten steel lends itself well to bending, welding, and shaping and acquires a gentle rusted patina from exposure to the outdoors. In this work, Hunt cut and welded the various pieces and then smoothed them with metal grinders or polishers before letting the sculpture weather to a dark, rich rust-brown color. "Metal is very flexible," he observed. "It

allows for both permanence and spontaneity. Since the medium is not esoteric, you have access to material and information about the process. And there's a recognition factor that's built into it because people are familiar with it." (In 1958 the architect Eero Saarinen became the first to specify use of the unpainted, high-strength, low-alloy steel in structural design, at the John Deere Company Administration Building at Moline, Illinois, built in 1964.)

The sculpture, made specifically for the site, is one of a series the sculptor calls "hybrids": organic, imaginative creations such as his *Why* (1975) at the University of Chicago, a tall bronze alive with curving protrusions, and the 1977 welded bronze *Cartwright Mound* playground piece in an Evanston park, a spiky, sharp-finned artwork suggesting a prehistoric animal.

Chicago born and internationally known, Hunt lives and works in his native city. His striking welded bronze *Slabs of the Sunburnt West* is located at the university's Chicago campus. Other works include those in the Metropolitan Museum of Art and the Museum of Modern Art, New York City; Howard University and the Hirshhorn Museum, Washington, D.C.; the Art Institute of Chicago; and the Museum of the Twentieth Century, Vienna, Austria. In 1971 the Museum of Modern Art held a major retrospective exhibition of his sculptures.

La Force Bailey (1893–1962) and senior art students

The Mineral Kingdom and Its Effect upon Society, 1933

Mural, oil on canvas, 8' x 43'

Map Room, 439 Natural Resources

The Depression-era mural in the Natural Resources Building map room reflects a major change of taste since Barry Faulkner had painted his four library murals some six or so years earlier. Innocuous embellishment and anecdotal classical imagery no longer appealed or seemed appropriate to a public severely affected by 1930s economic chaos, and in this canvas, as if in answer to workers' yearnings, heroic, hard-toiling men wrest minerals from the fecund earth, refine them, and put them to use for humanity's benefit. Optimism is expressed, the dignity of labor extolled, and the beauty of common folk celebrated.

La Force Bailey, an art professor, and six seniors in art prepared the 43-foot-long work for the Illinois Mineral Resources and Commodities display at the Century of Progress Exposition, Chicago, 1933–34. It shows workmen engaged in industries rooted in the natural wealth of the state—brick and tile, concrete and steel construction, coal mining and steel manufacture. It was later brought back to campus and installed in the new structure housing the geological and natural history surveys (1939). In order for it to conform to the room's smaller dimensions, modifications had to be made: twenty-four inches were cut from the central portion

Bailey and students at work on the mural

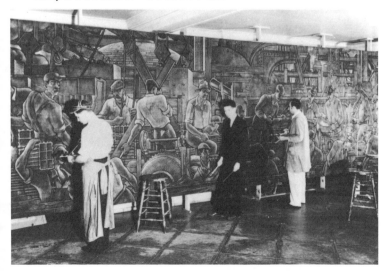

to fit around the doorway and the mural was bent at the side walls, creating three segments and diminishing the original panoramic sweep. Besides that, the four enormous fluorescent light fixtures hanging before it further limit continuity and obscure details.

Still, *The Mineral Kingdom and Its Effect upon Society* is impressive, an art object described in its time as "unusually fine," "inspiring," and "modernistic and in keeping with the rest of the Fair." Copper-hued and covering the upper half of a relatively limited space, it is a scene crowded with bricklayers, steelworkers, machinists, carpenters, coal miners, engineers, and draftsmen of diverse ethnicity, age, and race working in a tangle of blast furnaces, derricks, beams, girders, vehicles, dynamos, and locomotives.

Multitudinous activities occur simultaneously, but because of the nearly monochromatic color scheme of closely related metallic tones, the bold design's overall effect is unfrenzied, quiet. The copper tonality does more than act as a unifying agent. It underscores one of the painting's major themes: the significance of heat in transforming raw materials into fabricated products. Bailey told of the great amount of time spent arranging colors "to bring out the heat theory in full force." Heat was an element so important to the manufacturing process, he pointed out, that every object in the composition radiates it. The artist also gave much attention to the study of scientifically accurate safety and comfort equipment designated for use by factory and mine workers. For instance, in 1939 Bailey had to paint out the obsolete hats in the original version and substitute the most modern, explosion-resistant miners' electric headlamps then recommended.

On the mural's installation in Urbana, the geological survey chief noted with satisfaction that the painting reflected the greatness of the manufacturing industry and its giving rise, he said, to increased employment and higher standards of living. "The mural as an exhibit of art has been highly complimented by various artists in the country. Colors are in keeping with the mass of detail and are beautiful, and the geological survey is very proud to have the mural for its library."

Bailey studied with Charles W. Hawthorne and at the University of Illinois, where he taught from 1934 to 1960. Known among those assisting him on the mural were Richard E. Hult, who also joined the art faculty, specializing in portraiture; Harley McKee, later a professor of architecture at Syracuse University and an adviser on materials to the National Park Service; and V. S. Etler, whose painting of a steelworker hangs in a nearby fourth-floor office.

Aurora I, 1980

Welded and painted Cor-ten steel, 32' long

Acquired through Illinois "Percent for Art" program

West side, Agricultural Engineering Sciences

Although White's 32-foot-long, Cor-ten steel sculpture com-
plements its architectural setting, appearing as a fluid orange
line sweeping through space, contrasting in form and spirit
with the rather plain, factorylike brick structure behind it, it
was not designed for the site. The first of his works to be
fabricated at the Garbe Ironworks in the west suburban Chi-
cago community of Aurora (hence the title *Aurora I*), it was
originally displayed at Northwestern University in Evanston
and later shown at the Illinois Transportation Building in
Springfield, where, according to White's specification, it was
sandblasted and painted. Under the "Percent for Art" pro-
gram, the state then bought it for the university's Urbana
campus.

White uses industrial methods to bend heavy steel. For this
8,000-pound piece, workers stretched and twisted large, pre-
cisely cut metal plates into desired shapes by using overhead
traveling hoists and cables and hydraulic jacks, among oth-
er means. White particularly likes to invent ways of using the
mathematical Möbius strip, a continuous, one-sided surface
formed by twisting one end of a rectangular strip 180 degrees
and attaching it to the other end. The work "consists of two
triangular strips that take off from a single point, then reverse
to form a parallelogram," he explained. "The two triangular
members then separate and reverse themselves, turn them-

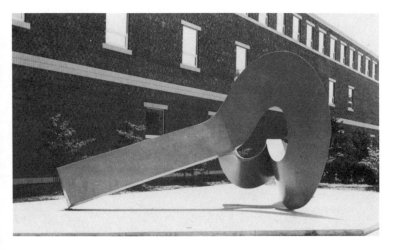

selves inside out and come back together again. Actually, they're reversed in the opposite way at the other end—if that makes sense," he said.

White earned master's and doctoral degrees from Columbia University and taught at City University, Queens College, and Adelphi University in New York; at Southern Illinois University, Carbondale; and at Florida State. Currently he is a professor of art at Northern Illinois University, DeKalb. His big commissioned works include a blue enamel aluminum plate construction for the Chicago Fire Department, Chicago Avenue and Lemon Street; a painted aluminum-and-steel sculpture at Quail Springs Mall, Oklahoma City; and an aluminum piece for the Willard Ice Revue Center, Springfield, Illinois.

Edward McCullough (1934–)

Argonaut III, 1979

Welded and painted Cor-ten steel, 11' x 24'

Acquired through Illinois "Percent for Art" program

North side, Agricultural Engineering Sciences

Illinois-born Edward McCullough, deeply impressed by four years of sea duty with the United States Navy, wrote that he related this piece to the ancient Greek story of Jason and his heroic shipmates, the Argonauts, that it forged a link between the land and the ocean he had come to know. "From the beginning stages of building *Argonaut III* I thought of it as a mythological ship at sea on the Illinois prairie. During winter storms in the North Atlantic ships can barely be seen—a jutting bow may appear, followed by a disappearing superstructure, then nothing until another glimpse (another abstract image of a ship) is visible against the heaving mass of water. So it is with this sculpture during winter storms in Illinois; and, throughout the seasons its forms imply movement into and out of the land."

McCullough uses standard welding and fabricating processes for his works in steel, a medium he finds compatible with his forms and the need for flexibility and strength. In this 24-foot-long piece, painted a cherry red consonant with the Agricultural Engineering Sciences Building's exposed stairwells, six tenuously balanced, inclined slabs of Cor-ten steel rest on a concrete base, creating interesting patterns of light and shade.

The sculptor has taught at Illinois Wesleyan University and held an appointment as artist-in-residence at Augustana

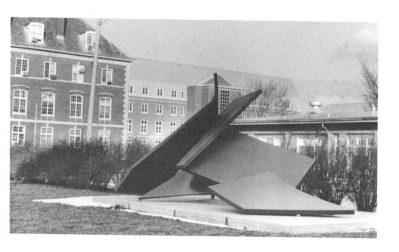

College. Examples of his work are in the Equitable Life Assurance Society of the United States, Des Moines, Iowa; Millikin University, Decatur, Illinois; University of Iowa Museum of Art, Iowa City; Southern Illinois University at Edwardsville; and Augustana Hospital, Chicago.

Buell Mullen (1901–86)

The Tree of Life and Chemical Molecular Forms Essential to Plant Growth, 1966

Stainless steel and epoxy mural, 8' x 23'

Gift 1973, International Minerals and Chemical Corporation

West entrance, Turner Hall

Buell Mullen designed and executed her 23-foot-long stainless steel and epoxy mural for the reception lobby of the International Minerals and Chemical Corporation, Libertyville, Illinois. With the building's remodeling in 1973, the piece was offered to the university and installed in Turner Hall in 1976. Ten inches had to be cut from its height in order for it to fit the cramped space, and after installation, Mullen came to touch up the design where it crosses seams between the four steel panels. So pleased was she with the university's attention to seeing the work done properly that she dispensed with her usual fee, remarking later that "it was a source of inspiration to see the great university that Illinois has become . . . may she ever increase in stature."

The mural, a complex yet uncluttered arrangement of organic and geometric shapes connected by heavily ridged bands and rods spreading across a silvery field, has as its theme "The Tree of Life." According to technical information taken from the appraiser's statement and the Turner Hall plaque, it depicts molecular forms of indoleacetic acid and chlorophyll, the two most important chemicals in the process of photosynthesis and plant growth. Ordinary molecular patterns show the structure of indoleacetic acid, the first

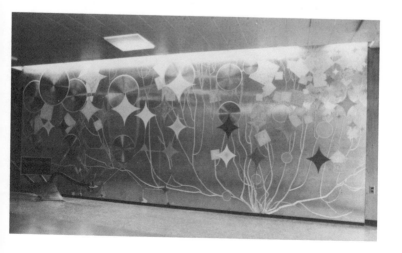

known plant growth regulator. Buffed circular discs (some as large as thirty-three inches in diameter) representing carbon atoms are linked by etched bands signifying chemical bonds. A light blue ellipse, standing for magnesium, symbolizes the chlorophyll composition. Ocher lines link the chemical structure together. Bright warm red-orange and red tetrahedrons represent carbon; light blue squares stand for hydrogen; and colorless circles mean oxygen. The plant form is shown with roots at the bottom of the composition, as in nature; branches and stems gradually become greener as they move upward toward the ceiling light fixtures, which imply sunlight. The plant structure, chlorophyll, the sun, and indoleacetic acid all denote scientific knowledge relative to the biochemistry of plants.

The artist's forms are arbitrary, not based on conventional scientific symbols. Without an explanation, even someone familiar with organic chemistry might find the mural's meaning elusive. For the uninitiated, it is likely to be irrelevant. A more fundamental message, beyond the purely aesthetic, is communicated by the mural's abstract, impersonal, mechanistic components and by Mullen's heavy reliance on technology itself.

Developing her unique method of painting on metals after eight years of rigorous experimentation—she worked on gold, monel, aluminum, copper, and chromium, besides stainless steel—Mullen learned how to accomplish a sound bond between epoxy resins and metals using a surface prepared by etching with acid. To achieve abraded and smooth textures and hard, durable finishes, she utilized electric sanders, carborundum discs, and vibro tools. Examples of her murals are in the Hispanic Room of the Library of Congress, the United States Naval Academy, the Chase Manhattan Bank in New York City, and Case Western Reserve. Metal portraits include those of President Eisenhower, General Pershing, Madame Chiang Kai-shek, and Cardinal Cushing.

Illinois Farmers' Hall of Fame, c. 1909–17

Eight portraits, oil on canvas and photograph, various sizes

Gift 1909–17, Farmers' Hall of Fame Commission

Agriculture Library, 226 Mumford Hall

Few people know that a nominal Illinois Farmers' Hall of Fame exists at the university. Except for elaborately engraved invitations to dedication exercises, some newspaper notices, a few letters preserved in the archives, and old identification labels on some of the portraits, little of its recorded history is left. Meant to be "one of the chief attractions and influences of the institution," the pictures no longer even hang together, as once they did in a fourth-floor hallway of Mumford Hall. They are dispersed now on walls of the more secure agriculture library in the same building.

The project began on October 6, 1909, when a group of prominent agriculturalists set themselves up as an informal commission to select candidates for admittance to an Illinois Farmers' Hall of Fame. Their stated purpose was not only "to give historical permanence and value to the labors of these great leaders, but by examples and instance to stimulate endeavors on the part of the younger men in order that this development so gloriously begun may proceed to its highest achievement."

Isaac Funk

Deciding promptly that the first name to be honored would be that of Cyrus Hall McCormick, the inventor of the reaper, they acquired his likeness and hung it that December. The other seven arrived in fairly regular succession until the dedication in 1917 of the last one, the portrait of Frank H. Hall, for many years an important figure in the Illinois Farmers' Institute. When in 1923 university trustees vetoed a proposal to have the university preserve "by portraits, the faces of men who have had by conspicuous achievement rendered valuable service to agriculture," the Illinois Farmers' Hall of Fame project (and the agriculturalists' commission) came to an end.

Edward J. Finley Timmons, a Chicagoan, adapted Lawton Parker's painting of Philip D. Armour for the commission. Newton Alonzo Wells, creator of the Altgeld Hall murals, depicted Benjamin F. Harris. Oliver D. Grover did the one of Frank H. Hall. The famous Chicago artist Ralph Clarkson portrayed William Parlin, but the painting disappeared with the move to the library. Unknown artists rendered three others, McCormick, Isaac Funk, and James N. Brown. The likeness of Jonathan B. Turner is not a painting but an enlarged photograph of an 1853 daguerreotype. They all deserve a better fate.

Joseph Wright Scott Memorial, 1979

Terra-cotta group with gold leaf, acrylic paint, and
stained glass, 26" high

Colwell Theatre lobby, Krannert Center for the Performing Arts

Harry Breen's vividly colored ceramic sculpture at the en-
trance to the Colwell Theatre honors Joseph Wright Scott, a
respected member of the Department of Speech and Theatre
from 1936 until his retirement in 1972. Inscribed on the base
are the words, "In memoriam—Joseph Wright Scott—teacher
and lover of the theatre 1913–1975."

Scott's doctoral dissertation dealt with traditional Japanese
Noh theater, which derives from folk mythology and reli-
gious sources. Since Noh actors frequently perform as ani-
mals or birds, the artist chose seven beasts that are typically
portrayed. He clustered them in a drum form much like
horizontal scrolls that unroll and mounted them on a ped-
estal that electrically rotates at a speed of one turn per
minute. Represented are a cat (white with blue spots), a rab-
bit (blue), a monkey (hairy and dark), a fox (orange with blue

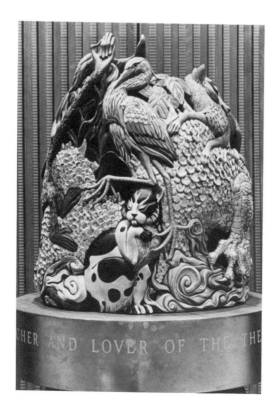

and purple overtones), a heron (gray-white with touches of lavender), a lion (blue and white, with a stag symbolic of the Scott family crest painted on its body), and a dragon (a not very ferocious creature heavily encrusted with gold-leaf scales, the inside of its red-orange stained-glass mouth seeming to "jump out," in the words of its creator).

Breen said he wanted to convey the richness of a stage presentation, creating effects that suggest brocades, hair, paint, "a highly tactile surface consisting of flat color areas contrasted with thickly roughened textures in various patterns." Color—polymer acrylic paint laid on terra-cotta after firing—is used as it appears in Kabuki theater, especially in the juxtaposition of iridescent and strong rather than low-keyed hues. The application of abundant beaten gold leaf allows light to bounce off the piece, giving it drama and focus. Light also comes into play with the stained glass, predominantly in reds and blues, that glows between plant leaves, behind the dragon's claws, and in the beast's pierced eye, where light from within shines through. According to the artist, the play of negative space becomes a visual and formal element.

Symbolic components play a part, too. Exaggerated spiraling wave forms signify clouds, a motif taken from Japanese art. The massed leaves of soybeans and corn plants allude to Scott's central Illinois heritage. His grandfather, James Robinson Scott, served as a very early member of the university board of trustees and later as mayor of Champaign.

A painter as well as sculptor, Harry Breen was a professor of art at the university from 1959 until his retirement in 1985. His work includes *Illinois Prairie/October Fields I*, a painted relief mural for the First Savings and Trust Bank, Taylorville, Illinois; large mixed-media murals for Holy Cross Church, Champaign, and for Covenant Hospital, Urbana; and the *Thomas A. Read Memorial Plaque* in the university's Mining and Metallurgy Building.

Emile-Antoine Bourdelle (1861–1929)

Beethoven: Study for a Monument, 1902

Bronze head, 24¾" high, base 15¼" high

Gift of Ellnora D. Krannert

Entrance to Foellinger Great Hall, Krannert Center for the Performing Arts

At the entrance to the Foellinger Great Hall of the Krannert Center for the Performing Arts is Bourdelle's strong, leonine bronze head of Beethoven, bent forward in intense concentration, brow furrowed, lips and eyes tightly shut, nearly black rippled surfaces catching and reflecting overhead light. The artist signed the work and inscribed on the base a quotation attributed to the composer: "Moi je suis Bacchus qui pressure pour les hommes le nectar delicieux" (I am Bacchus who presses delicious nectar for men).

The sculpture is one of a series of some fifty portrait heads, masks, and hands of Beethoven done by Bourdelle from 1887

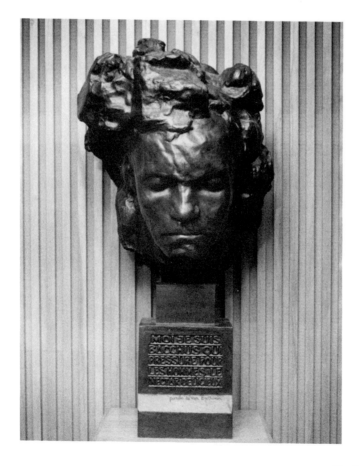

until the end of his life. Other castings of the Krannert head are in Lincoln Center and the Metropolitan Museum of Art, New York; Beethoven Hall, Bonn; and private collections. According to the Slatkin Galleries, which sold the work to the university, this cast was the third made.

Bourdelle was born in Montauban, France. He left for Paris in 1884 to study successively with Falguière, Dalou, and the great Rodin, who became a close friend as well as mentor. Finding inspiration in Greek archaic and Romanesque art, he combined the directness and simplification of those styles with something of the exaggeration of Rodin to invent an art of his own. A prodigious worker, Bourdelle created statues or busts of many of Europe's most prominent men. His greatest successes, however, were achieved with heroic and monumental works such as *Hercules Shooting the Stymphalian Birds,* the *Monument to the American Dead of World War I,* and the architectural reliefs for the Champs Elysées, Paris. The university owns other valuable Bourdelle sculptures: *The Death of the Last Centaur* at Robert Allerton Park, and the *Penelope* in the Krannert Art Museum.

2

▲

Robert Allerton Park

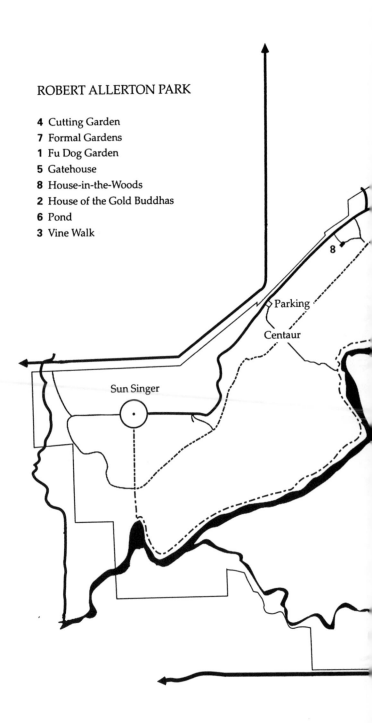

ROBERT ALLERTON PARK

Parking

Centaur

Sun Singer

8

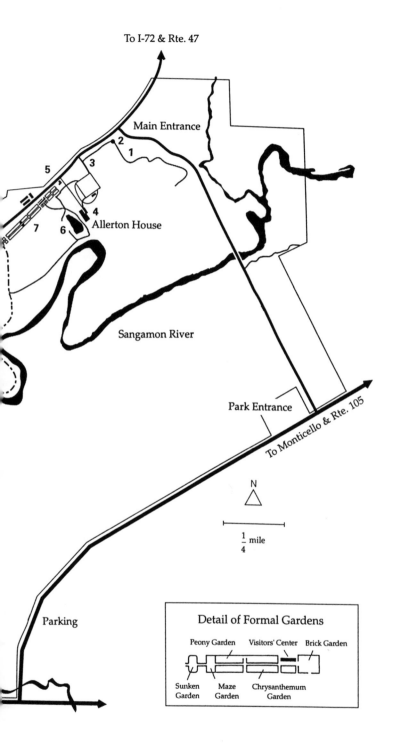

To I-72 & Rte. 47

Main Entrance

2
1
5
3

4
Allerton House
7
6

Sangamon River

Park Entrance

To Monticello & Rte. 105

N

$\frac{1}{4}$ mile

Parking

Detail of Formal Gardens

Peony Garden Visitors' Center Brick Garden

Sunken Maze Chrysanthemum
Garden Garden Garden

Robert Allerton (1873–1964) gave his 6,000-acre country estate, The Farms, to the university in 1946. Located some twenty-five miles southwest of campus near the small town of Monticello in Piatt County, the property had besides buildings, gardens, and sculpture, eight working farms and 250 acres of land designated for a 4-H camp. The indentures specified that the 1,500-acre portion that would become Robert Allerton Park be used as an educational and research resource, a forest, plant, and wildlife reserve, an example of landscape architecture, and a public park. "I am not interested in underwriting a hotel (or having the income from the farms do it)," Allerton told the university president at the time the property's practical relationship to the school was being defined. "I am still only interested in preserving the natural beauty of Illinois and that section of it which I spent so many years developing."

As a youth, Allerton had studied art at the Royal Academy, Munich, the Académie Julian, Paris, and the Art Institute of Chicago. Concluding after five years that his own painting was unlikely to attain the level of accomplishment necessary to achieve a professional career, he began instead to collect art and to develop as model stock and crop farms the 12,000 rich acres of Illinois prairie, pasture, and timber lands left him by his father, Samuel (who had made his fortune in livestock, banking, and farm property interests). By the end of his long life, Robert had handed down legacies of art to the University of Illinois, the Art Institute of Chicago, and the Honolulu Academy of Art.

He maintained a keen involvement in transforming his inherited land into a carefully planned gentleman's retreat. In the winter of 1898–99 he and his friend John Borie, the Philadelphia architect, studied buildings in Europe before Borie set plans to paper for Allerton House, the stately brick Georgian mansion modeled after Ham House, Surrey-on-Thames, England (1610). Completed in 1902, it is used now by the university as an educational conference center. Borie also designed the brick Gatehouse as a residence for the head gardener; the French Provincial House-in-the-Woods to demonstrate the practicality of hollow tile and stucco in the Illinois climate; the intimate, walled Brick Garden, which begins a series of varied gardens; and the Maze Garden, actually not a maze but a geometric pattern that Allerton liked and had copied from a design decorating his silk pajamas.

The donor garnered sculpture in the course of global travels alone or in the company of the university architecture student adopted years later as his son, John Gregg Allerton (1899–1986). Having wealth and artistic training, the older man could patronize the visual arts with a sensibility that went beyond the usual predilections of others of his class.

Robert Allerton and John Gregg Allerton in Kamakura, Japan, c. 1930

That may be seen in his commissioning of a number of choice works for the park, notably Bourdelle's magnificent *Death of the Last Centaur* and Milles's titanic figure of *Apollo, the Sun Singer.*

John Allerton fashioned the Balinese-inspired Sunken Garden, which functions occasionally as a wedding site; the much-altered and almost forgotten Lost Garden on the other side of the Sangamon River, far from the house; the long expanse that makes up the popular Fu Dog Garden; and several handsomely landscaped sculpture settings. "I really feel emotionally closer to my father here than I do in Hawaii," he once said, comparing the homes they had shared in Illinois and in Lawai-Kai, where they settled after World War II. "He created this house and we created the whole thing

from just a prairie. His spirit may be flying around here more than in Hawaii. That was a joint venture out there. . . . the dynamics of his work and everything is here."

As can readily be gathered from old photographs and a reading of documents, the park today is not what it once was. Harsh weather, vandalism, theft, and not always adequate or appropriate maintenance have taken their toll. Yet with all that, its miles of hiking trails, its extensive formal and informal gardens and open meadow spaces, its many objects of interesting sculpture located about the house and grounds still reflect Allerton's original intermingling of art and nature.

Visitors must explore shady groves and gravel walkways on foot to discover the stone, ceramic, bronze, wood, and marble statues placed about the grounds. These appear at intersecting garden paths, on lawns, at the ends of long vistas, or in inconspicuous, tucked-away spaces. Some are monumental in scale, heroic in spirit. Others function solely as decorative embellishments. Reproductions coexist harmoniously with fine originals.

In Robert Allerton's conception of his house and gardens, aesthetic considerations came before any others, and sculpture served the outdoors in much the same way that fine tapestries or porcelain animate and adorn an interior. He arranged ornamental statuary amidst greenery as essential components of the total scheme and moved them about at will. For him, apparently, requisites of authenticity or uniqueness played no significant part in the selection process. He chose what pleased him. This may be seen in replicas he had Illinois artisans make from pieces already in his possession, or in the full-scale figures modeled after small objects never meant as anything more imposing. A shift in taste is evident from the late 1920s to 1942, when he bought the last work for the property. How much John Allerton influenced him is not known, but in that period he acquired contemporary art of greater substance, size, value, and distinction for his collection.

For all the park's attractiveness, however, it would be misleading to imply that every sculptured object in it is a masterpiece or that the estate constitutes some sort of beguiling open-air museum. That is simply not the case. Many of the pieces fall into the category of garden ornamentation and have no pretension to anything grander. It is Robert Allerton Park in its entirety that should be judged a work of art— a graciously wrought assemblage of buildings and three-dimensional art objects in an environment of gardens, meadows, and wooded areas in which each element of the total composition interacts with and enhances the other.

Charioteers, c. 1924

Two limestone figures, approx. 5' high

Gift 1924, Robert Allerton

At the main entrance

Two erect stone figures, copies of a bronze *Charioteer of Delphi* made for the Art Institute of Chicago from the Greek original, stand on pillars at a park entrance. Each of the statues had just one arm at first, as does the ancient prototype, which shows remnants of an arm and a rein. But shortly after installation at the estate in 1924 the owner decided to have the remaining arms removed because, as he explained, "there was no chariot and there was this arm out, it just looked stupid." So much for art history.

With the arms gone in the park versions, the statues seem more attenuated than the original—despite their being rather stockier interpretations—as the vertical elements in the drapery stretch up to become in effect static fluted columns. This sort of artistic license lends credence to the supposition that for Robert Allerton, symmetry and balance came first and archaeological exactitude lacked relevance.

Diana and an Ephebe, before 1930

Two cast concrete figures, approx. 5' high

Gift 1946, Robert Allerton

At the Monticello Road entrance

High up on four-sided pillars, framed by trees at the Monticello Road entrance to the park, are these badly weather-damaged concrete statues representing the mythological Greek goddess of the hunt, Diana (right), and her chaste, athletic young male companion known as an ephebe (left). The loyal hounds placed at their feet lend stability and compositional weight.

As with so many of the objects in the park, these are reproductions, in this case works of English manufacture modeled after Italian baroque prototypes. They came from Allerton's friends Mr. and Mrs. Charles Pike, who took them from their own estate at Lake Forest, Illinois, to present as a gift. From the time of the figures' installation in 1930, Allerton always referred to them as "Charlie and Frances."

Sphinxes, c. 1900

Two limestone statues, 4' long

Gift 1946, Robert Allerton

In front of Allerton House

The placement of these two identical, recumbent stone crea-tures is unusual in that they look directly into the house in-stead of facing out toward the approaching visitor. In classi-cal mythology, sphinxes were most often represented as having the head of a woman, the body of a lion, and the wings of an eagle. Here they have lions' bodies, human fe-male heads and breasts, and are draped with wide sashes patterned with geometrical Greek key motifs. Ones similar to these in date and general appearance can be seen in Wash-ington, D.C., in the garden of Dumbarton Oaks and at Hill-wood and Anderson House.

John Borie practiced architecture in Philadelphia and London and was Allerton's close associate, designing Allerton House and other buildings and gardens for the estate. He was also a friend and occasional student of the great American real-ist artist Thomas Eakins, who painted a large oil portrait of him in 1896–98. It is in the Dartmouth College collection.

Terminal Busts, before 1900

Two marble statues, 6'6" high

Gift 1946, Robert Allerton

Allerton House library terrace

Two odd marble statues—partially draped, truncated, de-
mure armless female nudes on decorated, tapered shafts—
stand against the back terrace brick walls of Allerton House.
Renaissance-type figures such as these are sometimes adapt-
ed by architects for purely decorative purposes, but they
were used in antiquity as pillars to mark boundaries. Gar-
den books refer to them as "herms," for male and female
heads or figures of the Hermes type; as "caryatids," even if
they do not bear structural blocks or vases on their heads; or
"terms," standing for terminal busts or figures on four-sid-
ed columns. John Allerton described them as terminal busts,
"a rather poor name," he added, "but it's the official title."
In a 1952 memo, Par Danforth, the park's first director, attest-
ed that Robert Allerton purchased the pieces "in an antique
shop in Rome some fifty years ago. They either came from
the Pope's Villa or are copies of those at the Pope's Villa."

Glyn Warren Philpot (1884–1937)

Primitive Men, 1922

Two limestone figures, approx. 7'6" high

Gift 1946, Robert Allerton

On pathway leading from the pond to Brick Garden

When Glyn Warren Philpot was Allerton's houseguest in the autumn of 1921, he had an estate employee pose for him in order to conceptualize a figure he planned to include in a British mural commission on the birth of man. Allerton used the resultant plaster sketch, thought of as nothing more than an intermediary stage to a finished work, as the basis for these big stone statues he had a stonecutter carve the following year.

The two husky, rather blocklike male nudes push great chunks of land or rock from their shoulders as they laboriously emerge from the earth. Considering Allerton's penchant for graceful, pleasant pieces, especially in that early period, the ponderous, broadly expressed prehistoric men with rough, even crude facial features and anatomy seem anomalous. Yet the theme of human creation must have continued to interest him, for in 1924, just two years after installing the Philpot figures, he bought the "real thing," as it were: Rodin's superb bronze masterpiece of the vivifying first human, the *Adam* of 1881, which Allerton later gave to the Art Institute of Chicago—and soon after, had copied in stone for his own grounds.

Philpot enjoyed a successful career as a painter and sculptor in London after study at the Lambeth School of Art and in Paris at the Académie Julian. From 1904 he regularly exhibited allegorical subjects and portraits at the Royal Academy, and in 1927 he executed a mural for St. Stephan's Hall, Westminster. His elegant *Portrait of a Man in Black* in London's Tate Gallery is actually a painting of Robert Allerton, done on a visit to The Farms in 1913.

Marble Faun, before 1922

Marble figure, 36" high

Gift 1946, Robert Allerton

Near a path to Allerton House

Based on a Roman original in the Naples Museum, this little garden statue is located near a path leading from the parking lot to Allerton House. The sharply pointed ears, animal skin about its neck, wine sack resting on the knee, and distinctly jovial demeanor suggest a mythological reveler, which is what the figure does in fact represent. In an act of vandalism in 1958 the head and left arm were knocked off. Only the head has been found and reset. What remains of the arm is a mutilated stump.

Richard Kuöhl

Sea Maidens, 1930

Two bronze figures, approx. 6' high

Gift 1946, Robert Allerton

Flanking path to Brick Garden

The placement of Kuöhl's darkly patinated bronze figures at either side of a gravel pathway leading to the Brick Garden nicely relates them to the meditative *Girl with a Scarf* just beyond. In Art Deco style, they are mounted frontally on John Allerton's tall white fluted square columns.

Allerton commissioned the statues after seeing a similar figure done by Kuöhl in Hamburg to advertise the Hamburg-American Line, a passenger-ship company. That figure stood atop a kiosk and held a Viking longboat, but Allerton had the artist change the accessory to a bowl of plenty, more in keeping with the spirit of the sculptures' midwestern prairie destination. At first the patron thought also of having a pair, male and female, and asked the artist to work up a masculine counterpart to the kiosk woman. But, John Allerton recalled, his father turned down the proposed mate as "too static and without the grace and charm of the female."

Mirror images of each other, the maidens' lithe, pubescent bodies show under transparent drapery, their watery origins suggested by seaweed-embossed embroidery and ropey seaweed garlands. John Allerton wondered whether the male was ever made (he would have been an amusing fellow, garbed only in a derby), and described other Kuöhl work:

"We have here [in Hawaii] two small figures cast in 'clinker,' which is red terra cotta really. They were left over from a building in Hamburg called Chile Haus. I also have two bronzes of a mermaid riding a fish, also 'right and left' figures. Oh yes, and still more, ones he had done for a bank and were part of four window grilles. No wonder Kuöhl never became famous because we have so many of his creations hidden away."

Girl with a Scarf, 1941

Modeled concrete figure, 4' high

Gift 1946, Robert Allerton

In the center of the Brick Garden

Allerton bought Lili Auer's *Girl with a Scarf* at the Chicago Art Institute's annual Exhibition of American Painting and Sculpture, 1941–42, and had a special place prepared for it in the center of the Brick Garden. It was the last piece he acquired for his estate.

An agreeable addition conforming in every way to the aesthetic that Allerton established early in his years of collecting outdoor sculpture, it is graceful and unobtrusive—a rather dreamy sunbather leaning back on a coarse, peagravel-embed-

ded rock, letting a scarf arc round her slim nude body and through her legs. The smooth white silica sand surface of the figure is alive with brightness when sunshine plays on it.

Instead of modeling the work first in plaster or clay as was customary, Auer used an uncommon and difficult technique, first creating the framework for the hollow figure with iron bars and wire mesh (the armature) and then roughly troweling over it a relatively dry mixture composed of cement, fine and coarse crushed rock (aggregate), and water. Care had to be taken to keep the armature from breaking through the surface, or even from being close to the surface, as the iron oxide tends to leach through and stain the sculpture's original clean, clear appearance. Currently, the sculpture is weakened by cracks, and black lichen discolors the surface.

Auer studied at the Woodcarving Trade School and the Academy of Fine Art, Munich, from 1920 to 1930 and exhibited at the Art Institute of Chicago ten times between 1933 and 1945.

Lions, before 1922, and 1976

Four limestone statues, approx. 24" high

Gift 1946, Robert Allerton

On the path west of the Visitors' Center

Two pairs of stone lions look down from pillars at either end of a long gravel pathway near the greenhouse, one pair made before 1922 in Chicago from originals Allerton owned, the other in Indiana in 1976. John Allerton's recollection was that the prototype may have been Assyrian, but, he said, "I don't know how they were acquired. I think they must have been up against a building, a doorway, or at the base of a doorway."

Symmetrically arranged, the statues effectively demarcate a long expanse of formal garden walkway. They appear to be carved in the round. A closer inspection shows them to be very high reliefs with flattened backs, apparently once used (in their predecessor's ancient settings) as architectural decorations.

After marble original by Germain Pilon (1535–90), 1559

The Three Graces, before 1916

Limestone group, approx. 6' high

Gift 1946, Robert Allerton

Along east wall of Peony Garden

Allerton had two limestone copies of Pilon's *Three Graces* made. One adorns the east wall of the Peony Garden, on the path west of the Visitors' Center; the other is at the Lake Geneva, Illinois, grave of his aunt, Mrs. Lester McCrae.

In Greek mythology the Graces—Aglaia, Thalia, and Euphrosyne—personified beauty, charm, and grace. Associated with the arts, they were known as smiling goddesses whose presence brought joy to the world.

Pilon created the figures as elegant marble caryatids, for they supported a large gilt bronze funerary urn (by Domenico Fiorentino) that held Henry II's heart. With an inscription stating that the Graces "are holding up a heart that was once its own," they comprised a tomb commissioned by Henry's grieving widow, Catherine de Médicis, who gave it to the monastic church of the Célestines in Paris. During the French Revolution the heart disappeared. The statue and now-empty urn are displayed in the Louvre.

Partially draped in heavy, deeply cut cloth, the long-limbed figures stand motionless back to back in a circle, holding hands, poised as if ready to begin light dance movements. An engraved incense burner by Raphael and Raimondo served as Pilon's artistic source.

Pilon was court sculptor to the later Valois sovereigns, excelling at portraiture. His busts of Henry II and Francis II are in the Louvre, as is the work considered his masterpiece, the kneeling bronze of Chancellor René de Birague. He did more than create sculpture: as Master of the Mint under Charles IX he produced fine medals, medallions, and coins.

After marble original by Antonio Canova (1757–1822), 1812

Venus, prob. late nineteenth century

Marble figure, 5' high

Gift 1946, Robert Allerton

Along east wall of Chrysanthemum Garden

Probably dating from the late nineteenth century, the park *Venus* is a close copy of Canova's famous *Venus Italica* in the Pitti Palace, Florence. Allerton bought the copy from a European dealer and had it placed in a small latticed pavilion in the Lost Garden, but since the structure was torn down in the 1970s it is located now in the Chrysanthemum Garden west of the Visitors' Center, virtually obscured from view by dense shrubbery.

Ludovici I, King of Etruria, gave Canova the commission for the original figure in 1802, asking him to interpret the magnificent, almost transparent white marble *Venus de Medicis*,

which at the time was in France, having been carried off by Napoleon. (It is again in the Uffizi.) He created several versions of the subject, working on his *Venus Italica* from 1804 until its completion in 1812.

The antique model that Canova used as inspiration, believed to be a Greco-Roman copy of a Hellenistic *Aphrodite Rising from the Sea*, presented the goddess of beauty and love in a straightforward, unselfconscious manner, wholly nude and empty handed. Canova's neoclassical adaptation, however, is a free invention portraying the beautiful woman clutching drapery to her breast in a gesture both seductive and coy.

Canova exerted tremendous influence on his contemporaries, skillfully creating neoclassical reliefs and large-scale sculpture of great grace. Among his many significant works are the monument to Clement XIII (1792) in St. Peter's Cathedral, the reclining life-size marble *Pauline Borghese as Venus* (1808) in the Borghese, and a number of famous portraits of Napoleon.

After a bronze original by Auguste Rodin (1840–1917), 1881

Adam, 1977

Limestone figure, 7' high

Gift 1946, Robert Allerton

At intersecting paths west of the Visitors' Center

Inspired by Dante's *Inferno*, Rodin conceived his original *Adam* and *Eve* as figures to flank *The Gates of Hell*, a huge bronze portal commissioned for the Museum of Decorative Arts, Paris, that included 186 high-relief and freestanding dynamic figures. He never finished the ambitious work, which also included a version of *The Thinker*. The *Adam* is nude, with swelling muscles, portrayed as languidly coming to life. Indisputably it finds its artistic source in Michelange-

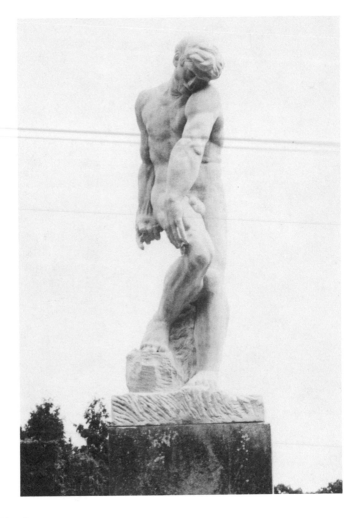

lo's twisting, massive sculptural types such as his *Slaves* for the tomb of Julius II. The actual model for it, however, was Calloux, a Parisian weightlifter reputed to be able to raise barbells of two hundred pounds or more over his head.

In 1924 Allerton purchased a bronze casting of the *Adam* from the Rodin estate and gave it to the Chicago Art Institute for its permanent collection. With the museum's consent, he then had a stone copy made for his Monticello gardens, but as it was transported downstate an ankle split and the statue had to be installed in a somewhat weakened condition. No further misfortune befell it until 1975, when a park visitor attempting to climb to the top knocked the figure over, leaving it irreparably broken. An Indiana stonemason made this version two years later. It looks crude and lacks artistic fidelity, attributable in part to the stone's being deliberately left uncut between the legs and fingers and near the right hand (which seems to possess six fingers), a decision evidently made to lend the sculpture durability and strength.

Widely acknowledged to be one of the late nineteenth century's most influential, controversial artists, Rodin produced varied and innovative sculpture of great vitality and aesthetic value, and, often, of considerable romantic poetic imagery. Among his best-known creations are his monuments to Balzac and to Victor Hugo, and *The Thinker, The Burghers of Calais, The Kiss,* and *The Hand of God.* He would not think much of Allerton Park's *Adam.*

Shepherd and *Shepherdess*, originals from the nineteenth century

Two lead figures, 49" high

Gift 1946, Robert Allerton

In front of the House-in-the-Woods

Allerton bought a pair like this one early in his residency at the Monticello estate, but because of vandalism the figure of the shepherd recently had to be replaced. He no longer holds a long shepherd's crook as he did in the original. The shepherdess carries fruit in her apron and offers an apple or peach in her extended left hand.

Similar rustic types are fairly common in English landscape decoration and even a cursory examination of books on ornamental garden statuary will turn up examples. Most are replicas of eighteenth-century statues by John Cheere. Many variations to the basic models exist, with figures holding tools, weapons, musical instruments, or even a small lamb. John Allerton was of the opinion that the first park versions dated from the early nineteenth century. They are virtually indistinguishable from two at Tyninghame, Haddingtonshire, England. Still, since so many copies are known and are in fact still manufactured, here and in England, no definitive date can be assigned.

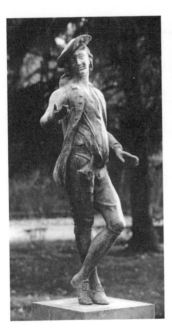
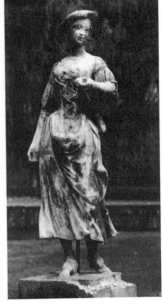

Lew Wagy (1884–1968)

The Little Shepherdess and Her Dog, 1940

Limestone, 40" high

Gift 1946, Robert Allerton

Southeast of the Gatehouse

Hidden almost from sight southeast of the Gatehouse is this unpretentious little stone shepherdess and her dog, which Allerton had Lew Wagy, a Monticello gravestone carver, adapt from an eight-inch-high German porcelain figurine in the house.

The figure is conceived two-dimensionally, much as a tombstone relief might be, and for the spectator standing off to the side, the broad-visaged lady and her alert dog very nearly evaporate into space.

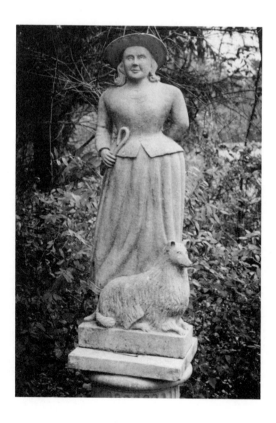

"Chinese" Musicians, 1977

Twelve limestone figures, approx. 27" high

Gift 1946, Robert Allerton

Along the path to the Sunken Garden

Visitors usually call these stone figures "Chinese" musicians, but a closer look shows that their features are Western. The present sculptures are not those Allerton bought in England early in the century. Initially he obtained ten statues cut in soft stone to use as garden ornaments; later he had Lew Wagy, a Monticello gravestone carver, make two more. For a long time all twelve stood along a wooded path in the Lost Garden on the other side of the Sangamon River, but erosion, squirrels sharpening their teeth, and acts of vandalism eventually necessitated replacement. The new group functions nicely as a "musical interlude" along the path between the Maze Garden and the Sunken Garden, but they do not faithfully reproduce details of the six different instruments shown in the English originals. According to John Allerton, those prototypes were purchased before his time and "nobody knows the history of them."

Chinese Goldfish, nineteenth century and the 1930s

Ten stone fish, 35" high

Gift 1946, Robert Allerton

Two in the Maze Garden, eight in the Sunken Garden

In 1930 Allerton bought two nineteenth-century fish fountains from a Peking dealer with the understanding that they came from a prince's garden, and he subsequently placed them in the Maze Garden. Soon after, he had eight nearly identical granite copies made for the Sunken Garden, but since these did not need to function as fountains, the water channels going through the originals were omitted. Striking in appearance, they are simplified to the point of abstraction, composed of delightfully curling tails, repetitive arc-patterned scales, playful renditions of eyes, mouths, and fins, and curved linear designs in their bases symbolizing waves.

Although edges of a wide green lawn seem unlikely locations for fish, their presence nonetheless imparts a cool underwater aspect to the gigantic illusionary "swimming pool." In the twenties and thirties, sculptured dolphins, seahorses, fish, and mermaids cavorted in America's most elegant gardens, ponds, and fountains, sometimes sharing space with incongruous bulls, elephants, and polar bears. A taste for such

creatures was evident in nearly all decorative arts of the period, and they appeared in the most utilitarian and modest of objects as well as in grand-scale mural designs.

After sculpture at Nagoya Castle, Japan, seventeenth century

Japanese Guardian Fish, original copies c. 1931

Sixteen gilded bronze fish, approx. 40" high

Gift 1946, Robert Allerton

In the Sunken Garden

On pylons in the Sunken Garden, looking very much like glittering sea creatures diving into a vast subterranean world, surfaces modeled in wonderful deep and shallow designs, teeth huge and fearsome, are sixteen guardian fish, reduced-scale versions of originals at Nagoya Castle, Japan. Several are recent reproductions necessitated by theft, but most are the original bronzes covered by three layers of gold leaf (now badly worn) that Allerton had made by Yamanaka and Company, Tokyo.

Representations of these mythological, scaly-armored aquatic fire protectors, called *shachi*, were used as roof ornaments in Japanese palaces and castles, and until its destruction in World War II, Nagoya Castle possessed the most famous pair: a male and female mounted atop the high inner tower, first created in the seventeenth century and remade several times, in 1726, in 1827, and again in 1846. (The castle, built c. 1610, was reconstructed in 1959.) The postwar versions are of copper covered with eighteen-karat gold mixed with bronze, but the nearly nine-foot-high originals were of wood plated with lead and then encased in a layer of gold.

Emile-Antoine Bourdelle (1861–1929)

The Death of the Last Centaur, 1914

Bronze sculpture, 9'9" high

Gift 1946, Robert Allerton

At intersecting paths west of the Sunken Garden

The eminent French artist Bourdelle, regarded by many of his contemporaries as the greatest sculptor of his generation, himself thought *The Death of the Last Centaur* the "summit" of his achievements. He showed it first in plaster at the Salon of 1914 and in bronze at the Tuileries in 1925. Smaller versions of the work exist, but only five others identical to it were cast (although an edition of ten was planned, according to Mme. Bourdelle). Allerton bought his directly from Bourdelle in his Paris studio shortly before the artist's death in 1929. The university is fortunate to own it.

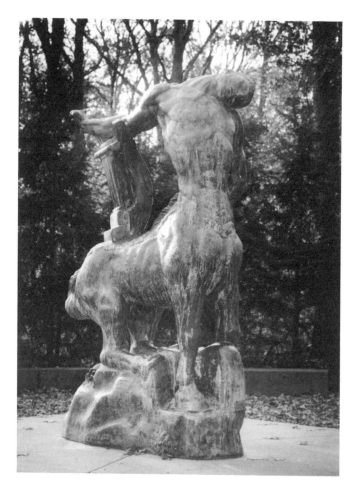

In large block letters at the front of the statue's base is the inscription "La Mort du Dernier Centaure," and at the lower right side, "Emile Antoine Bourdelle 1914." Greek mythology furnished the subject matter, but its more profound, symbolic meaning—the end of paganism; the centaur is dying because no one believes in him anymore, the artist said—is emphasized in John Allerton's stark, extraordinarily fine landscape setting.

Located in a circular clearing in the forest some distance to the west of the Sunken Garden, the pathetic form of Chiron, the last centaur, is set at viewer's level on a low, spreading octagonal base. Four plain benches define the space, and four perfectly straight, broad walkways radiate out to form a distinct cross. At the ends of these paths, four hundred feet away yet still visible from the statue, are four white concrete rectangular pillars, each twenty-two feet tall, surmounted by large cast-iron Swedish urns. To complete this evocative environment, three evenly spaced rows of hemlocks form a background enclosure to the columns and benches—the entire scene conjuring up images of a clandestine, mysterious rite, at once primeval and Christian.

Chiron taught ethics, music, and medicine to many mythic Greek heroes, had friendships with humans, and was one of the few centaurs celebrated for wisdom and kindness. When wounded accidentally by a poisoned arrow of Heracles, he brought his suffering to an end by exchanging his own immortality for the mortality of Prometheus.

Bourdelle shows that awesome moment of Chiron's death, as the contorted, pained body—right arm stretched across the lyre he will play no more, hind legs caving in under the muscular, collapsing weight—sinks to the ground. In the exaggerated angle of the nearly horizontal head resting on the shoulder and in the tranquil facial expression, a serene death is suggested, one recalling the dead Christ of Romanesque crucifixes.

The park sculpture was made with gold embedded in the bronze, a process now forbidden because of hazards to foundry workers. Gold can be seen in glinting flecks in the finely burnished surface. It breaks up the dark green mass and creates a lively, sparkling effect. In 1963, a park administrator made a serious proposal to gild the centaur, which would have destroyed the patina—not to mention the integrity of the work. Happily, nothing came of it.

Another of Bourdelle's fine works, the Beethoven head, is displayed at the entrance to the Foellinger Great Hall of the Krannert Center for the Performing Arts on the university's Urbana-Champaign campus.

The Sun Singer, 1926; this casting, 1929

Bronze sculpture, 15'2" high

Gift 1946, Robert Allerton

Sun Singer Meadow, at west end of Robert Allerton Park

Carl Milles created three colossal *Sun Singer* statues: one in Stockholm, commissioned in 1919 by the Swedish Academy of Sciences to honor the influential poet-patriot Esaias Tegner (1782–1846), who did so much to bring Norse sagas and Scandinavian literature to the public; another in National Memorial Park south of Falls Church, Virginia, in the Washington, D.C., area; and this one at Robert Allerton Park.

Tegner's prolix romantic poem "Song to the Sun" abounds in references to ghosts, angels, vassals, warriors, avengers, and the Almighty. But for his tribute Milles chose Apollo, the Greek god of the sun, music, poetry, and civilization, depicting him as a nude youth greeting the radiant morning sky with song and extended arms. On his helmet is the rearing horse Pegasus, and under his right foot, the tortoise, an al-

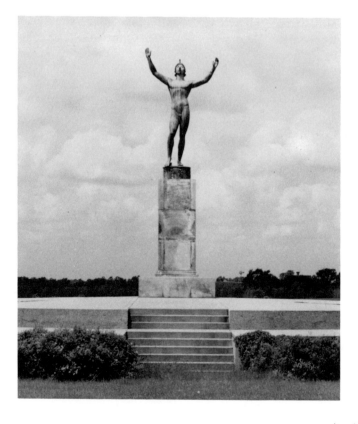

lusion to the first lyre, made of tortoise shell by Hermes and given to Apollo. On the base, in the archaic Greek style popular in the 1920s, are draped and nude figures rendered in low relief—the nine Muses often associated with Apollonian festivities: Euterpe, the muse of music and lyric poetry; Polyhymnia, oratory and sacred poetry; Urania, astronomy; Clio, history; Thalia, comedy; Melpomene, tragedy; Terpsichore, dance and choral song; Erato, love poetry; and Calliope, epic poetry.

Allerton saw the first *Sun Singer* on the Stromparterre overlooking the Stockholm harbor in 1929 and personally sought out Milles in his suburban Lidingö studio to commission a reduced-scale version for himself. Misunderstandings about size, however, developed because of language difficulties, and when this spectacular figure in all its enormity arrived from Sweden, John Allerton remembered that he and his father were "flabbergasted." Scrapping their plan to put it close to the house, where the Apollo would have seemed to be looking directly into a second-story window, it was set in 1932 in a wide circular base surrounded by low shrubbery in the dramatic isolation of an enormous meadow at the farthest end of the estate. Two farmhouses had to be moved to provide an unobstructed site. Both the landscaping and base, an adaptation of the symbolic Altar of Heaven in Peking, are John Allerton's designs.

Milles wrote feelingly of his sculpture in Illinois some years later. Asking Allerton if photographs of the *Sun Singer* could be obtained for him, he said, "I need 6 of the statue against the clouds and I need 6 with the whole setting which I think is magnificent—the most beautiful setting I have ever seen—except how the Chinese have done with their works. They ask me from London, two different art writers from Paris—Prague and Stockholm and I wish to show them how you have understood to do that outstanding way of placing a statue in our time. I hope this bronze will stay there in that way till the last man has gone—when the earth is as dead as the moon—and still this is there. Such a dream!"

John Allerton deserves credit for the outdoor arrangement, of course. As for Milles's dream, despite park motorcyclists, sharpshooters, and the graffiti-obsessed, the *Sun Singer* does still retain all its vivid beauty and immense popular appeal.

The university possesses another Milles masterwork, the bronze and marble *Diana Fountain* that once graced Chicago's Michigan Square Building. Due to the efforts of alert, generous alumni, it is situated now in a lovely courtyard just west of the Illini Union on the Urbana-Champaign campus.

Unknown artists

Fu Dogs, nineteenth and twentieth centuries

Twenty-two blue ceramic, one green ceramic, and two in granite, approx. 29"–36" high

Gift 1946, Robert Allerton

In the Fu Dog Garden, the Cutting Garden, and at the end of the Vine Walk

Mythological lion-dogs such as these are ubiquitous in Asian art, found in cemeteries, temples, shops, and domiciles and utilized traditionally as Buddhist guardian effigies to ward off demon spirits. Fabricated of materials such as stone, wood, ivory, and terra-cotta, they appear with variations of fringed manes, long hairy ears, spiraling tails, ornamental eyebrows, curved horns, broad square muzzles, enormous globular eyes, and upcurled wide mouths that suggest laughter rather than ferocious snarls. Often they are shown with playful cubs and brocaded balls representing sun spheres. Their image combines features of Pekingese pug dogs (known commonly as *hsiao kou,* small dogs) and long-haired lion dogs (*shih-tzu kou*).

Possibly most appealing of all park art objects are the twenty-two lustrous, gorgeously colored lapis-lazuli–blue ceramic Fu Dogs that Allerton purchased in pairs from European and American art dealers and in 1932 had placed in a specially designed garden. Considering their similarity in size, overall look, and hollow construction, they may well have been created for the export trade in the same factory. They are very like each other, differentiated only slightly by spots or blazes on their foreheads, by their white or blue beards, by nuances in modeling, and in the treatment of tails and ears. "The Chinese craftsmen who made the dogs did not try to make exact duplicates," professor of art Donald Frith explained. "Each was unique and had several imperfections, giving the impression they had been made somewhat hastily." Not all in the garden now are originals. Because of theft and winter freezes that cause great damage, Frith was called upon to reproduce four. It is impossible to tell which four.

As for the other Fu Dogs in the park, the two of granite on high pedestals at the end of the Vine Walk near the House of the Gold Buddhas are of Korean origin. The green ceramic dog in the Cutting Garden behind Allerton House is notable for its unusual crouching position; but it is notorious too, for the repair given it by untrained park personnel after thieves dropped and extensively broke it—a "restoration" one art faculty member described as "a three-dimensional nightmare."

Siamese Buddhas, c. 1930–31

Two polychromed teak figures, approx. 8' high

Gift 1946, Robert Allerton

In the House of the Gold Buddhas

Amazingly, these two slim, delicate images of Buddha were fashioned from single logs of teakwood. Students of the Royal School in Bangkok, Thailand, made them from prototypes Allerton selected in nearby wats (Buddhist monasteries or temples), waiting for two years for the wood to season properly before embarking on the project.

Standing solemnly under multi-tiered parasols of brass like those traditionally part of a Thai crown prince's regalia, the figures are attired in customary monastic garb, the *uttarasanga*, a simple clinging, draped cloth reaching almost to the ankles. Because Thai religious iconography attaches exceptional importance to stance and gesture, the Buddha with arms bent up at the elbows and both palms turned out toward the spectator signifies "calming the waters" and is meant to dispel fear and give protection. The other Buddha, his right arm placed diagonally across the chest to his opposite shoulder and his left hand holding up his garment, is in a pose not specified in any of the standard sources for Buddhist imagery.

The figures' firm, upright, frontal attitude conforms to the requisite "feet with level tread" in Buddhist Sanskrit and Pāli canonical texts. Other conventional signs identifying the Buddha include long fingers and toes, a complexion the color of gold, delicately smooth skin, a divinely straight frame, blue-black hair in little curling rings, intensely blue eyes (the original mother-of-pearl is intact here), and a head like a royal turban—all particulars met in both Allerton statues.

Gently curved shapes and plain costumes contrast with decorative, linear patterned bases and lacy, filigreed parasol bands. Headdresses are elaborate too, consisting of arrangements of small, tight haircurls extending into mounds forming what is known as the *ushnisha,* surmounted in turn by flame finials called the *rasmi.* The characteristic spiraling ringlets allude to the legend of the grateful snails that formed a helmet over Buddha's skull to protect him against the sun's burning rays. The cranial protuberance conventionally signifies "a bump of wisdom on top of the head." The flame-shaped ornament emanating as a ray of light symbolizes Buddha's power and glory. Lastly, the elongated earlobes, split and distended in a custom still practiced in southern India, denotes Buddha's rejection of royal ornaments.

After seventh-century Cambodian model

Hari-Hara, 1934

Limestone figure, 6'5" high

Gift 1946, Robert Allerton

In the House of the Gold Buddhas

This stone figure represents a composite Brahmin god, Hari-
Hara, and is a copy of a seventh-century stone statue in the
Musée Albert Sarraut in Phnom Penh, Cambodia. Robert
Allerton had the copy made from a plaster cast he purchased
at the Musée Guimet in Paris and later presented to the Chi-
cago Art Institute. All four arms are mutilated as in the orig-
inal Cambodian work, but the Illinois carver left the rough
stone between the legs and corrected the broken ankles and
feet, probably to give the sculpture additional strength.

The image of the Hari-Hara resulted from the fusing of two venerated gods into a single divine being in an effort to reconcile followers of different cults. The idea of a continuously enduring, dynamic life force is conveyed in this deity: preservation and destruction are made one by merging the traits of Hara (the popular name for Vishnu, creator and maintainer of life) with that of Hari (which stands for Shiva as the decaying process in nature). According to tradition, the figure is simultaneously a perfect, sacred idol, a master yogi, and a portrait of a prince or king.

His countenance suggests an air of concentration and perpetual serenity. The high cylindrical headdress is divided vertically down the center to indicate Shiva to the left (for the spectator looking at the figure), and Vishnu to the right. Its decorative pattern symbolizes Shiva's matted hair ritualistically spiraling in left-to-right ringlets, while the plain crown bordered by a band of flowers is part of Vishnu's usual costume. At the center of the forehead is the curved mark (*urna*), the "third eye of spiritual wisdom." The mustache, eyebrows, distended earlobes, and thin, clinging short sarong draped over the strong, nearly nude body are rendered in simple lines. Based on attributes shown in ancient times, the four missing hands might have held items such as the conch shell, sundisk, wheel, club, mace, battle-ax, spear, or trident.

Bear and Man of the Stone Age, 1885
Gorilla Carrying off a Woman, 1887

Bronze groups, 8' and 6'8" high

Gift 1959, Stacy B. Rankin

In storage at the park, awaiting permanent installation

These statues came to the Urbana campus by mistake with the purchase of the contents of Lorado Taft's studio in 1937. After years of being kept in storage and following prolonged negotiations, they were donated to the university in 1959 by the heir of the original owner. On display since then in the park's woods, in the Krannert Art Museum, and in a major four-city national traveling exhibition, The Romantics to Rodin, they are back again in storage awaiting permanent installation in Allerton Park. These important works are included in this guide against the day when they will again be on view.

Beautifully realized in bronze by the accomplished French sculptor Emmanuel Frémiet, the two powerful groups represent a standard of late nineteenth-century academic and popular taste that favored works contrasting bestial force with human figures of grace and vulnerability: angry beasts acting in accordance with their animal instincts, victims as well as perpetrators of terrifying violence, statues at once repulsive and sentimental.

When Frémiet first showed *Bear and Man of the Stone Age* at the 1885 Salon in Paris, it was made of plaster and listed in the official catalogue as *Ours et Homme de l'âge de pierre*. But to make the deadly serious subject matter wholly unambiguous, as if somehow in the abundance of telling details the story might somehow be misunderstood, the artist imprinted the words "Denicheur d'Oursons" on the statue—literally "Snatcher of Bearcubs from Their Nest." Besides our original bronze, another cast of the same size is at the Jardin des Plantes, Paris, where children enjoy climbing over it.

No decorative statue this, the tragic scene captures a moment of raw jungle justice in which all participants die helplessly. The cub, a pathetic, humanlike corpse, hangs by a tight noose from the burly trapper's belt. The trapper's closed eyes, claw wound, and last gasping breath herald an imminent demise. The furious mother bear, mortally wounded by the heavy dagger thrust in her throat, roars mightily and retaliates in a crushing death squeeze.

The *Gorilla Carrying off a Woman* won a gold medal when displayed in plaster at the 1887 Salon. An earlier version of the same subject, but with a female gorilla dragging off a cadaverous woman, caused a sensation at the 1859 Salon. According to one Frémiet biographer, "emotional workmen, mostly Belgian with childlike minds," deliberately destroyed it when transporting it back to the artist's studio. The sculptor cast three other bronzes like the one at the park; they are in the Menagerie of the Jardin des Plantes and in the museums of Nantes and Melbourne.

A slithering snake at the statue's base is the only element in the overstated drama that might be construed as symbolic, since its association with evil is generally recognized. The hapless woman—attired only in a furry loincloth (very like

Bear and Man of the Stone Age

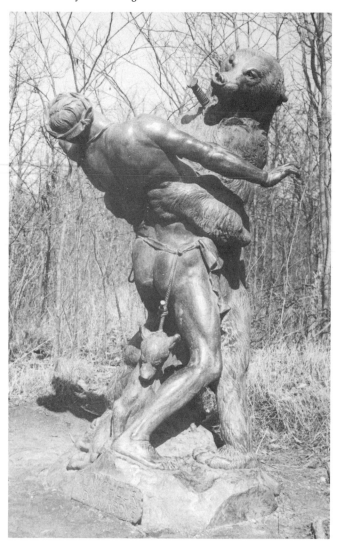

Gorilla Carrying Off a Woman

the gorilla's own coat), her hair adorned with a large gorilla jawbone with teeth intact, a decorative amulet, and another ornament primitively carved with a face—feebly tries to push her vengeful abductor away. In the sculpture's original state, an arrow dangled conspicuously under the animal's shoulder, but it has long been lost.

Frémiet's considerable reputation arose from the anatomical accuracy of his works and his attention to archaeological details, his innovative techniques in rendering life-size animal groups, and his successful selling of copies and reproductions. Among his major works are the *Wounded Dog* in the Louvre, *Faun Playing with Bear Cub* in the Luxembourg, a gargantuan *Elephant* in the Trocadéro, and the gilt-bronze *Joan of Arc* in the Place des Pyramides.

3

●

*The University of Illinois
at Chicago*

CHICAGO CAMPUS

WEST SIDE

8 Campus Health Services, 914 S. Wood
5 Clinical Sciences, 840 S. Wood
3 Clinical Sciences North, 820 S. Wood
7 College of Dentistry, 801 S. Paulina
2 College of Medicine West, 1819 W. Polk
6 College of Pharmacy, 833 S. Wood
1 Library of the Health Sciences, 1750 W. Polk
11 Lions of Illinois Eye Research Institute, 1905 W. Taylor
4 Medical Sciences South, 905 S. Wolcott
9 Neuropsychiatric Institute, 912 S. Wood
10 University of Illinois Hospital, 1740 W. Taylor
12 University of Illinois Hospital Eye and Ear Infirmary, 1855 W. Taylor

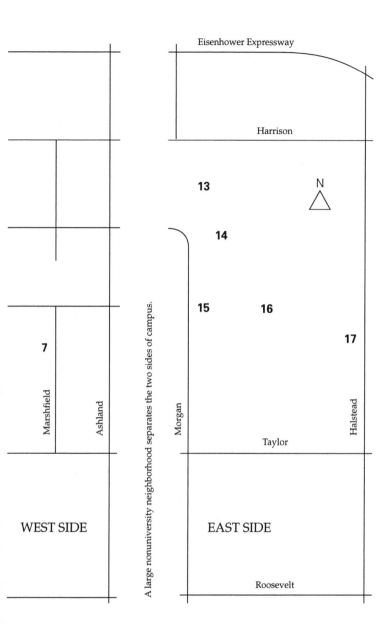

Eisenhower Expressway

Harrison

13

N

14

15 **16**

17

Morgan

Marshfield

Ashland

Halstead

A large nonuniversity neighborhood separates the two sides of campus.

Taylor

7

WEST SIDE

EAST SIDE

Roosevelt

EAST SIDE

17 Jane Addams' Hull-House, 800 S. Halstead
16 Lecture Center, 803 S. Morgan
15 Library, 801 S. Morgan
14 Stevenson Hall, 701 S. Morgan
13 University Hall, 601 S. Morgan

The University of Illinois at Chicago (UIC) was created in 1982 by the merger of the Medical Center and Chicago Circle campuses of the University of Illinois. As the two units evolved in very different ways, they are literally split down the middle by remnants of a vast and diverse historical neighborhood. Roots of the Health Sciences Center, to the west, go back to when the Chicago College of Pharmacy (founded 1859) and the College of Physicians and Surgeons of Chicago (1881) affiliated with the university as its medical department in 1896. The Health Sciences Center is within the west-side medical center district, the world's largest and most advanced concentration of public and private health care facilities. Chicago Circle's history began at Chicago's Navy Pier in 1946. Mainly a two-year undergraduate unit for returning war veterans then, it served more than 100,000 students before the present full-service campus on the east side opened in 1965. Today the university in Chicago is an important research institution, with professional and graduate students making up a third of its 25,000-student enrollment.

Forming UIC's single largest concentration of art are the murals, sculptures, frescoes, mosaics, and window designs made expressly for the medical school by federally funded Works Progress Administration (WPA) artists of the 1930s. Since 1977 the acquiring and curating of art for all campus units has been under the aegis of the Arts Study Collection, administered by the Department of Art and Architecture. Jane Addams' Hull-House, acclaimed for many decades as a sanctuary for Chicago's poor immigrants, also figures in the story. The university owns and operates it as a memorial to the founder and, in the process, preserves and displays noteworthy period art objects as well as art produced at Hull-House.

WPA/FAP Art at the Health Sciences Center

Imaginatively responding to grim economic times brought about by the Great Depression, Congress in 1933 initiated what was to be an alphabet soup of emergency relief agencies to foster employment and purchasing power. New Deal projects put needy people to work on roads, bridges, dams, and forests and, in a series of dynamic ventures unprecedented in American history, gave jobless artists assignments to embellish post offices, libraries, schools, courthouses, hospitals, community centers, and other public buildings. The government became a patron, a veritable promoter of the arts.

The Works Progress Administration Federal Art Project (WPA/FAP) became the most renowned and influential of all culture programs. Lasting from August 1935 through June

Dedication of *The Spirit of Medicine Warding Off Disease*, c. 1935

1943, when the war effort brought it to an end, it employed some five thousand people at its peak and cost some $35,000,000. Experts and beginners alike participated in innovative theater, music, opera, writing, and visual arts divisions. A very small percentage of professional or technical staff, not on relief, taught, directed, and did research. Sponsoring institutions paid for materials and could veto choices of subjects or designs. In art centers, classes, and galleries, in public places all across the nation, a host of people who never before had access to original art saw and learned and were affected by it.

Critical reaction was mixed. The *Chicago Tribune* saw WPA art as subversive, too abstract, churned out by "lazy" "social misfits" who couldn't get jobs otherwise. Some objected to tax money's being spent on "bum amateurs" and their "disgusting junk." But many like Robert Harshe, director of the Chicago Art Institute, thought differently. "The Federal Government in suddenly becoming the greatest patron in the world has contributed incalculably to the rise of American art," Harshe proclaimed. "Not only has the project itself expanded in many useful social directions, knitting itself more and more into the life of Chicago, but under it, individual artists have developed and grown to maturity."

Artists found the government projects the most exciting place to be. They could emerge from their isolation, share experiences, experiment with styles and themes. Rather than being considered outsiders or bohemians, many for the first time found themselves valued by their country, respected for their accomplishments. "It was an absolutely crazy time, and we were all young and full of energy," recalled Rainey Ben-

nett, supervisor of the University of Illinois's medical school FAP section. "Even if you didn't need the money, you tried to get in. We all felt part of a grand adventure."

Bennett's "mini-project" group of sculptors, painters, designers, plasterers, stonecutters, janitors, and timekeepers "settled in the tower above Macroscopic Anat. [Anatomy] sometime in 1935," he said. Because they received union wages, careful watch had to be kept to see they did not go over budget. "We (from twenty to thirty people) painted some of the murals, schematic panels, etc. in the tower. Many other works were done in artists' studios. Edwin Boyd Johnson's frescoes, for instance. Thomas League worked on his precious object in the tower. Thomas used paper towels to open the elevator door. The elevator in the tower was smack in the middle of macroscopic dissection and he felt leery. A couple of our people wouldn't come up at all. . . . Dr. Maurice Visscher wanted schematic panels of dog experiments. We did a nice clean job. Dr. Kampmeier gave us a four-page list of themes for the windows. It all came through Tom Jones, of course. He was liaison and a great one." Bennett went on to remark on media response to the project: "The *Tribune*, of course, was satirical. 'Artists Bone Up On Anatomy' was one comment. Boondoggling, I suppose."

That was a notion shared by some at the university too, and Tom Jones, its famous medical illustrator and teacher, gingerly went about gaining administrative approval and funds for materials. In early 1938 he apprised the medical school dean, David Davis, of Edouard Chassaing's plan to create two stone statues of "impressive size" for archways between the library and hospital. "The subjects tentatively chosen are Aesculapius and Hygeia. The treatment and handling of the work would be in very capable hands and carving would not be begun until large preliminary clay models have been approved by us. In my opinion," he added, "these figures would be an important addition to our campus and since the cost [$400] to the University would be so low in proportion to what we would gain, I heartily recommend the project to your consideration." To William Day, the dean of pharmacy, Jones sent a similar letter, listing murals, carvings, sketches, portrait paintings, and special decorations already underway. Dean Day in turn immediately communicated with the physical plant department in Urbana (which handled such matters), to ask for a special fund of $200 to continue the work; he had authorized an expenditure of $37.50, he said, for sketches of proposed permanent decorations for his college, but his budget could not spare any further appropriations.

A testy note arrived the next day from Ernest Stouffer, the university's chief architect. While he heartily approved of murals "where we have full choice in selecting the artist we

believe will give us the result we desire, and with whom we can confer as the work develops," he emphatically stated his opposition to "a program of made work for distressed artists (leading artists are not on relief) over whom we have no control as to selection, subject matter, or selection of application, and whose product we are regrettably to hang regardless of results. I am rather afraid that any blank wall appears to them as a proper place for application of murals," he continued. "Should not this department have been consulted before this work reached the stage it has? . . . Can you justify the expenditure in view of the numerous other demands on the Minor Improvement Fund? P.S. There have been some delicate situations created through the work of this group of artists."

President Willard, obviously influenced, dispatched a reply to Dean Davis and Dean Noyes (of the College of Dentistry) about the statues they wished placed in the archways adjacent to the medical library: "While the statues are desirable, I think we could use the money to better advantage for other purposes at this time, especially since there are so many demands on the University budget for necessary minor improvements and extensions. I hardly see how we could be justified in spending money for statuary, even though the amount is small."

We do not know the exact appropriations provided. We do know that Chassaing's heroic figures still stand, albeit eroded by time, in their original courtyard archways, and that League's historical panels, intended for unknown architectural spaces, presently decorate two Pharmacy Building basement lecture halls. Whether the university got its money's worth, contemporary viewers will have to judge for themselves.

The Arts Study Collection

From its inception in 1977 on the east side of campus, the Arts Study Collection (ASC) was intended to play a role on the west side as well. In fact, as early as 1964 the first dean of architecture and art and the two chancellors of the brand-new University of Illinois at Chicago Circle and the long-established Medical Center appointed a committee on art objects.

The primary aims of the ASC are to support the curriculum of the university, to humanize the environment by placing works in public and office spaces, and to collect items other local institutions are not now purchasing, notably objects of interior or industrial design, Chicago artists of the twenties and thirties, or other American art not readily available or accessible. These aims reflect certain advantageous conditions within and outside the university. With the Art Insti-

Richard Koppe, *Yellow Directional*, first floor, Library of the Health Sciences

tute of Chicago barely five minutes away by subway, and the wealth of museums and galleries in the Chicago area, UIC has not felt it necessary to create the sort of comprehensive art museum traditional at many universities.

On campus, the university library enhances the mission of the ASC. It possesses substantial collections relating to Chicago art before 1950, such as the 1933 Century of Progress papers and a wealth of archival materials connected with the history of architecture, urban planning, and design, notably those of the Institute of Design (now IIT), the school rooted in the Bauhaus that was founded in Chicago by the designer László Moholy-Nagy. The Albert Reese Collection boasts graphics by artists such as van Leyden, Callot, Degas, Maillol, Bonnard, Ensor, Rouault, Pennell, Homer, Bacon, Levine, and Bellows. In 1986 the library established the R. Hunter Middleton Chicago Design Archives.

Some might question if indeed the earliest gift to the east side of the campus, while UIC was still located at Navy Pier, should even be called art. In 1950 a loan collection of about sixty (chiefly bronzed) replicas of ancient sculpture was transferred to the university by the School of the Art Insti-

tute of Chicago. These plaster casts, useful to generations of art students learning to draw and to look at the art of the past, are precious relics from the World's Columbian Exposition of 1893, where they were displayed in the Italian Government Pavilion. They now dot university offices and waiting rooms.

Even more important from an historical point of view are two *ramma* (carved openwork transoms) from the Japanese Pavilion at the 1893 exposition. Removed from the pavilion for cleaning (along with two others owned by the Art Institute) during World War II, they are all that remain of that historic exhibition building, which was otherwise destroyed by fire.

A suite of furniture designed by Frank Lloyd Wright in 1914 for S. H. Mori, a dealer in Oriental art, has been the collection's most significant contribution. It consists of desk, work table, chairs, stools, plant stands, easels, and display cases. Currently, because the university lacks appropriate facilities for exhibiting or storing the group, the furniture is on long-term loan to the Frank Lloyd Wright Home and Studio in Oak Park.

There are also designs by another Chicago-based world-renowned architect, Louis Sullivan. When the old Stock Exchange was demolished in 1974, the City of Chicago transferred to the university a sixty-foot-long, eighteen-foot-high section of the attic story and cornice of the building, which, perhaps more than any other, stirred public consciousness about historic preservation. This large fragment, for lack of funding, was not erected on campus, as intended, but lies in pieces in a parking lot. Also in storage are terra-cotta fragments of an earlier Sullivan masterpiece, the Meyer Building. Elevator grilles from the old Chicago Stock Exchange are on view in the health sciences library and in the lobby of the College of Dentistry.

While fragments of architecture and furniture by famous architects seem especially appropriate in Chicago and in a university with a school of architecture, they are only a small part of the Arts Study Collection in terms of numbers. The majority of objects displayed or in storage relate to the work of three former members of the faculty of the School of Art and Design: Richard Koppe, John Walley, and Robert Nickle. All had close ties to Moholy-Nagy at the Institute of Design. Many of Walley's surrealist and abstract works, which date from the early thirties to the late seventies, enliven bare walls throughout the university, and his papers are in the library.

Bought and framed with funds provided by the Health Sciences Center Auxiliary are a number of drawings, sculptures, and paintings in conference rooms, offices, and clinics on the

west side of the campus. Among the important names represented are Dali, Agam, and Christo. The auxiliary also commissioned two Nicholson tapestries and Samter's bronze abstract sculpture, placed in the hospital lobby, and Richen's big bronze and Cor-ten steel work, in the plaza near the building. A large group of works by avant-garde artists of foreign birth working in Paris after World War I (the School of Paris) and other artists commonly shown around Chicago and suburban galleries was given to the university in the years 1983–85.

Jane Addams' Hull-House

Jane Addams' Hull-House is at the east edge of campus, on Halstead at Polk Street. Designated a National Historic Landmark and a Chicago Landmark as Chicago's first settlement house, it is made up of two architecturally distinguished, meticulously restored original buildings that now serve as a museum offering educational programs to the general public. Topics relate to the life and work of its founder, Jane Addams (1860–1935), the American social worker and leader in woman suffrage and pacifist movements, the many notable people who aided her, and the settlement's history as an immigrant community and labor welfare center.

Hull Mansion, built in 1856 and occupied by Jane Addams in 1889, is a gracious and lovely example of Italianate architecture of the 1850s. With hand-carved woodwork, floor-to-ceiling windows, and marble fireplaces in each room, it is one of the oldest and finest examples of surviving residential Chicago architecture. Next door is the residents' dining hall, built by Jane Addams in 1905 as a communal dining center

Jane Addams' Hull-House

for colleagues. Designed by the architects Pond and Pond, its detailing reflects Arts and Crafts influence.

Hull-House contains restored rooms, exhibits, artifacts, documents, and memorabilia. On permanent display are numerous examples of artwork produced by members of the staff. Included are several oil paintings and pastels done by Enella Benedict, head of Hull-House Art School for more than forty years; woodcuts, etchings, and paintings by Hull-House teachers William Jacobs, Morris Topchevsky, Carl Linden, Frank Hazen, and Nora Hamilton; and a large oil of an Italian woman and child done by a Hull-House friend and associate, Alice Kellogg Tyler. In addition, there are striking works of pottery, woodwork, metalwork, and textiles produced by community residents.

Also on exhibit are several paintings and drawings of Jane Addams, most notably a beautiful oil portrait by George DeForest Brush (1910). Photographs include a remarkable series of 1920s and 1930s images by Wallace Kirkland, a nationally known photographer for Time-Life who worked at Hull-House as a social worker in his early years.

The History of Anatomy, 1938

Eleven simulated stained-glass windows; 9" x 12" panes
WPA/FAP

Anatomy Museum, 618 College of Medicine West

The Anatomy Museum's simulated stained-glass windows picture historical aspects of the study of human anatomy. Dr. Otto Kampmeier, head of the anatomy department, planned them with the designer, Ralph Graham. They are presented singly or grouped in triple panels and have illustrations that derive mainly from old manuscripts and books. Three un-identified WPA assistants worked on their execution.

Painted in glowing, translucent oil washes and cassein tempera on glass that was sandblasted first to create a rough surface to which paint could adhere, the pieces were then covered with second sheets of glass secured and sealed by means of lead channels. The two hundred or more illustrated, patterned, or plain glass panes do more than decorate. They protect complex dissections, tissue and organ samples, colored cross-sections, and wax and other models from the deleterious effects of strong sun glare, yet allow light to filter through. The pieces also create what the museum's planners hoped would be a lively, humanizing atmosphere rather than a cold, post-mortem look. In a 1939 *Alumni News* article about the windows, Dr. Kampmeier pointed out that anatomists,

The Beginnings of Anatomy

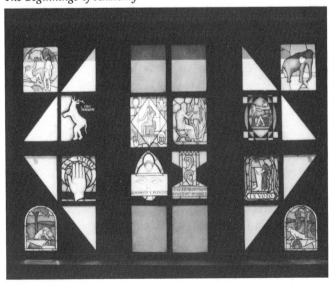

despite basic medical school tasks that assured soiled hands and redolent clothes, still always understood the dignity of their calling. As for the friendless people whose remains furnished the museum's specimens, he added, they never imagined "as they approached the end of their journey, that they would come to rest not in a pauper's grave but with honor in such a colorful sepulchre."

The first window to the right side of the door refers to the beginnings of anatomy: a Cro-Magnon medicine man; votive offerings made up of a hand and a leg; canopic jars containing embalmed organs; an Egyptian god transforming clay into a human figure; Prometheus carving a rock into a human skeleton; and sacrificial animal livers used to augur the future.

Window two alludes to the monastic and scholastic periods of medicine; at top is an archaic map of southern Europe, and below, methods of dissection as depicted in a 1345 manuscript.

Certain fundamental divisions of the science of morphology—cytologica, embryologica, histologica, and anatomica—are identified in the third window. Common allusions to life and death are the skulls behind a barred window, and bell, book, and burning candle.

The fourth window consists of three nude male figures, with circles centered on their joints.

The fifth window demonstrates the revival of anatomical study of animal cadavers in the early Middle Ages. One picture shows a flayed human cadaver walking away with his skin, scalp and all, dangling from a staff flung over his shoulder. The lowest pane, adapted from an Arab scroll, bears diagrammatic eyes and optic tracts.

Two scenes in window six depict mischievous baby angels busily robbing graves or cutting down bodies from gallows to furnish much-desired dissection materials. Drawings below illustrate veins, arteries, bones, muscles, and nerves in the human figure. Although inaccurate, such images furnished the medieval doctor his only anatomical knowledge.

The next two windows are dedicated to thirty-five great anatomists. Space limitations prevented full graphic treatment of each man's outstanding achievements, leading Dr. Kampmeier and the artists to devise emblems such as the terrestrial sphere for Aristotle's universality of mind.

The ninth window, a recent addition, commemorates the hundredth anniversary of the university's College of Medicine in 1981. Leonardo's ideally proportioned human body is shown, and around it, the university's motto, Learning and Labor, and the names of five of its founders.

As Dr. Kampmeier described the tenth window, the upper series of pictures suggests the sequence of evolution from protozoa to humans, and below, illustrations for a poem he wrote on evolution.

The last window includes a Mayan sun god, the zodiac man, and a Mayan priest tearing out a human captive's quivering heart.

Because of some forty years of destructive weathering and vibrations, a number of panes recently faced extinction. A grant from the John Needles Chester Fund in 1981–82, however, permitted many to be restored to their original brilliance and those beyond repair to be reproduced in an exacting process using fire-glazed enamels. More needs to be done.

Ralph Graham worked as a painter, photographer, and designer. He exhibited at the Toledo Museum, the Seattle Art Institute, the Art Institute of Chicago, and the Chicago Century of Progress. Joining the WPA at the urging of his friend Rainey Bennett, he served as supervisor of the Chicago WPA poster division after completing work for the university medical unit. Examples of his art are in the Brookfield Zoo, the Shedd Aquarium, and the Chicago public schools.

Olga Chassaing (1897–1944) and Edouard Chassaing (1895–1974)

The Spirit of Medicine Warding off Disease, c. 1935

Cast stone sculpture, 4'7" x 5'6"

WPA/FAP

Behind Campus Health Services

Olga Chassaing and her husband, Edouard Chassaing, made the allegorical *Spirit of Medicine Warding off Disease* as a fountain, with a wide arc of water spraying from the mouth of the dragon. Placed originally on a short, low retaining wall of layered flagstones alongside a rock-edged pool that stretched some twelve feet to form the focus of a lovely landscaped garden (now a parking lot), it is relegated today to an out-of-the-way grassy spot, set flat into the ground, its porous surface abraded and weather-stained by the elements and pollution, mostly forgotten and little seen.

Fine aggregate pink sand gives the cast (poured) stone its grainy appearance. The powerful figure of Medicine clutches the infant Humanity high on her right shoulder while calmly but strenuously warding off the Dragon of Disease with her taut left arm. She does this in much the same way that Hippodameia, on the ancient Temple of Zeus at Olympia, serenely repels an attacking centaur. The bulging serpent-dragon writhing round her back derives from pre-Columbian sources, recalling in particular the spiraling eye

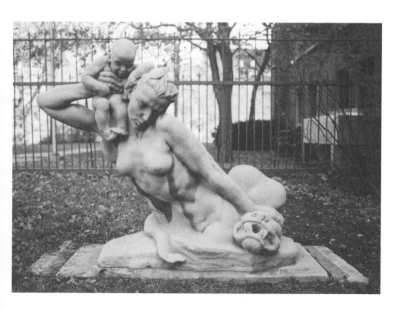

designs and sharp, prominent teeth carved on the Quetzal-coatl heads at Teotihuacan, Mexico.

Olga Chassaing was born in Paris and settled permanently in Chicago in 1927. She worked for the Federal Art Project sculpture division for a brief period in the mid-1930s. Between 1927 and 1933 she exhibited at five Chicago Art Institute shows and also at the Century of Progress. Her charming polychromed stucco *Shepherd Boy* of 1929 won the Eisendrath Purchase Prize and is now in the Art Institute's Children's Museum permanent collection. For the sculptured portrait head of her husband, Edouard, she won the Hearst Prize in 1933. She also did a piece for the Washington School in Evanston.

Edouard Chassaing served as head of the WPA Illinois Arts Project sculpture division. He supervised about seventy people, among them sculptors, woodcarvers, stonecutters, plasterers, and other support personnel. The designers would make a model in clay, wood, or plaster and craftsmen would execute it. Because they received union wages, the project administrators had to keep careful watch to see that they did not go over budget. Chassaing was known for innovative methods and, as is the case in this piece, experimented with the poured-stone process, a variation of the technique of poured or cast concrete. His dramatic ten-foot-high figures of *Aesculapius* and *Hygeia* in the courtyard arches behind the College of Medicine West, however, are of carved limestone.

Girl with a Fish, 1938

Limestone figure, 6'5" high (incl. base)

WPA/FAP

Garden east of Medical Sciences South

Viviano fashioned his *Girl with a Fish* in broad, simplified forms typical of the pseudo-archaic style favored in the period. Reminiscent of a sixth-century BC Greek kore figure, she stands facing front like a ritual votive object, static except for a slightly forward-leaning stance, her arms close to her sides, eyes blank and staring hypnotically ahead, lips suggesting a slight, enigmatic smile. The forms about her are equally understated: the fish in her left palm, the seaweed in the

right, the web-footed pelican winding round her knee, the sea plants rising up in stiff, rhythmic rows.

Originally designed for use as a fountain, the gray limestone sculpture's rosette-studded basin spills over now in summertime with a bright array of varicolored flowers—a pleasant counterpoint to the rather dark, Collegiate Gothic buildings bordering the quiet little area of which it is the central attraction.

As a boy, Viviano began his career by cutting fragments of old tombstones and large tree trunks with tools forged from piston rods and discarded files. Later he trained at the Art Institute of Chicago, exhibited widely, and taught at Indiana University and Columbia University. A natural experimenter, he produced sculpture from wood, stone, metal, mosaic, and stained glass, often combining, with great originality, different materials in one object. His work is included in private collections; the Illinois State Museum in Springfield; the Baltimore Museum; and the Boston Museum of Fine Arts. For the Illinois Federal Art Project, he also created a fountain of a young girl with a flamingo, for an Oak Park playground; animal carvings such as rocky mountain sheep and a wart hog for the Brookfield Zoo; and wall ceramics for Nancy Hill High School, Aurora.

The University of Illinois, Champaign-Urbana, 1936, 1936

Mural, oil on canvas, 8' x 12'

WPA/FAP

Vestibule outside Room 106, College of Medicine West

It seems rather remarkable that this huge illustrated map of the Urbana campus is displayed at Chicago. Evoking more than astonishment when one comes upon it unexpectedly in the medical school halls, it serves as a reminder that the two campuses are part of one great institution.

Rainey Bennett designed the work and other WPA artists executed it. As it appears today, pale greens, violets, and other toned-down (probably faded) hues predominate. Streets, trees, buildings, objects, and symbols arranged in a grid pattern animate its flat, static surface. Featured vertically down its left side are Memorial Stadium, the Auditorium, and University Hall (a structure replaced by the Illini Union). Taft's *Alma Mater* is pictured to the right of center at the bottom. Neatly placed about are stylized little symbols such as a plow for agriculture, a watering can for floriculture, a sailing ship with outsize dollar sign for commerce, a measuring scale for physics, a span bridge for civil engineering, and a horse and rider at the Armory. Also represented are greenhouses, steers, pigs, protractors, compasses, and musical instruments—and even books and students.

Bennett, the recipient of numerous awards and commissions in a long art career, has works in the collections of many

museums and other institutions. He studied at the Art Institute of Chicago and the Art Students League, and graduated from the University of Chicago. From 1935 to 1938 he served as supervisor of the WPA/FAP group assigned to the University of Illinois medical school. Under his direction some twenty to thirty people, among them painters, sculptors, plasterers, and timekeepers, produced the WPA frescoes, mosaics, murals, and windows discussed in this book. A large Bennett abstract painting, *Wisconsin Ways* (1961), a gift to the university from Benjamin Heineman of Northwest Industries, hangs in the Chicago Circle Center cafeteria.

Edouard Chassaing (1895–1974)

Aesculapius and *Hygeia,* c. 1938

Two limestone figures, approx. 10' high

WPA/FAP and Medical Alumni Association

Courtyard, College of Medicine West

In the legend of Aesculapius, the ancient Greek god of medicine and healing, the centaur Chiron taught him pharmaceutical knowledge about curative drug plants found on the Thessalonian plains. With the aid of his two daughters, Hygeia and Panacea, he ministered to followers of his mystery cult through suggestion, dreams and hallucinations, miracle remedies, and medical lore. Throughout Greece his spirit dwelt in sanctuaries much like places of religious pilgrimage.

Aesculapius

Represented in art as young or old, bearded or clean shaven, standing or seated, he was almost without exception shown with his attribute of a staff entwined by a serpent: the staff suggested the weary wandering of the itinerant doctor; the serpent, because of its periodic sloughing of skin, was emblematic of the renewal of life and health. Through time, the graphic Aesculapian sign of rod and sacred snake became the internationally recognized symbol of the medical profession.

Chassaing's interpretation of Aesculapius is unusual. Statues from antiquity show the god heavily draped. Here he is partially covered by an ambiguous cascade of stone between the legs—part column, part drapery—and by an incredibly long serpent winding familiarly over one shoulder, behind the back, and spiraling heavily around the thick staff. The staff, rather than being a branch or long, crutchlike stick reaching to the armpit to support a body in contrapposto, as it was often in the past, is more a magical club, a weapon to battle pain and disease. Conveying strength, not gentle earnestness, the figure is erect, almost militant in stance; muscular, with streamlined proportions, it conveys intense self-confidence. While close in style to vigorous, and beautiful, late Renaissance and Mannerist nude depictions of the god by di Giorgio and Tribolo, for example, Chassaing's portrayal transcends the idea of mythological physician to become instead the altruistic, heroic worker epitomized in 1930s social realist art.

Lost to erosion is the *omphalos* with interlaced pattern that can be seen clearly between the feet of Aesculapius in a 1938 *Time* magazine photograph of the work. The Greeks believed the conical, webbed sacred stone marked the center or navel of the earth, indicating the place where the life of the world began. It often appeared with Aesculapius because he called forth life from death.

Hygeia, the goddess of health, assisted her father in conjuring up visions of supplicants. In classical depictions she is shown young, smiling or serene, heavily swathed in a chiton, and with ritual utensils such as a tripod, a wine pitcher, a basket with the venerated snake, and a plate, the patera, from which the snake feeds. Chassaing presents her with only a friendly plump snake wriggling lazily about her body, intertwined in her long tresses in back. She is as idealized as Aesculapius: long-legged, sleek, with boyish build, exemplifying contemporary standards of beauty. Her direct gaze, slight expression in the lips, frontal pose, and deep-cut, zig-zag drapery, moreover, reflect the period's interest in archaic Greek art.

Edouard Chassaing studied sculpture in Paris under Hector Lemaire and came to the States in 1927 to take part in plan-

Hygeia

ning Chicago's 1933–34 Century of Progress Exposition. He stayed on as WPA Federal Art Project sculpture supervisor in Chicago until the program ended in 1941. Because of administrative duties, he did few works of his own during this time; these include the *Babylonian Seals* and *Assyrian Frieze* at the Field Museum of Natural History and several utilitarian pieces for the Brookfield Zoo. He exhibited widely in France and in this country and received a number of honors and awards. From 1938 to his retirement in 1965, he taught at the Chicago Art Institute and made decorative sculptures for public and corporate buildings. His most famous Chicago-area work, *Hope and Help* (1955), is outside the International College of Surgeons on Lake Shore Drive. In collaboration with his wife, Olga Chassaing, he created *The Spirit of Medicine Warding off Disease* for the university's medical school campus.

John Stephan (1906–)

Signs of the Zodiac and Celestial Bodies, 1936

Sixteen ceramic mosaics, 11" x 15"

WPA/FAP

Archway at 1819 West Polk Steet

Surely one of the most durable and ancient of crafts, mosaic enjoyed renewed popularity in the twenties and thirties because of contemporary taste for color and decoration in architecture and renewed appreciation of mosaics' practicality in withstanding outdoor exposure. Despite complexities of technique, a wide range of available and often inexpensive materials could stimulate the artist's imagination and be used for tesserae: pebbles, glass, mirrors, clay, gravel, marble, cork, veneers, shells, and porcelain, for instance, left in their natural state or dyed and polished to a sparkling brilliance.

Here, enlivening a barrel-vaulted passageway leading from the street to a cloistered garden and hospital beyond, are sixteen bright mosaic pictures representing signs of the zodiac—Taurus, Pisces, Virgo, Aquarius, Cancer, Capricornus, Leo, Gemini, Libra, Sagittarius, Scorpius, and Aries—and the celestial bodies—Terra, Sol, Luna, and Stella. They alternate, checkerboard fashion, with equal-sized rectangles made up of narrow, orangey bricks and plain white stone. The tiles are of glazed terra-cotta and dyed stone cubes, irregularly cut and set in cement at different angles to reflect elusive light and create a variegated surface. Juxtaposed turquoises and greens, lustrous blues, oranges, and yellows, and ochers and reds contribute to their beauty. Black or dark lines, broken for textural interest, define forms and emphasize boundaries.

Illustrative of the artist's use of contrasting hues and shapes are the sun and moon panels. The glowing yellow sun, its rays curving and seeming to emanate heat, is laid against a

clear blue sky—a combination that intensifies the visual impact. The moon's cold, blue-black pointed edge seems to emphasize its frigidity and distance.

John Stephan, born in Maywood, Illinois, was active as a painter and muralist in Chicago. He exhibited at the Art Institute seven times between 1934 and 1941, and in 1934 won the Chicago Women's Club prize of $100 for his *Nude*, in oils, amid protests that most of the awards went to unknowns. For the Federal Art Project he did a mammoth full-length mosaic portrait of Benjamin Franklin at Carl Schurz High School (no longer visible) and easel paintings.

Terence Karpowicz (1948–)

Amelioration, 1989

Stainless steel and granite, 11' high

Gift of the Illinois chapter of Alpha Omega Alpha

Courtyard, College of Medicine West

Amelioration replaces a five-foot-tall stone statue of Apollo, the ancient Greek god of music, poetry, prophesy, and medicine, that had stood atop a fountain in the same location since 1946. When the figure was irretrievably damaged in 1984, Illinois chapter members of Alpha Omega Alpha, the national medical honor society founded at Illinois in 1902, sponsored a competition for a new work. They paid for the original sculpture and the present stainless steel and granite piece.

Terence Karpowicz, the competition winner, spoke of the challenge of reflecting the spirit of the earlier piece. "The idea

of a symbol that would represent the physicians' concept of healing and learning and discovery of the yet-unknown is what inspired *Amelioration*. The idea of making something better, with the knowledge gained through the process of discovery through investigation, was the driving force behind its imagery.

"Using the granite as chronicle, or a record or a historical map taken by our ancestors in the medical field and the stainless steel ring to represent a focal point or a microscopic lens, and the deliberate break of the granite to represent a specific malady or disease, I tried to put forth the notion that once the medical field focuses their collective energies on that problem, they will continue to investigate until a solution is discovered and once found, that very answer will alter the course of medical history."

Karpowicz earned his MFA at the university's Urbana campus in 1975. Among his major commissions are those for Northern Illinois University, DeKalb, the Kellogg Business School at Northwestern, and the Jewish Reconstructionist Congregation in Evanston. The last work involves a thousand marble pieces in a wall construction. He is known for his exacting craftsmanship and monumental works featuring implied or actual motion.

The Story of Natural Drugs, 1937

Five mural panels, oil on canvas, 5'6" x 7'6" and 2' x 7'6"
WPA/FAP

32 and 36 College of Pharmacy

Jefferson League made these five bright mural panels for a specific, no longer remembered architectural space in the medical school. They currently hang in two big lecture halls of the College of Pharmacy, and they deserve more attention. Illustrating the origins and applications of drugs derived from natural sources, their stories are told by means of composition, scale, and directional lines—"read" vertically, down from upper left-hand portions to increasingly prominent and more recent scenes set in stagelike lower areas nearest the viewer. In this manner, fragmentary, richly detailed incidents separated in time and place become cohesive wholes.

The indigenous New World drug quinine is the subject of room 32's south wall. Spectacularly attired Peruvian Indians gather bark, called *quina quina* by natives, which is then prepared into an infusion to treat intermittent fevers such as malaria. Spanish explorers and Jesuits help in its manufacture and transport. A ship in full sail suggests the transporting of the remedy to Europe by the mid-seventeenth century; in the lower portion, an aristocratic woman administers the drug. By this period, quinine allayed a variety of ailments, not just those related to fevers.

The north wall shows North American Indians teaching settlers to identify and collect medicinal plants and barks, and an elaborately outfitted nineteenth-century drugstore interior. A rigidly postured, wooden cigar-store Indian holding a patent medicine bottle forms a theatrical backdrop to two fashionable customers in the foreground. A bundle of crude drug bark, the raw material for quack remedies, nostrums, and panaceas, lies at his feet. Connecting the disparate images is an iron horse trailing boxcars.

The first of three narrow panels in room 36 focuses on digitalis. Painted in distinct sections, the scene shows Death waiting to claim yet another victim of congestive heart disease. Foxglove plants (*Digitalis purpurea*) are gathered and sorted and the dried leaves readied for an infusion. A determined physician, holding a single symbolic digitalis leaf over a cyanotic patient's heart, vanquishes Death, shown as a skeleton in commedia dell'arte costume, standing with swordtip poised directly over the sufferer. Foxglove plants in full

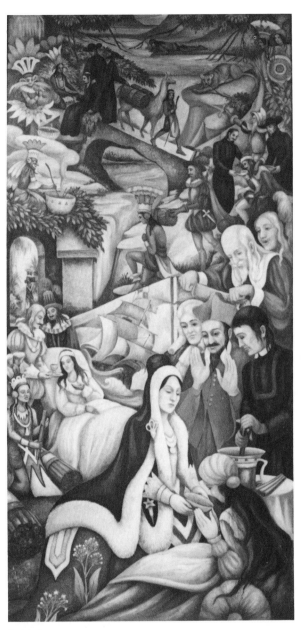

Quinine

bloom and considerable botanical detail form a pleasant floral border.

Hallucinatory and psychotropic drugs—substances that tend to produce visions and changes in perception, induce euphoria, and suppress fatigue brought about by physical exertion—are the subjects of the last two paintings. To the left, North American and South American Indians produce the mood-altering agents cocaine and peyote from cocoa shrubs and spineless cactus. Some of the Indians appear drugged, a state shared with nobles, workers, and religious leaders.

To the right the theme is opium. Employing Old World techniques, Turkish men cultivate, gather, prepare, store, and trade gum opium made from the poppy capsule (*Papaver somniferum*). A Moor displays the dried gum to a business-suited exporter. Below that, nearest in space and memory to a 1930s medical student, a World War I battlefield scene depicts a trench nurse ministering opium to wounded, suffering soldiers.

Jefferson League, born Thomas Jefferson League in 1892 in Galveston, Texas, left at age sixteen to study art in Chicago. We know little about him except that early in his career he dropped his first name in his signature and that he worked for the Chicago WPA/FAP from 1933 to 1943, producing four murals showing *The Growth of America* for Henry Clissold High School and an *Indian Scene* and a *Medieval Scene* for Albert Lane Technical High School.

Carl Hallsthammar (1897–)

The Royal Touch, Hippocrates Examining the Sanity of Democritus, and The Destruction of the Alexandrian Library, c. 1936

Three mahogany wood reliefs, 32" x 24½"

WPA/FAP

Special Collections, 320 Library of the Health Sciences

Carl Hallsthammar's pictures and frames are integral, consisting of relatively shallow reliefs cut from single slabs of mahogany. Incised block letters along the lower edges tell their historical meanings. In the case of the plaque of Hippocrates, the border merges with the illustration by means of the columns and the uneven "floor," and even through the

The Destruction of the Alexandrian Library

placement of figures. Although forcefully and expressively chiseled in a style derivative of Scandinavian Gothic prototypes, the carvings nonetheless lack authority because of the artist's naïve spatial organization that tries to convey three-dimensionality.

The caption for *The Royal Touch* explains that the story had been in vogue since earliest times and "reached its height of popularity during the reign of Charles II of England, who was believed to have the power of healing physical ailments such as 'King's evil' by laying hands on the diseased patient."

Hippocrates Examining the Sanity of Democritus tells how "Hippocrates the Great was requested at one time to examine into the mental condition of the philosopher Democritus who was thought by his narrow-minded countrymen to be insane. Hippocrates found him deeply engrossed in the study of natural philosophy and asked him what he was doing. Democritus replied that he was investigating the foolishness of men whereupon Hippocrates reported that he considered Democritus the wisest of men. Democritus devoted most attention to construction of the human body, the noblest portion of which being the soul which after death was supposed to arise and float in the air like fire-atoms or comets."

The third panel depicts the violent *Destruction of the Alexandrian Library* in 640 AD at the orders of Muhammed's adviser, Caliph Omar, who had captured the city. "John the Grammarian, a famous philosopher and student of medicine protested the destruction with all his power," the caption reads. "The Caliph declared that the Koran contained the truth of the universe rendering useless all other literature. By his command 700,000 books fueled the fires at the public baths."

Hallsthammar, born in Sweden in 1897, left for the United States in 1924 to pursue an art career. He did a series of six huge wooden figures (later presented to the Rosenwald Museum in Jackson Park) for the General Motors Building at the 1933 Chicago Century of Progress. In this period too he sculpted a gigantic *Covered Wagon*, half-size low reliefs of *Lincoln* and *Edison*, and the *Venus in Red Cherry*, for which he won the Art Institute Logan medal and a cash prize. But most of his carvings were of modest dimensions and of a quaint, gentle or comic nature, portraying people of humble occupations in everyday situations. His *Singing Brothers* has been in the Art Institute's Children's Museum collection since 1926.

Don Quixote de la Mancha and Sancho Panza, 1982

Assemblage, approx. 7' x 11'

Gift of the artist, 1985

Third floor, Library of the Health Sciences

"It was a labor of love," ophthalmologist Maurice Pearlman said of the only artistic work he ever produced, the novel and intriguing *Don Quixote de La Mancha and Sancho Panza*. An admirer of Cervantes's famous Spanish knight, he explained that he used him as subject because "I think he's a character we all identify with, sort of the Walter Mitty of his era." For technique he was influenced by the Chicago artist John Kearney, who concocted sculptured animals from assorted metal automobile parts. Over the years the doctor accumulated a great store of discarded surgical instruments and hospital equipment; near the end of his life he supervised the transformation of his design into actuality with the advice and expertise of an unidentified welder friend in Las Vegas.

Although he lacked conventional training in art or in welding, Dr. Pearlman demonstrated sensitivity to materials and form. Lank old Don Quixote on his bony horse Rosinante and the stocky servant Sancho Panza on his small ass Dapple attack a windmill. Represented in detail are most of the major organ systems of the body—the central nervous, spe-

cial senses, gastrointestinal, respiratory, cardiovascular, genitourinary, osseous, and integumentary. By cleverly assembling artifacts of stainless steel, brass, wood, rubber, plastic, and fibers, Dr. Pearlman transformed utilitarian medical objects into whimsical caged, meshed configurations that suggest bones, skin, hearts, bladders, lungs, kidneys, intestines, rectums, urethras, spinal cords, brains, skulls, ribcages, mustaches, eyes, noses, thoraxes, blood vessels, manes, lances, and helmets. For Don Quixote he used Von Petz special gastric stapling clamps, Babcock and Allis clamps, kidney basins, interocular lenses, X-ray film and towel clips. For Sancho Panza there are an open thumb forcep, basin, speculum, proctoscope, adenotome, and retractors, and for fabricating the horse and the ass, materials such as anesthetic balloon bags, vaginal speculum, welded hemostats, different kinds of scalpels, urethral sounds, flexible tubing, ear syringes, tweezers, Deaver retractor, Padgett fermatome, traction weights, orthopedic splint, dental drill, and fiberoptic fibers.

Yet not all is fun and invention. Dr. Pearlman's deep commitment to the humane in medical practice is indicated in words he wrote when arranging for his gift. "Behold!" he proclaimed. "Don Quixote de la Mancha, defender of our profession against all assailants or detractors, and knight-errant against life's cruelties. This sculpture is dedicated to His (and Medicine's) noble ideals." Illustrative of Pearlman's intent is the windmill, constructed of crutches mounted on an intravenous stand, its center labeled "Disease" and its sails reading "Poverty," "Injustice," "Ignorance and Fear," and "Despair." One of Sancho Panza's banners says "Enlightenment," the other bears the word "Peace" in twenty-three languages and also a quotation from Cervantes: "Only he who intends the absurd may attain the impossible." (The banners are kept in special collections; the lances have been stolen.)

Dr. Pearlman, a 1939 graduate of the University of Illinois medical school, Chicago, served as a flight surgeon and captain in the U.S. Army during World War II. After further study at several London hospitals, he worked as university clinical faculty member in ophthalmology for some twenty years. From his move to Las Vegas in 1969 until his death in 1985, he practiced privately and held an appointment as a clinical associate professor at the University of Nevada School of Medicine.

Edwin Boyd Johnson (1904–)

Great Pioneers of Science, 1936

Nine fresco portraits, 20" x 30"

WPA/FAP

Faculty-Alumni Center, 119 College of Medicine West

Somber earth tones and solemn demeanor characterize all nine fresco portraits in the Faculty-Alumni Center, the former Quine Library main reading room. Depicted are great pioneers of medical science: *Ambroise Pare* (c. 1510–90), a French army surgeon noted for breaking past surgical traditions and for setting forth sound principles in a general surgery treatise; *Louis Pasteur* (1822–95), the French chemist and bacteriologist, originator of immunization by attenuated viruses, considered the founder of microbiology; the English biologist *Charles Darwin* (1809–82), who advanced the theory of the origin of species by natural selection and the evolution of humans from ancestors common to man and ape; *Rudolph Virchow* (1821–1902), a German professor of pathology who emphasized the cellular basis of disease; and the English physician *Edward Jenner* (1749–1823), originator of vaccination as protection against smallpox. There are also *Robert Koch* (1843–1910), the German professor of bacteriology noted for original methods of obtaining pure cultures of patho-

Louis Pasteur

genic bacteria and the discoverer of tubercle bacillus; *Marcello Malpighi* (1628–95), an Italian microscopist and professor of anatomy regarded as the founder of histology, who made numerous great discoveries in the minute structure of plants and animals; *Joseph Lister* (1827–1912), the English professor of surgery celebrated for recognition of wound infection due to microrganisms and for establishing antiseptic methods of surgery; and the English physician *William Harvey* (1578–1657), discoverer of blood circulation, considered the father of physiology.

That the artist chose to employ the enduring but demanding fresco technique for small-scale portrait panels seems unusual. The method, used extensively during the Renaissance, requires tedious application of pure powdered pigments mixed with water to sections of wet, freshly laid lime plaster ground—ordinarily part of a vast expanse of wall—so that pigments are incorporated into the plaster itself. WPA supervisor Rainey Bennett explained that "the frescoes were frescoes because they were originally intended to be set in niches flush with the wall—a kind of conceit never executed." Frescoes had been integral with architecture for centuries, but their use in the 1930s reflected a nationwide revival of interest mainly due to the influence of Mexican muralists such as Diego Rivera. His stylistic tricks of showing arcs of drapery echoed in globular shapes and simplified facial features are evident in Johnson's portraits too.

Johnson studied at the Art Institute of Chicago, at the National Academy of Design, and in Paris, Vienna, and Alexandria, Egypt. He supervised the Elgin, Illinois, WPA project and later served as a member of a FAP group sent out to document Alaskan life. Mural commissions include Cook County Hospital and public buildings in Melrose Park, East Aurora, and Tuscola, Illinois, and in Sioux City, South Dakota. His last known place of residence was Mexico.

Marilyn Jusko (1955–)

Education and *Medicine,* 1982

Two wool wall rugs, 8' x 5'

Purchase 1982, John Needles Chester Fund

Faculty-Alumni Center, 119 College of Medicine West

Medical school administrators involved in developing the faculty-alumni center in 1982 at first considered purchasing oriental rugs as art objects to fill the blank walls at either side of the baronial fireplace. Finding costs too high and then learning that the Chester estate fund was available "to improve the cultural milieu of the campuses," they proceeded with their planning in consultation with a custom rug maker and an interior designer. The latter, Florence O. Force, stipulated that the area be given a "lift," yet be done in good taste for such a prestigious location. She specified that hangings be fabricated and evidently abided a design trend to use one large decorative piece on a wall instead of small items collected in a group. As noted in a decorators' journal of the time, "a big painting, tapestry or wall rug produces a much more stunning and dramatic effect because of its basic impact." Still, it must be said, despite excellent workmanship, these rugs, as art, disappoint.

Hand-tufted from the back with an electric needle and executed in wool yarns skein-dyed to incorporate tones in the room, the rugs' figures and columns are in needlepoint—the better to define lettering and details—while the backgrounds are cut-pile beveled wool. Jusko intended her two figures to

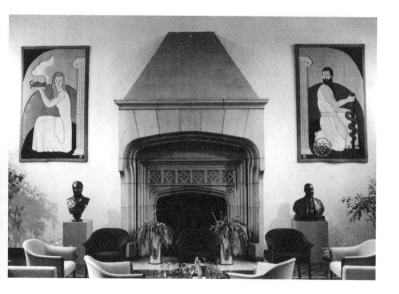

harmonize with Chassaing's attenuated *Aesculapius* and *Hygeia* statues in the archways nearby, but they seem even closer in style to Rockwell Kent's linear illustrations of the early thirties.

Personified as a blank-eyed, strangely seated woman balancing a steaming lamp of learning, *Education* is poorly drawn, her legs much too short for her torso and her graceless pale yellow sleeveless dress more current than classic. *Medicine* is equally blank eyed, a better-proportioned kneeling bearded figure in sandals lightly grasping the staff and entwined serpent of Aesculapius, the emblem of the medical profession. A fluted Ionic column appears in each rug. In one, "Centennial 1881–1981" is embroidered in an arc; the other bears the College of Medicine seal with the number "100," for the topical anniversary. The initials "EF" at the lower edge of each of the rugs stand for Edward Fields, Inc., the Chicago firm responsible for their manufacture.

Jusko, a graphic design graduate of the School of the Art Institute of Chicago, worked seven years for Fields before going into business for herself as a free-lance artist.

Hippocrates, 1972

Pentelic marble, 10' high

Gift 1972, Andrew Fasseas and the Chicago Hellenic-American Community

In front of University of Illinois Hospital

Contemporary artists tend to lack interest in creating naturalistic commemorative sculpture. The Greek sculptor Costas Georgakas, on the other hand, retained humanistic and classical values in his work throughout his life.

The *Hippocrates* is one of four nearly identical statues commissioned by Greek-Americans to present to American medical schools. The others stand at Wayne State University, Detroit; the University of Alabama, Birmingham; and the University

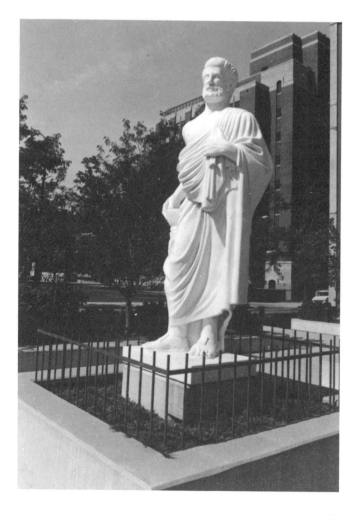

of Arizona, Tucson. Members of Chicago's Hellenic-American community, led by the publisher of the *Greek Star*, began raising funds to underwrite costs for the Illinois version as early as 1963. Much sentiment was attached to the project because of the patrons' pride in their ancestral homeland and love for America, as well as their appreciation for opportunities afforded Greek immigrants in the city of Chicago.

The heavyset, massive, colossally scaled figure of Hippocrates (c. 460–c. 370 BC), disturbingly tilted backward yet in contrapposto, rests weight on his left leg and with his right hand lightly touches a thick, columnar tree trunk on which the venerated serpent winds. The sculpture is cut from a single block of sparkling white, fine-grained marble quarried at Mount Pentelicus near Athens, where ancient Greeks obtained marble for the Parthenon and other important buildings.

Georgakas recalled that he had been fortunate to find the last, "literally the last," piece of the largest possible size, twelve by five by five feet, from the nearly defunct quarry. He checked the material using what he said was the old conventional method—"If the sound from my hammer was like a bell, then the marble was healthy and proper for sculpture"—and carved it himself over a period of two years, using first an air chisel and then a hand chisel for details. To be as authentic as possible he deliberately modeled the head, with its introspective countenance, on a very beautiful fourth-century BC statue of Hippocrates excavated (c. 1940) on the Dodecanese island of Cos, near Turkey, where the physician was born, and where he studied, worked, and taught.

Up to the time of Hippocrates, medicine had been largely superstitious faith healing and philosophical speculation or, as practiced by contemporaries, routine categorization of disease to the point of disregarding the patient. With Hippocrates, medicine became a science. He is credited with introducing a system of close, objective observation and rational diagnosis and treatment of illness, investigating links between symptoms and family histories, and even noting correlations between disease and environment. He stressed hygienic practices and appropriate diet, the effects of psychology on bodily health, and the principle that the doctor was to resort to no more drastic measures than necessary— "To help, or at least to do no harm." The Hippocratic oath, an enormously significant concept of professionalism, freedom, and obligation, has become the ethical maxim of physicians, administered in abridged form to medical school graduates throughout the world.

Georgakas studied in Athens and Paris and is best known for sculpture created in Ethiopia and Eritrea after World War II.

Establishing himself at Addis Ababa, he produced portrait busts, life-size statues, animal sculptures, and other monuments. He considered the titanic figure of Emperor Haile Selassie in Asmara, the port of Ethiopia, his masterpiece, but it was destroyed. After his return to Athens in 1967 he concentrated on small-scale works, generally busts of family and friends.

Crystal Forest, 1986

Bronze and Cor-ten steel, 7'11" x 5'10"

Gift 1986, Health Sciences Center Auxiliary

Plaza northwest of University of Illinois Hospital

John Richen's stained and weathered abstract sculpture demonstrates a particularly effective interplay of organic and hard-edged geometric components. Five sharply thrusting, blunt-ended, stalagmite-like shapes unite the solid, ground-level rectangular base and the large open circle balanced eccentrically on it. Embedded in the curving inner rim are iridescent, silvery-green crystalline rock clusters evocative of geodes or other natural forms. According to the artist, the crescent suggests the earth, moon, and sun, while shafts that rain down from the top to pierce the bottom of the circle represent crystals that fall and create trees, flowers, and other forms of life.

Richen studied at Oregon State University and the University of Washington. His works are in private, public, and corporate collections from Seattle, Portland, Vancouver, and Dallas to Lucerne. He lives now in Newburg, Oregon, and says he sells everything he and two full-time assistants produce. His welded bronze and steel sculptures fetch large prices. Recently Richen observed that he had almost begun to feel guilty because of an art-world tendency to look down

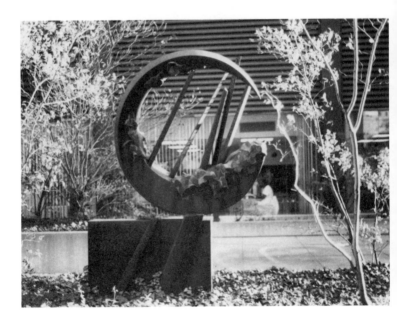

a little on commercially successful artists, a sort of reverse snobbery. "There's nothing wrong with marketing your work intelligently," he said, noting that opportunities to create great art might never have been afforded Moore or Picasso had they not done this and been poor all their lives. "I'm as highly trained, as much a professional, as any doctor or lawyer. I finally decided it was time to start acting like it."

Delicate Balance, 1985

Bronze, 5' high

Gift 1988, UIC Health Sciences Center Auxiliary and the artist

Lobby, University of Illinois Hospital

This austere, sharp-edged sculpture, precisely shaped of thin bronze plates, is set on a white Bedford stone slab atop a black Cor-ten steel base. Commissioned specifically for the hospital lobby as part of the Health Sciences Center Auxiliary beautification program, it has an elegance gained through gradually modulated, textured surfaces, burnished to catch light, and through a bent ovoid form with convoluted core poised delicately on three points. The style derives from the impersonal, enormously influential sculpture of constructivism formulated by the Russian engineer-artists

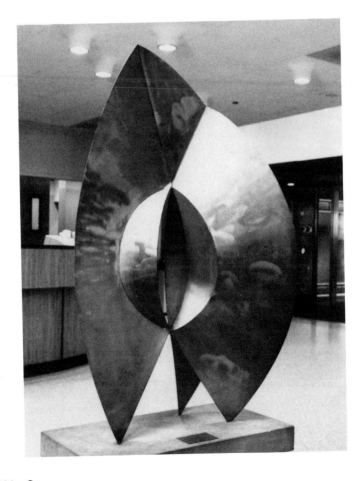

Antoine Pevsner and Naum Gabo after 1921, an approach to art that concentrates on spatial and geometric aspects of objects and the use of nontraditional materials and techniques.

Samter studied painting with André L'Hote, Fernand Léger, and Amadée Ozenfant in Paris and at the Corcoran Institute, Washington, D.C., and had a long career as a medical illustrator. She turned to metal sculpture in 1968, working under Nelli Barr and Mychajlo Urbhan at the Evanston Art Center. "My interest in three-dimensional form had two sources," she said recently. "First of all, I am a frustrated dancer, but as a sculptor, I too can make gestures in space. Later when I became a medical illustrator, I became fascinated with the forms of the human body—the magnificent hollows of the torso. The spinal column swoops down its length, defining cavities on either side. I have always fooled around with paper making little animals and angels or horses for my children and friends. Thus, cutting and bending sheets of metal was a natural transition from my 'paper sculpture.' With metal, it is possible for me to produce the thin, wing-like forms I first made in paper."

Laura Foster Nicholson

Common Ground and *Healing Green,* 1983

Two wool tapestries, each 5' x 8'

Gift 1983, UIC Health Sciences Center Auxiliary

Lobby, University of Illinois Hospital

These handsome tapestries are of wool, double woven and embroidered, with some of the fibers hand dyed with colors not commercially available. Basing her geometric, abstract designs on motifs taken broadly from scenes or architectural features around campus, Nicholson used simple combinations of warm and restful colors and repetitious, mainly sharp, straight lines, bandings, angles, stripes, and checkered patterns to bring clarity and structural unity to their many details. Only configurations of trees and shrubbery rendered in rounded or spiky curves offer contrasts in forms.

Healing Green loosely suggests two medical-sciences quadrangles as peaceful walled herbaceous gardens providing respite from constant and insistent staff duties. In unusual perspective are the mosaic zodiac signs in the entrance passageway at lower center. Identifiable too are the lovely window arches of the old Quine Library opposite. Even the old Dental Tower has been incorporated into the piece, as have the green shutters with white slats on Taylor Street housing at upper left.

Common Ground, on the east wall, alludes to the neighborhood's diverse ethnic and architectural makeup: the domes

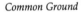

Common Ground

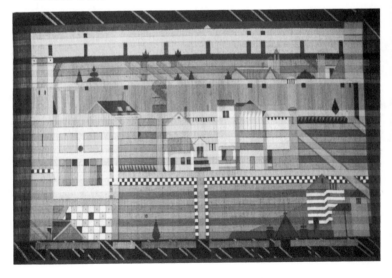

and spires of Greek Orthodox churches; the cluster of elegant, rehabilitated Victorian houses and the rooftops of ordinary dwellings; the tall smokestacks from the power plant that heats the university; and the headquarters building of the International Ladies Garment Workers Union (ILGWU). Black-and-white checkered bars cutting across and down are reminders of taxis that transport patients to and from the hospital.

Nicholson earned her MFA at the Cranbrook Academy of Art in 1982 and worked as a textile designer, conservator, and curator. She has taught creative arts and weaving and has exhibited, primarily in the Midwest.

Structural Arch in Time, c. 1968–73

One of four Cor-ten steel sculptures, various sizes

On indefinite loan from the artist

Plaza in front of University Hall

Jacquard's large and enigmatic sculptures relate perfectly to the aggressive architectural style on the east side of campus. Two stand in the plaza in front of University Hall, and another two are at the entrances to the Education, Communications, and Social Work Building and the Architecture and Art Building. Made of Cor-ten steel, an industrial self-weathering material that forms an impervious iron-oxide coating, they are boldly composed of dark, machinelike, curved and straight geometrical forms juxtaposed with leftover volumes of space that function, in shadows and in shapes, as positively as the solid substance. Because of their great weight, the sculptures appear immensely stable; yet due to their being balanced partially on oversized casters—a touch typical of the artist's other pieces—a lightness and potential for movement is implied.

Jacquard wrote that his work "seems strange to me sometimes," that if asked to characterize it in one word, he would say it is paradoxical. Although his sculpture is very massive, the artist explained, "it appears to me to have no weight. The sculpture appears to be solid and carved from one large mass which, in fact, is the exact opposite. The sculpture is made

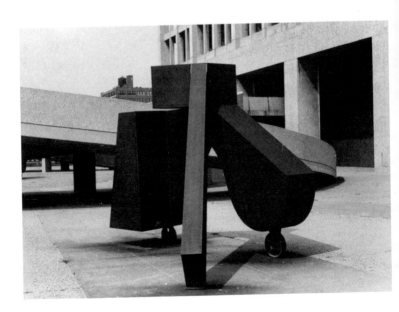

of planes that are constructed to make forms that are sculpt-
ed into a self-contained structure. . . . The ideas are a mixture
of conscious and subconscious information that is trans-
formed into static matter that, hopefully, is a reflection of my
particular expression."

A member of the UIC art faculty from 1966 to 1975, Jacquard
presently chairs the sculpture department at Indiana Univer-
sity, Bloomington. His works are in the collections of New
York's Museum of Modern Art; the Detroit Institute of Arts;
Michigan State University, East Lansing; and the Kalamazoo
Art Institute. In Chicago, untitled steel pieces stand at the
Kimball Transit Terminal and at the entrance to Ogden Mall
opposite Lincoln Park. *Oblique Angles* is at Governors State
University, Park Forest South.

Richard Hunt (1935–)

Slabs of the Sunburnt West, 1975

Bronze sculpture, 30' x 30'

Gift 1975, B. F. Ferguson Monument Fund

South of Library

Richard Hunt's hammered and welded bronze ground-plate sculpture, diamond-shaped with curved and pointed projections jutting from its gradually indented basin, dominates the great space between the library and the science and engineering offices. It honors the Illinois poet, biographer, novelist, and balladeer Carl Sandburg (1878–1967) and was said by the artist to have been influenced by colorful images suggested in lines of the 1922 poem "Slabs of the Sunburnt West":

> Into the night, into the blanket of night,
> Into the night rain gods, the night luck gods,
> Overland goes the overland passenger train.
>
> Stand up, sandstone slabs of red,
> Tell the overland passengers who burnt you.
> Tell 'em how the jacks and screws loosened you.
> Tell 'em who shook you by the heels and stood you on
> your heads,
> Who put the slow pink of sunset mist on your faces.

Weathered now to a dark, reddish brown patina, the work evokes both a visual and a physical response. Hunt conceived it as a desert landscape in miniature. "People walk through it, stand on it. Like eroded forms that rise up from the desert floor, it is intended to invite interaction with the passerby and with itself. Another aspect is that it also develops a dialogue between architectural and sculptural forms, that is, it repeats the diamond shape that the architect used in the planned surrounding buildings, the rotating square as a planning module. The way it's set in the plaza is a reflection of that, a point of reference for me for developing the initial configuration of the base."

Sandburg was born to poor Swedish immigrants in Galesburg, Illinois. Much of his verse exults in the beauty inherent in ordinary folk and objects. Considered one of the giants of twentieth-century American literature, he earned two Pulitzer prizes: in 1940 for his six-volume Lincoln biography, and in 1951 for his *Complete Poems.* The rare book and special collections library at the university's Urbana campus boasts one of the largest collections of Sandburg's manuscripts, correspondence, and published works.

The B. F. Ferguson Monument Fund commissioned the sculp-

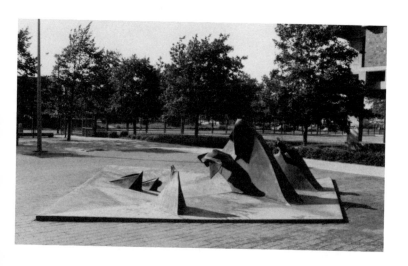

ture. Administered by the Art Institute of Chicago, it stipulates that its resources be used "for the erection and maintenance of enduring statuary and monuments, in the whole or in part of stone, granite, or bronze, in the parks, along the boulevards, or in other public places within the city of Chicago," and must memorialize worthy men and women of America or important events in American history.

Hunt is credited with having opened the door to public acceptance of large-scale abstract art throughout the state. His welded Cor-ten steel *Growing in Illinois* is at the university's Veterinary Sciences Building in Urbana.

José Aguirre (1955–), Raul Cristancho (1955–),
Graham Stewart (1956–)

Nuestra Esencia, Nuestra Presencia, 1985

Mural, acrylic over cinderblock, approx. 1,000 square
feet

Gift of the artists

Rafael Cintron Ortiz Cultural Center, Lecture Center B2

Painted in acrylic on four cinderblock walls, thirty-three to
forty feet long, and prepared with a mixture of sand, marble
dust, and acrylic gesso to create a surface that looks and feels
much like fresco, this huge mural—*Nuestra Esencia, Nuestra
Presencia* (Our essence, Our presence)—depicts historical and
cultural images of Latin America, including aspects of the
Chicago experience. It represents the donated collaborative
work of a team of young artists trained at the School of the Art
Institute of Chicago: José Aguirre, from Mexico; Raul Cristan-
cho, a Fulbright traveling fellowship recipient, from Colom-
bia; and the coordinator, Graham Stewart, also a Fulbright
scholar, from England. UIC student José Luis Lopez of the
Confederation of Latin American Students initiated the project
in 1984, aware, as were the others, that many students were
the first in their families to receive a university education; that
students often understood little of their roots; that a mural
could inspire and deliver a message.

For centuries, murals have been a way of voicing opinion. In
the twentieth century they have been tied closely to the
Mexican revolution, in which the mural movement flour-
ished under government patronage to create a didactic art to
educate a largely illiterate populace. Contemporary murals
in Chicago and other urban centers chiefly concern everyday
struggles and appear—permanently or ephemerally and
painted by artists of diverse ethnic backgrounds—in hun-
dreds of outdoor and indoor settings. Unfortunately, the
Ortiz Center is low-ceilinged, windowless, and claustropho-
bic, not an ideal physical space for a work of art. Nonethe-
less, the painting is an ambitious work.

The many busy images incorporated into the mural depict
native Indian myths and legends, Peruvian textile patterns,
pre-Columbian sculpture, the Spanish influence in Latin
America, the Afro-Latin cultures of the Caribbean, current
Central American and South American political struggles,
the Latino experience in the United States, and the future as
seen in family, children, and education, symbolic of a better
future—subjects, Aguirre explained, that are "important to
keep our identity alive."

Based on what Stewart wrote of the work, the left-hand wall includes images of gods descending through a storm; a cross-like shadow of an airplane on the pyramid underscoring the end of Aztec civilization; a backbone referring symbolically to women and their roles in Hispanic culture, including fertility and labor; and black Latin American celebrations indicated in a Caribbean carnival of music and dancing.

The right-hand wall is more consciously political, rendering the Spanish penetration of the New World in a deliberately traditional way: a conquistador on horseback murders a native under an Indian god's gaze, and the Christian crucifix is imposed for the first time. "The whole event is being filmed," Stewart explained. "A movie camera in place records the event and converts the concept of violent corrupt invasion into an equivalent, that is, 'the disappeared ones,' thousands of missing people directly related to repressive regimes."

The front-central wall relates to the Latino family, especially in life for first-, second-, and third-generation members in Chicago. Depicted are factories, laborers, television screens, cars, skyline reflections in Lake Michigan, cameras, voodoo, American Express, refugees, and illegal immigrants, and the border fence between Mexico and the United States.

Charles Wiesen (1952–)

Shallow Boat/Deep Well, 1987

Limestone, aluminum and wood, 8'6" long

Acquired by UIC Institute for the Humanities

West side of Stevenson Hall

This nearly nine-foot-long form, inscribed with the words "Shallow Boat" on one side and "Deep Well" on the other, is the winning entry of a 1986 competition sponsored by the Institute for the Humanities for a work to stand outside its center. The contest was open to current and former UIC students and based on the theme of the humanities at the university; it was judged on the successful interpretation of the theme and the suitability of the work to the site.

Wiesen said he submitted his proposal because he "attended UIC and I enjoy doing things for people I know. Also the university was very generous to me and my teachers really inspired me. I wanted to repay these favors and I felt this was an appropriate kind of personal exchange."

The artist noted, "This notation in wood, stone, metal, paint, and word portrays metamorphically the instruments we use to penetrate human experience. The humanities are of this nature, creating systems of understanding which become tools to use for explorations. The University is a harbor where the journey begins." The piece is further connected to the humanities, he added, since "the boat and oars are instruments and scholars use various kinds of instruments in research and in making discoveries."

He chose the boat as a form to work with as "the shape symbolizes cutting through space and is a metaphor for delving

194

into an idea, mentally piercing through information. The oars and the boat cut through the water and a body of water is symbolic because when you look at the surface you really don't know what's underneath." (Originally, an oar hung in a nearby doorway, but vandals broke it shortly after installation.)

Wiesen received his MFA in sculpture in 1982. In 1991 he won the John G. Curtis, Jr., prize. He has exhibited at the Chicago Cultural Center and at the Illinois Art Gallery, at Indiana University, and at Clark College, among other places. In an article about a 1993 exhibit, a *Chicago Tribune* writer suggested that no one should miss Wiesen's *Expressive End*, "in which viewer participation is crucial. It's a beautiful essay on curiosity and irritation, and how both may lead to art."

Portraits

Colleagues, students, alumni, family, and friends of university notables seldom commission portraits for the school anymore. The conviction that these likenesses can serve as a record for posterity, that they are appropriate tokens of esteem, that they can motivate and influence, seems no longer to prevail. Perhaps photographs—less costly and time-consuming to produce—have become, to judge by their increasing frequency in recent years, the functional if not particularly aesthetic substitutes for painted and sculptured portraits. Not that every portrait in the university collection is remarkable; no one would assert that. Yet most commemorate in a distinctive way—through the handling of brush or chisel, the choice of color, texture, and form—the presence of the artist or even a little of the soul of the sitter.

Art faculty members Charles E. Bradbury, Newton Alonzo Wells, Mary M. Wetmore, James D. Hogan, Richard E. Hult, J. William Kennedy, Harry Breen, Peter Fagan, and Billy Morrow Jackson made many of the works, as did Lorado Taft, so long associated with his alma mater that he was in effect an honorary department member. Other accomplished portraitists represented include Louis L. Betts, whose commissions came from all over Europe; Ralph Clarkson, who exhibited widely and whose works are in the Newberry Library and the Art Institute of Chicago; Fred Conway, nationally known also for his murals, easel paintings, and stained-glass windows; and Charles W. Hawthorne, described in the *Daily Illini* as the "successor to John Singer Sargent as the leading American portrait painter."

Francis O. Salisbury, the famous London painter who attracted a wide circle of patrons among British notables and the royal family, has works in Buckingham Palace, Canterbury Cathedral, and even Huff Gym. Sydney E. Dickenson's paintings are in the Corcoran, the St. Louis Art Museum, and numerous private collections. Merton Grenhagen's are at Beloit College and the University of Wisconsin. Leopold Seyffert is well represented at the Metropolitan Museum of Art, the Carnegie Institute, and the Art Institute of Chicago. Ellen G. Emmet Rand was affianced to Robert Allerton at the time she created his likeness, so the work ought to be regarded as an intimate document and no mere commission. Oskar Gross, born in Vienna and highly regarded as a portraitist,

197

Oskar Gross, *Dr. Carl Beck*

came to the United States in 1902 and practiced for many years in Chicago. Others renowned in their field include Leonard Crunelle, Egon P. Weiner, Hermon Atkins MacNeil, Paul Trebilcock, Jo Davidson, Oskar J. W. Hansen, and Albin Polasek.

The *Editors' Hall of Fame* and the *Illinois Farmers' Hall of Fame* (the portrait groups in Gregory Hall and the Agriculture Library, respectively) are described earlier in the text.

Urbana-Champaign

Roger Adams (1889–1971)
Professor of Chemistry, 1916–57; Head, 1926–54
> R. K. Fletcher
> Oil on canvas, 30" x 24½", 1954
> Chemistry Library, 255 Noyes Laboratory

Philip D. Armour (1832–1901)
Head, Armour and Company, Chicago; developer in meat industries
> Edward Timmons (1882–1938), after Lawton Parker (1868–1925)
> Oil on canvas, 45½" x 35", 1912
> Agriculture Library, 226 Mumford Hall

Hugh Atkinson (1933–86)
University Librarian, 1976–86
> Mary Phelan (1953–)
> Oil on canvas, 44" x 26", 1988
> Circulation Desk, 203 Library

Ira Osborn Baker (1853–1925)
Professor of Civil Engineering, 1874–1925; Head, 1879–1915, 1920–22
> Merton Grenhagen (1878–?)
> Oil on canvas, 42" x 32", c. 1915
> Reception, Newmark Civil Engineering
>
> Richard E. Hult (1908–)
> Oil on canvas, 27" x 22", after 1936
> 201 Engineering Hall

William Melville Baker (1823–73)
Professor of English Language, 1868–73
> Artist unknown
> Pastel, 20½" oval, undated
> Newspaper Library, 1 Library

Lita Bane (1887–1957)
Professor of Home Economics and Head, 1936–48
> Charles E. Bradbury (1888–1967)
> Oil on canvas, 39½" x 31½", 1958
> 180 Bevier Hall

Davis Wright Barkley (1842–1908)
Publisher-Editor, *Wayne County Press*
> Viola Norman (1899–c. 1934)
> Bronze bust, 28" high, 1930
> First floor, Gregory Hall

William S. Bayley (1861–1943)
Professor of Geology, 1907–32
> J. William Kennedy (1903–57)
> Oil on canvas, 33" x 27", c. 1930
> 227 Natural History

Arnold O. Beckman (1900–)
Benefactor, Beckman Institute
> Peter Fagan (1939–)
> Bronze figure, 6' high, 1988
> Rotunda, Beckman Institute
>
> Peter Fagan (1939–)
> Bronze bust, 20" high, 1988
> Fourth floor, Swanlund Administration

Arnold O. Beckman (1901–) *and his wife, Mabel Beckman* (1900–89)
Benefactors, Beckman Institute
> Billy Morrow Jackson (1926–)
> Oil on panel, 72" x 48", 1988
> Director's Office, Beckman Institute

Isabel Bevier (1860–1940)
Professor of Home Economics and Head, 1900–21
> Louis L. Betts (1873–1961)
> Oil on canvas, 50" x 40", 1920
> Second floor, Bevier Hall

Joseph Cullen Blair (1871–1940)
Professor of Horticulture, 1900–38; Dean, College of Agriculture, 1938–39
> Charles E. Bradbury (1888–1967)
> Oil on canvas, 49½" x 39½", 1946
> Agriculture Library, 226 Mumford Hall

Charles E. Bradbury (1888–1967)
Professor of Art, 1913–56
> Charles E. Bradbury (1888–1967)
> Oil on canvas, 56" x 42", c. 1935
> Krannert Art Museum, storage

Carl A. Brandly (1900–79)
Dean, School of Veterinary Medicine, 1956–68
> J. William Kennedy (1903–)
> Oil on canvas, 41" x 32½", 1968
> 3234E, Veterinary Medicine Basic Sciences

James W. Brown (1806–68)
Organizer and first president of the Illinois State Fair
 Artist unknown
 Oil on canvas, 29" x 24½", before 1911
 Agriculture Library, 226 Mumford Hall

Leslie A. Bryan (1900–85)
Director, Institute of Aviation, 1946–68
 J. William Kennedy (1903–)
 Oil on canvas, 52½" x 40½", 1968
 Institute of Aviation, Willard Airport

John T. Buchholz (1888–1951)
Professor of Botany, 1929–51
 Miriam Buchholz
 Oil on canvas, 28" x 33", undated
 306 Natural History

Thomas Jonathan Burrill (1839–1916)
Professor of Botany, 1868–1912; University Vice-President, 1879–1912;
Acting Regent, 1891–94; Dean, Graduate School, 1894–1905
 Newton Alonzo Wells (1852–1923)
 Oil on canvas, 30" x 25", 1899
 East entrance, Library

Pauline V. Chapman (1907–92)
Engineering Placement Director, 1955–73
 Robert Leach (1949–)
 Bronze plaque, 15" x 11", 1973
 207 Engineering Hall

Thomas Arkle Clark (1862–1932)
Professor of English, 1893–99; Dean of Undergraduates, 1901–9; Dean
of Men, 1909–31
 Charles W. Hawthorne (1872–1930)
 Oil on canvas, 59½" x 47", 1927
 Pine Lounge, Illini Union

Henry Wilson Clendenin (1837–1927)
Pioneer editor, *Illinois State Register*
 Lorado Taft (1860–1936)
 Bronze bust, 27" high, 1930
 Outside 112 Gregory Hall

John E. Cribbet (1918–)
Professor of Law, 1947–67; Dean, 1967–79; Chancellor of University of
Illinois at Urbana-Champaign, 1979–84
 Painted photograph, oil on canvas, 60" x 40", 1980
 Courtroom, Law

Arthur Hill Daniels (1865–1940)
Professor of Philosophy, 1895–1934; Dean, Graduate School, 1919–33,
Acting President, 1933–34
 Charles E. Bradbury (1888–1967)
 Oil on canvas, 40" x 32", 1944
 Pine Lounge, Illini Union

Eugene Davenport (1856–1941)
Dean, School of Agriculture, 1895–1922; Vice-President, 1921–22
 Sidney E. Dickenson (1890–1978)
 Oil on canvas, 49" x 39", 1932
 Agriculture Library, 226 Mumford Hall

William Osborne Davis (1837–1911)
Publisher-Editor, *Bloomington Pantagraph*

Albin Polasek (1879–1965)
Bronze bust, 29" high, prob. 1930
Second floor, Gregory Hall

Henry Johnston Detmers (1833–1906)
Professor of Veterinary Medicine, 1870–73
Artist unknown
Oil on canvas, 30½" x 26", undated
First floor, Veterinary Medicine Basic Sciences

Robert B. Downs (1903–91)
University Librarian and Dean, Library Administration, 1943–71
Mary Phelan (1953–)
Oil on canvas, 44" x 26", 1988
Circulation, 203 Library

Andrew Sloan Draper (1848–1913)
President of the University, 1894–1904
F. Wyle
Bronze plaque, 32½" x 26", 1903
Mathematics Library, 216 Altgeld Hall

Newton Alonzo Wells (1852–1923)
Oil on canvas, 48" x 33½", 1901
East entrance, Library

Newton Alonzo Wells (1852–1923)
Oil on canvas, 60" x 41", 1901
Location unknown

Melvin L. Enger (1881–1956)
Dean, College of Engineering, 1934–49
Charles E. Bradbury (1888–1967)
Oil on canvas, 40" x 32", 1949
Second-floor hallway, Talbot Laboratory

William L. Everitt (1900–86)
Dean, College of Engineering, 1949–68
Peter Fagan (1939–)
Bronze plaque, 30" x 24", 1989
First floor, Everitt Laboratory

James A. Fairlie (1872–1947)
Professor of Political Science, 1909–41
Kate Flowers
Oil on canvas, 30" x 21½", 1947
361 Lincoln Hall

Edmund Gustave Fechet (1844–1910)
Professor of Military Science, 1900–1910
Leonard Crunelle (1872–1944)
Bronze plaque, 39½" x 28½", c. 1910
South wall, first floor of Armory

Harris F. Fletcher (1892–1979)
Professor of English, 1926–61
Zlatoff-Mirsky
Oil on canvas, 19" x 15", 1943
Rare Book and Special Collections, 346 Library

Isaac Funk (1797–1865)
Pioneer farmer and seed culturist of McLean County
Artist unknown
Oil on canvas, 26" x 21" ellipse, before 1913
Agriculture Library, 226 Mumford Hall

James W. Garner (1871–1938)
Professor of Political Science, 1904–38
 W. A. Cunrom
 Oil on canvas, 30" x 20½", 1930
 361 Lincoln Hall

Robert Graham (1888–1971)
Professor of Veterinary Pathology and Hygiene, 1917–41
 Richard E. Hult (1908–)
 Oil on canvas, 30" x 25", 1956
 3234E Veterinary Medicine Basic Sciences

William W. Grainger (1895–1982)
Founder, Grainger Foundation
 Peter Fagan (1939–)
 Bronze plaque, 37" diameter, 1994
 North wall, first floor, Grainger Engineering Library

Harold E. "Red" Grange (1904–91)
Football player, 1923–25
 Fletcher C. Ransom
 Oil on canvas, 48" x 60", undated
 Lounge, Football Headquarters, Memorial Stadium

Frederick Green (1868–1956)
Professor of Law, 1904–56
 Charles E. Bradbury (1888–1967)
 Oil on canvas, 50" x 31", 1928
 Courtroom, Law

John Milton Gregory (1822–98)
First University Regent (President), 1867–80
 Peter Roos (1850–1919)
 Oil on canvas, 46½" x 38½", 1881
 East entrance, Library

 Artist unknown
 Oil on canvas, 48" x 34" oval, undated
 364 Henry Administration

Frank H. Hall (1843–1911)
Originated idea of Farmers' Institutes
 Oliver Dennett Grover (1861–1927)
 Oil on canvas, 29" x 24½", 1916
 Agriculture Library, 226 Mumford Hall

Arthur S. Hamilton (1886–1967)
Professor of Spanish, 1919–54; Assistant Dean to Foreign Students,
1946–54
 James D. Hogan (1899–1970)
 Oil on canvas, 48" x 34", 1954
 Pine Lounge, Illini Union

Austin A. Harding (1880–1958)
Director of Bands, 1905–48
 Charles E. Bradbury (1888–1967)
 Oil on canvas, 57" x 39¾", 1950
 First floor, Harding Band

Oliver Albert Harker (1844–1936)
Professor of Law, 1903–26; Dean, 1903–16, 1920–21
 Charles E. Bradbury (1888–1967)
 Oil on canvas, 25" x 39½", 1924
 Courtroom, Law

Albert James Harno (1889–1966)
Professor of Law 1903–26; Provost, 1931–44
 Albert K. Murray (1906–)
 Oil on canvas, 50" x 40", 1952
 Courtroom, Law

Benjamin F. Harris (1811–1905)
Pioneer farmer, stockman, and banker of Champaign County
 Newton Alonzo Wells (1852–1923)
 Oil on canvas, 35" x 29½", before 1915
 Agriculture Library, Mumford Hall

Peter Hay (1935–)
Professor of Law, 1963–91; Associate Dean, 1974–80; Dean, 1980–89
 Painted photograph, oil on canvas, 60" x 40", 1989
 Courtroom, Law

David Dodds Henry (1905–)
President of the University, 1955–71
 Artist unknown
 Basalt plaque, approx. 24" x 24", 1987
 First floor, Henry Administration

Mark Hindsley (1905–)
Director of Bands, 1948–70
 Fred Conway (1900–73)
 Oil on canvas, 57" x 39¾", 1971
 First floor, Harding Band

Charles F. Hottes (1870–1966)
Professor of Botany and Plant Physiology, 1913–38
 Miriam Buchholz
 Oil on canvas, 29½" x 24", 1938
 Natural History, storage

Robert R. Hudelson (1886–1977)
Professor of Agriculture, 1925–54; Dean, 1952–54
 Charles E. Bradbury (1888–1967)
 Oil on canvas, 49" x 39", 1955
 Agriculture Library, 226 Mumford Hall

George A. Huff (1872–1936)
Director of Athletics, 1896–1935
 Francis O. Salisbury (1874–1962)
 Oil on canvas, 43" x 33", 1928
 115 Huff Hall

Stanley O. Ikenberry (1935–) *and His Wife, Judith L. Ikenberry*
(1936–)
President of the University, 1979–95
 James Ingwerson (1929–)
 Oil on canvas, 64" x 41½", 1985
 University President's House

Edmund Janes James (1855–1925)
President of the University, 1904–20
 Ralph Clarkson (1861–1942)
 Oil on canvas, 69½" x 48½", 1929
 East entrance, Library

 Newton Alonzo Wells (1852–1923)
 Mosaic, 25½" diameter, c. 1919
 President's Conference Room, Henry Administration

David Kinley (1861–1944)
President of the University, 1920–30

Paul Trebilcock (1902–81)
Oil on canvas, 72" x 53½", 1926
East entrance, Library

Laurence Marcellus Larson (1868–1938)
Professor of History, 1907–37
Richard E. Hult (1908–)
Oil on canvas, 29½" x 24½", 1936
309E Gregory Hall

Victor Fremont Lawson (1850–1925)
Publisher-Editor, *Chicago Daily News*
Lorado Taft (1860–1936)
Bronze bust, 28" high, 1930
Outside 112 Gregory Hall

Abraham Lincoln (1809–65)
President of the United States, 1861–65
Hermon Atkins MacNeil (1866–1947)
Bronze bust, 28" high, before 1928
Niche, east entrance to Lincoln Hall

Elijah Parish Lovejoy (1802–37)
Abolitionist editor, *Alton Observer*
Oskar J. W. Hansen (1892–1970)
Bronze bust, 29" high, 1929
First floor, Gregory Hall

Matthew Thomson McClure (1883–1964)
Dean, College of Liberal Arts and Sciences, 1934–47
James D. Hogan (1889–1970)
Oil on canvas, 50" x 39", undated
Pine Lounge, Illini Union

Cyrus Hall McCormick (1809–84)
Inventor of the reaper
Artist unknown
Oil on canvas, 29" x 24½", before 1909
Agriculture Library, 226 Mumford Hall

Jack Harris McKenzie (1930–)
Dean, College of Fine and Applied Arts, 1971–90
Erlane Carter Sellers (1930–)
Oil on canvas, 36" x 30", 1990
First floor, Architecture

Wyck E. McKenzie (1915–)
Nonacademic Instructor, 1949–75
Carol Dominic
Bronze plaque, 34" x 15", 1975
Crane Bay, Engineering Hall

William B. McKinley (1856–1926)
U.S. Senator and donor of McKinley Health Center
Mary M. Wetmore (1870–1940)
Oil on canvas, 52" x 39", 1928
East entrance, McKinley Health Center

Carl Shipp Marvel (1894–1988)
Professor of Chemistry, 1920–61
Charles Cropper Parks (1922–)
Bronze bust, 27" high, undated
433 Roger Adams Laboratory

Joseph Meharry Medill (1823–99)
Editor, *Chicago Tribune*
Oskar H. W. Hansen (1892–1970)

Bronze bust, 29" high, 1929
First floor, Gregory Hall

Douglas Mills (1908–83)
Director of Athletics, 1941–66
James Ingwerson (1929–)
Oil on canvas, approx. 60" x 30", 1966
Memorial Stadium, storage

Lloyd Morey (1886–1965)
University Comptroller, 1916–53; President of the University, 1953–55
Charles E. Bradbury (1888–1967)
Oil on canvas, 53½" x 41", 1955
West Lounge, Illini Union

Egon P. Weiner (1906–87)
Bronze head, 17" high, 1955
Location unknown

George Espy Morrow (1840–1900)
Professor and First Dean of Agriculture, 1878–94
Newton Alonzo Wells (1852–1923)
Oil on canvas, 23½" x 17½", c. 1899
Agriculture Library, 226 Mumford Hall

Herbert W. Mumford (1871–1938)
Dean, College of Agriculture, 1922–38
Sidney E. Dickinson (1890–1978)
Oil on canvas, 49½" x 39½", 1938
Agriculture Library, 226 Mumford Hall

Rexford Newcomb (1886–1968)
Professor, Architectural History, 1918–54; Dean, College of Fine and
Applied Arts, 1932–54
Charles E. Bradbury (1888–1967)
Oil on canvas, 49½" x 39½", 1945
First floor, Architecture

Nathan W. Newmark (1910–81)
Professor of Civil Engineering, 1937–76; Head, 1956–73
Billy Morrow Jackson (1926–)
Oil on canvas, 35" x 28", 1974
Reception, Newmark Civil Engineering

William Albert Noyes (1857–1941)
Head, Department of Chemistry, 1907–26
Charles E. Bradbury (1888–1967)
Oil on canvas, approx. 31" x 27", 1930
Chemistry Library, 255 Noyes Laboratory

Timothy Nugent (1923–)
Director of Rehabilitation Services, 1948–85
Billy Morrow Jackson (1926–)
Watercolor on paper, 29" x 22", 1985
Lobby, Rehabilitation Education Center

William Abbott Oldfather (1880–1946)
Professor of Classics, 1909–45; Head, 1926–45
James D. Hogan (1899–1973)
Oil on canvas, 31" x 26", 1942
Classics Library, 419A Library

Arthur William Palmer (1861–1904)
Professor of Chemistry, 1889–1904; Head, 1894–1904
Charles E. Bradbury (1888–1967)
Oil on canvas, 30" x 28", 1931
Chemistry Library, 255 Noyes Laboratory

William Parlin (1817–91)
Pioneer developer of agricultural machinery and implements
 Ralph Clarkson (1861–1942)
 Oil on canvas, 29" x 14", c. 1911
 Location unknown

Samuel Wilson Parr (1857–1931)
Professor of Chemistry, 1891–1926
 Charles E. Bradbury (1888–1967)
 Oil on canvas, 29½" x 24½", 1931
 116 Roger Adams Laboratory

Selim H. Peabody (1829–1903)
University Regent (President), 1880–91
 Leopold G. Seyffert (1887–1956)
 Oil on canvas, 39½" x 33½", 1922
 East Entrance, Library

 Newton Alonzo Wells (1852–1923)
 Oil on canvas, 30" x 25", before 1907
 University Archives, 19 Library

Henry Means Pindell (1860–1924)
Publisher-Editor, *Peoria Journal and Transcript*
 Oskar H. W. Hansen (1892–1970)
 Bronze bust, 28" high, 1930
 First floor, Gregory Hall

Thomas A. Read (1931–66)
Head, Metallurgy and Mining, 1954–66
 Harry Breen (1930–)
 Bronze plaque, 22¾" x 17", 1966
 Near elevator, Metallurgy and Mining

Nathan Clifford Ricker (1843–1924)
Head, Architecture, 1873–1910; Dean, College of Engineering, 1878–1906
 Newton Alonzo Wells (1852–1923)
 Oil on canvas, 29" x 14", 1899
 First floor, Architecture

 Samuel Chatwood Burton (1881–1950)
 Bronze bust, 24½" high, 1915
 Architecture and Art Library, 208 Architecture

 Newton Alonzo Wells (1852–1923)
 Mosaic, 25½" diam., 1917
 Architecture and Art Library, 208 Architecture

William C. Rose (1887–1985)
Professor of Biochemistry, 1922–39
 James D. Hogan (1899–1970)
 Oil on canvas, 36" x 30", undated
 301A Roger Adams Laboratory

Henry Perly Rusk (1884–1954)
Head, Animal Husbandry, 1922–39; Dean, College of Agriculture, 1939–52
 Charles E. Bradbury (1888–1967)
 Oil on canvas, 49½" x 39½", undated
 Agriculture Library, 226 Mumford Hall

Thomas E. Savage (1866–1947)
Professor of Geology, 1906–47
 Charles E. Bradbury (1888–1967)
 Oil on canvas, 36" x 26", 1941
 227 Natural History

Violet Jayne Schmidt (1867–1937)
First Dean of Women, 1897–1904
> Richard E. Hult (1908–)
> Oil on canvas, 28½" x 22½", undated
> Newspaper Library, 1 Library

Edward Wyllis Scripps (1854–1926)
Founder of the United Press and Scripps-Howard Enterprises
> Jo Davidson (1883–1952)
> Bronze bust, 30" high, 1922
> Outside 112 Gregory Hall

Katharine Lucinda Sharp (1865–1914)
Director of the Library School, 1893–1907
> Lorado Taft (1860–1936)
> Bronze plaque, 48" x 35½", 1921
> Hallway, 306 Library

Samuel W. Shattuck (1841–1915)
Professor of Mathematics, 1871–1912
> Newton Alonzo Wells (1852–1923)
> Oil on canvas, approx. 36" x 24", 1899
> Mathematics Library, 216 Altgeld Hall

Irwin Small (1923–)
Professor of Veterinary Medicine, 1958–92
> Daniel W. Hunt (1961–)
> Bronze plaque, 17½" x 24½", 1992
> 245 Small Animal Clinic

Captain Thomas J. Smith (1836–1918)
Donor of Smith Memorial Hall
> M. Burk Roysden
> Oil on canvas, 84" x 41", 1906
> South entrance, Smith Memorial Hall

Tina Smith (1847–1903)
Wife of donor of Smith Memorial Hall
> M. Burk Roysden
> Oil on canvas, 84" x 41", 1906
> North entrance, Smith Memorial Hall

Edward Snyder (1835–1903)
Professor of German, 1868–95; Dean, College of Literature, 1874–80
> Lorado Taft (1860–1936)
> Marble bust, 32" high, 1915
> Krannert Art Museum, storage

Seward C. Staley (1893–1991)
Dean, College of Physical Education, 1937–61
> James D. Hogan (1899–1970)
> Oil on canvas, 35½" x 30", 1950
> Applied Life Studies Library, 146 Library

Harry Harkness Stoek (1866–1923)
Head, Mining and Engineering, 1909–23
> Lorado Taft (1860–1936)
> Bronze plaque, 49½" x 36", 1925
> West staircase, Engineering Hall

Melville Elijah Stone (1842–1929)
Founder and General Manager, the Associated Press
> Frances Savage Curtis
> Bronze head, 27" high, c. 1930
> Second floor, Gregory Hall

Russell Neil Sullivan (1901–88)
Professor of Law, 1939–67; Dean, 1957–67
James D. Hogan (1899–1970)
Oil on canvas, 49" x 42", 1965
Courtroom, Law

Lorado Taft (1860–1936)
Sculptor and University alumnus
Mary Webster (1881–?)
Bronze bust, 31" high, 1936
110 Architecture, Architecture

Arthur Newell Talbot (1857–1942)
Professor of Municipal and Sanitary Engineering, 1890–1926
Ralph Clarkson (1861–1942)
Oil on canvas, 62" x 39½", 1925
220 Talbot Laboratory

Edgar J. Townsend (1864–1955)
Professor of Mathematics, 1893–1929; Dean, College of Science, 1905–13
Charles E. Bradbury (1888–1967)
Oil on canvas, approx. 36" x 24", 1929
Mathematics Library, 216 Altgeld Hall

Fred H. Turner (1900–75)
Dean of Students, 1931–68
Fred Conway (1900–73)
Oil on canvas, 48" x 36", 1968
West Lounge, Illini Union

Jonathan B. Turner (1805–99)
Agriculturalist, leader in establishment of the University
Photographic enlargement of 1853 daguerreotype, 33½" x 19½"
Agriculture Library, 226 Mumford Hall

Harold R. Wanless (1898–1970)
Professor of Geology, 1923–67; Chairman, 1946–47
Joseph Raphael (1872–1950)
Oil on canvas, 24" x 20½", undated
247 Natural History

Allen S. Weller (1907–)
Professor of Art History, 1947–75; Dean, College of Fine and Applied
Arts, 1954–71; Director, Krannert Art Museum, 1964–75
Erlane Carter Sellers (1930–)
Oil on canvas, 36" x 30", 1971
First floor, Architecture

George White (1903–85)
Professor of Geology 1947–71
Judith Shackelton
Oil on canvas, 24" x 20", c. 1973
Geology Library, 223 Natural History

Arthur Cutts Willard (1878–1960)
President of the University, 1934–46
Charles E. Bradbury (1888–1967)
Oil on canvas, 70" x 43", 1946
North Lounge, Illini Union

Sitter Unknown
Newton Alonzo Wells (1852–1923)
Oil on canvas, 48" x 32", 1905
University Archives, 19 Library

Robert Allerton Park

Robert Allerton (1873–1964)
Donor of Robert Allerton Park
　　　Ellen G. Emmet Rand (1876–1941)
　　　Oil on canvas, 24" x 24", 1901
　　　Allerton House

Chicago

Raymond B. Allen (1902–86)
Executive Dean, Chicago Colleges, 1939–46; Dean, College of Medicine, 1943–46
　　　Freeman Schoolcraft (1905–　)
　　　Bronze plaque, 22" diam., 1946
　　　Foyer, Faculty-Alumni Center, 119 College of Medicine West

Percival Bailey (1892–1973)
Professor of Neurology and Neurological Surgery, 1939–58
　　　Edmund Giesbert (1893–　)
　　　Oil on canvas, 43½" x 35", 1957
　　　Third floor, Library of the Health Sciences

Carl Beck (1864–1952)
Professor of Surgical Pathology, 1898–1913
　　　Oskar Gross (1871–1963)
　　　Oil on canvas, 35" x 43½", 1913
　　　First floor, Library of the Health Sciences

Granville A. Bennett (1901–86)
Professor of Pathology, 1944–70; Head, 1944–54; Dean, College of Medicine, 1954–67
　　　Hooker Goodwin (1907–82)
　　　Oil on canvas, 51½" x 35½", 1962
　　　Department of Pathology, 437 College of Medicine West

Allan G. Brodie (1897–1976)
Professor of Orthodontics, 1929–66; Head, 1937–66; Dean, 1947–54
　　　Edith S. Wright
　　　Oil on canvas, 42" x 32", c. 1956
　　　Brodie Room, Orthodontics Library, 135A College of Dentistry

Warren Henry Cole (1898–1990)
Professor and Head, Department of Surgery, 1936–66
　　　Howard Glassford
　　　Bronze bust, 17½" high, 1976
　　　First floor, Library of the Health Sciences

　　　Hooker Goodwin (1907–82)
　　　Oil on canvas, 41½" x 31½", 1965
　　　518J Clinical Sciences

David John Davis (1875–1954)
Dean, College of Medicine, 1925–43
　　　James H. McConnell (1914–　)
　　　Bronze plaque, 17½" diam., 1941
　　　Special Collections, 320 Library of the Health Sciences

Charles Davison (1858–1940)
Professor of Surgery, 1899–1926; Head, 1917–26
　　　Lorado Taft (1860–1936)
　　　Bronze bust, 26" high, 1926
　　　Special Collections, 320 Library of the Health Sciences

Harry Filmore Dowling (1904–)
Professor and Head, Department of Medicine, 1951–69
>Eugene A. Montgomery (1905–)
>Oil on canvas, 43½" x 33½", 1969
>1010 Clinical Sciences

Charles Warrington Earle (1845–93)
Professor of Obstetrics and Gynecology, 1882–93
>Ellen Rankin Copp (1853–?)
>Bronze bust, 29" high, 1894
>Faculty-Alumni Center, 119 College of Medicine West

Frederick Howard Falls (1885–1974)
Professor and Head, Obstetrics and Gynecology, 1925–54
>Carle Tolpo (1901–)
>Oil on canvas, 47¾" x 35½", 1986
>Mengert Library, W236 Clinical Sciences North

Francis Gerty (1892–1994)
Professor and Head, Psychiatry, 1941–61
>Eugene H. Montgomery (1905–)
>Oil on canvas, 49½" x 31½", undated
>Third floor, Library of the Health Sciences

Morton Falk Goldberg (1937–)
Professor and Head, Opthalmology, 1970–89
>Istvan Nyikos
>Oil on canvas, 41" x 33½", 1986
>Library, L163 Lions of Illinois Eye Research Institute

Edward Louis Heintz (1874–1932)
Associate Professor of Clinical Medicine, 1901–27
>Artist unknown
>Bronze plaque, 21½" x 15", undated
>North corridor, College of Medicine West

Julius H. Hess (1876–1955)
Professor of Pediatrics, 1913–44
>James H. McConnell (1914–)
>Bronze plaque, 17½" diam., undated
>Foyer, Faculty-Alumni Center, 119 College of Medicine West

Edward L. Holmes (1828–1900)
Founder, Chicago Charitable Eye and Ear Infirmary, 1859
>Artist unknown
>Oil on canvas, 26" x 21½", undated
>Auditorium foyer, UI Hospital Eye and Ear Infirmary

Paula Weiser Holmes
Wife of Edward L. Holmes
>Artist unknown
>Oil on canvas, 26" x 21½", undated
>Auditorium foyer, UI Hospital Eye and Ear Infirmary

William F. Hughes, Jr. (1913–)
Professor and Head, Ophthalmology, 1947–58
>R. D. Bentley
>Oil on canvas, 39" x 31", 1987
>Auditorium foyer, UI Hospital Eye and Ear Infirmary

Abraham Reeves Jackson (1827–92)
Professor of Obstetrics and Gynecology, 1882–92
>Ellen Rankin Copp (1853–)
>Bronze bust, 28" high, 1893
>Special Collections, 320 Library of the Health Sciences

Richard Hermann Jaffé (1888–1937)
Professor of Pathology and Bacteriology 1922–28, 1931–37
 A. Miller
 Oil on canvas, 26½" x 19", 1938
 Special Collections, 320 Library of the Health Sciences

Howard Kubacki (1895–1978)
Professor of Prosthodontic Dentistry, 1931–63; Head, 1960–63
 Peter Darro
 Oil on canvas, 24" x 36", 1963
 102 College of Dentistry

Abraham Lincoln (1809–65)
President of the United States, 1861–65
 Edith von Nostrand
 Oil on canvas, 29½" x 24½", by 1893
 Corridor, Faculty-Alumni Center, 119 College of Medicine West

William F. Mengert (1899–1976)
Professor and Head, Obstetrics and Gynecology, 1955–68
 Edward Fazziu
 Oil on canvas, 39" x 29½", undated
 Mengert Library, W236 Clinical Sciences North

George Harvey Miller (1901–72)
Senior Technologist, Anatomy
 Artist unknown
 Bronze plaque, 18" x 36", undated
 North corridor, College of Medicine West

Eric Oldberg (1901–86)
Professor and Head, Neurology, 1936–71
 Dominic Vignola
 Oil on canvas, 25" x 20", 1985
 765 Neuropsychiatric Institute

 Egon Weiner (1906–87)
 Bronze bust, 18" high, 1969
 First floor, Library of the Health Sciences

Nelson M. Percy (1875–1958)
Professor of Surgery 1914–58
 Edgar Miller
 Oil on canvas, 41" x 37½", undated
 Third floor, Library of the Health Sciences

William Allen Pusey (1865–1940)
Professor of Dermatology, 1893–1915
 Alfred Lienzo
 Bronze bust, 18" high, 1932
 Special Collections, 320 Library of the Health Sciences

William Edward Quine (1847–1922)
Professor of Medicine 1883–1914; Dean, 1897–1913
 Zanvill David Klopper (1870–)
 Oil on canvas, 22" x 19", 1911
 Special Collections, 320 Library of the Health Sciences

 Santa Eulalio
 Bronze bust, 26" high, 1907
 Special Collections, 320 Library of the Health Sciences

Daniel Atkinson King Steele (1852–1931)
Professor of Surgery, 1881–1917; Head, 1912–17
 Leonard Crunelle (1872–1944)
 Bronze bust, 28" high, undated
 Faculty-Alumni Center, 119 College of Medicine West

Selected Bibliography

Periodicals

American Magazine of Art

Architectural Record

Art Digest

Art Journal

Champaign-Urbana News-Gazette

College Art Journal

Daily Illini (also published as the *Illini*)

Illinois Alumni News (also published as the *Alumni Quarterly* and the *Alumni Quarterly and Fortnightly Notes*)

Illio

University of Illinois *Annual Reports of the Board of Trustees*

General Works

Armstrong, Tom, Wayne Craven, et al. *Two Hundred Years of American Sculpture.* New York: David R. Godine in association with the Whitney Museum of American Art, 1976.

Bach, Ira J., and Mary Lackritz Gray. *A Guide to Chicago's Public Sculpture.* Chicago: University of Chicago Press, 1983.

Craven, Wayne. *Sculpture in America.* Newark, Del.: University of Delaware Press, 1968; New York: Cornwall Books, 1984.

Goode, James M. *The Outdoor Sculpture of Washington, D.C.* Washington, D.C.: Smithsonian Institution Press, 1974.

Post, Chandler R. *A History of European and American Sculpture.* Cambridge, Mass.: Harvard University Press, 1921.

Proske, Beatrice Gilman. *Brookgreen Gardens Sculpture.* Brookgreen, S.C.: Brookgreen Gardens, 1943.

Riedy, James L. *Chicago Sculpture.* Urbana: University of Illinois Press, 1981.

Scheinman, Muriel. "Altgeld Hall, the Original Library Building at the University of Illinois: Its History, Architecture and Art." M.A. thesis, University of Illinois at Urbana-Champaign, 1969.

———. "Art Collecting at the University of Illinois: A History and Catalogue." Ph.D. diss., University of Illinois at Urbana-Champaign, 1981.

Solberg, Winton. *The University of Illinois, 1867–1894: An Intellectual and Cultural History.* Urbana: University of Illinois Press, 1968.

Solender, Katherine. *The American Way with Sculpture, 1890–1930.* Cleveland, 1986.

Sparks, Esther. "A Biographical Dictionary of Painters and Sculptors in Illinois, 1808–1945." Ph.D. diss., Northwestern University, 1971; Ann Arbor, 1974.

Taft, Lorado. *The History of American Sculpture.* Rev. ed. New York: Macmillan, 1924.

———. *Modern Tendencies in Sculpture.* Chicago: University of Chicago Press, 1921.

Zimmer, Heinrich. *Art of Indian Asia.* 2 vols. New York: Pantheon, 1955.

Index

215